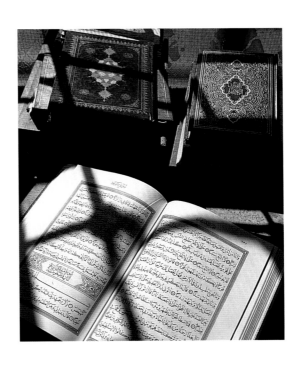

Portrait of Islam

A JOURNEY THROUGH THE MUSLIM WORLD

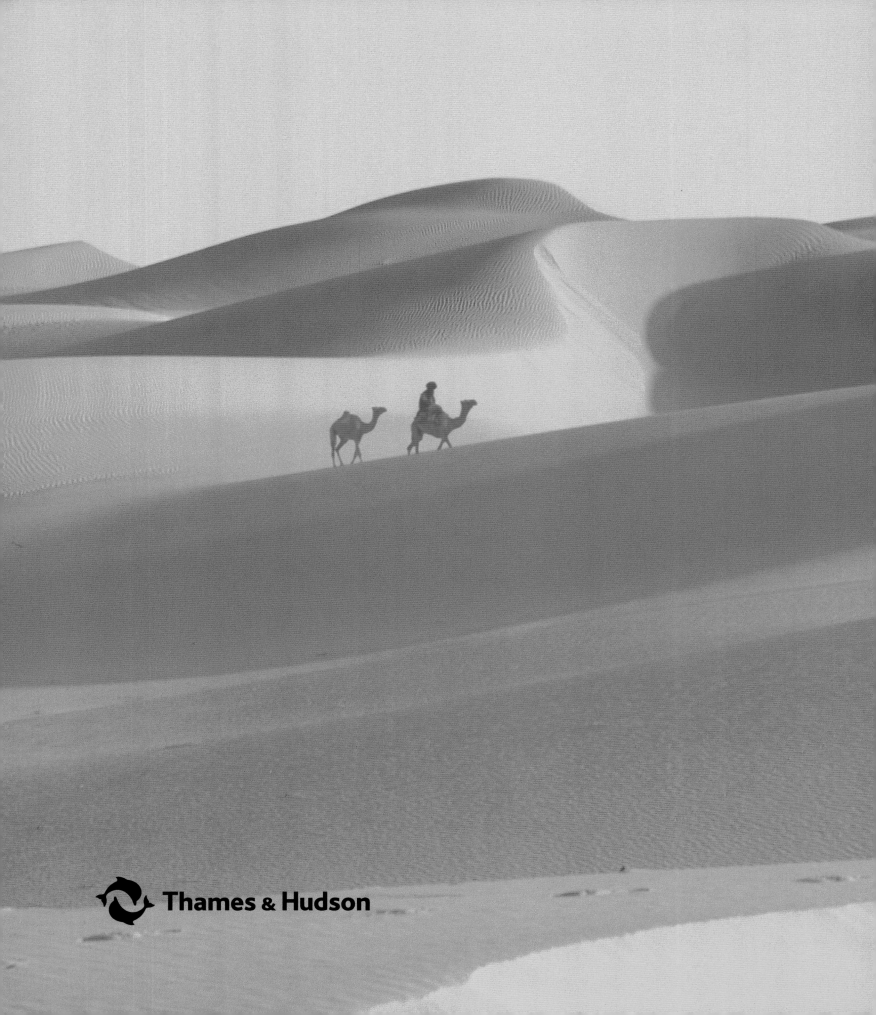

Thames & Hudson

Portrait of Islam

A JOURNEY THROUGH THE MUSLIM WORLD

With 156 illustrations in color

ROBIN LAURANCE
INTRODUCTION BY ROBIN OSTLE

For Aileen

Designed by Joanna Dale

Map illustration by Ken Cox

© 2002 Robin Laurance
Introduction © 2002 Robin Ostle

First published in hardcover in the United States of America in 2002 by
Thames & Hudson Inc., 500 Fifth Avenue, New York, New York 10110

thamesandhudsonusa.com

Library of Congress Catalog Card Number 2002101477
ISBN 0-500-51098-9

Printed in Hong Kong by H & Y Printing Limited

CONTENTS

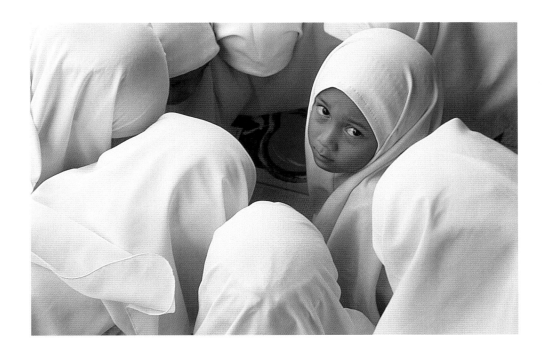

Half-title page: Korans resting in an alcove of a mosque in Tripoli. LEBANON

Title page: Winds that blow across the Sahara constantly remould these dunes north of In Salah. ALGERIA

Preceding page: Wearing the white *hijab*, children on a school outing in Kuantan. MALAYSIA

Right: On the coast of eastern Java, a woman tends to her husband's fishing nets. INDONESIA

Page 10: The Dome of the Rock, more sanctuary than mosque, is the third most holy place in Islam after Mecca and Medina. The dome stands over the rock on the Temple Mount from which the Prophet Muhammad is said to have ascended to heaven. JERUSALEM

When, some six years ago, I set out to photograph the Muslim world – or as much of it as I could sensibly cover – I did so for no better reason than that it seemed to be wonderfully photogenic. And for that I make no apology.

But several things soon became clear that would add a political dimension to my journey.

The first was, quite simply, that wherever I was the mosques were full on Fridays – full to overflowing. Nowhere in the Christian world did I see packed churches every Sunday.

And during the month of Ramadan, people really did fast. Businessmen, politicians, shop-keepers and even photographers all resisted food and drink between sunrise and sunset. This showed a degree of discipline seldom found in other world religions.

There were, to be sure, huge differences in the way people chose to express their faith, and there were many aspects of national character that clearly owed their existence to local culture rather than to the dictates of Islam. There was also in many of these Muslim societies a hunger for Western culture – the music, the clothes, the films, the fast food – and a desire, particularly amongst the young, for much greater freedom of political expression.

Overall, it was clear that Islam was a growing force in our world. And while aspects of Western culture were admired and emulated, there were also signs of a growing resentment towards these Western nations whose very culture was proving so popular. It was also abundantly clear back home that Islam was misunderstood. And because it was misunderstood it was feared, and because it was feared it was in turn resented and sometimes vilified.

This resurgence of Islam, coupled with this lack of understanding of the faith in the non-Muslim world, began to look decidedly worrying. So my journey was no longer just a search for strong pictures but an attempt to show that Islam was very different from the stereotyped image so often portrayed in the West.

True, I found people whose strict adherence to the code of Islam might be questioned. And of course, as with all societies, there are fanatics and militants who are Muslims. A number of them wrought unimaginable terror on America in September 2001. But I had all but completed the photography by then, and anyway they do not represent the Muslim world I found. What I found were extra-ordinary people in no ordinary lands. And I saw a need to build greater understanding between the Muslim and the non-Muslim worlds.

ROBIN LAURANCE

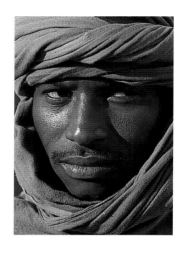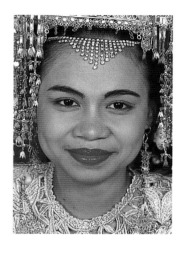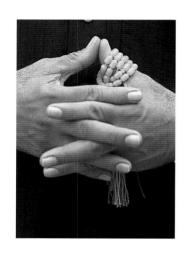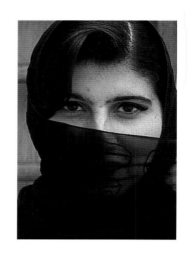

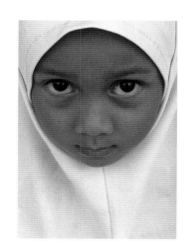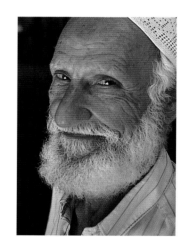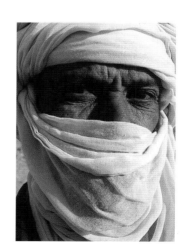

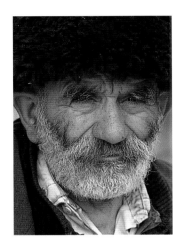
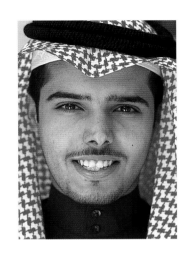
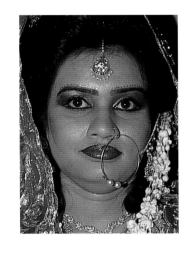
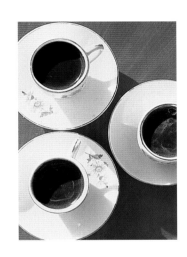
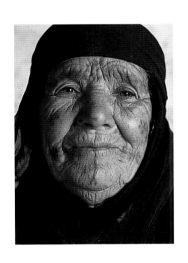

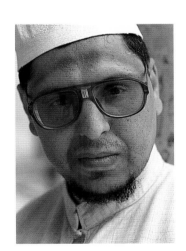

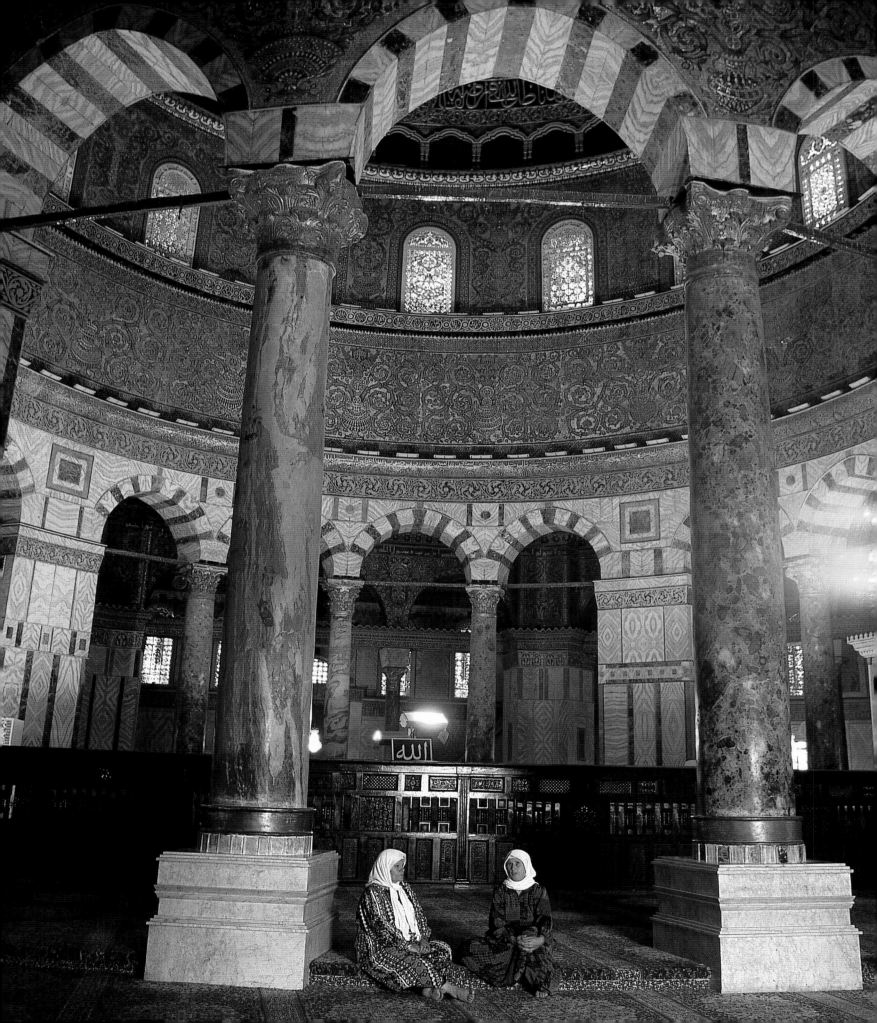

The number of Muslims in the world today is approximately 1.25 billion, or at least one-fifth of the total population of the planet. One tends naturally to associate Islam with its heartlands of the Near and Middle East and North Africa where it exists as the majority religion, and yet the most populous country of the world of Islam is Indonesia with over two hundred million inhabitants, while the Muslim populations of South Asia in Pakistan, Bangladesh, India and Afghanistan exceed by far those of the Near and Middle East.

As well as being the majority religion in the regions and countries mentioned above, Islam is now the religion of substantial and permanent communities in Europe (more than ten millions) and the United States of America (at least six millions): both Europe and the USA have now become Christian-Jewish-Muslim continents where the three major monotheistic religions co-exist, along with the secular ideologies which shape their constitutions and their societies. Thus it is obvious that Islam, spanning the continents of the world as it does, exists in a bewildering variety of social, political and cultural contexts, a variety which is often reflected in the ways in which Muslims interpret and practise their faith. Yet in spite of the differences in the daily experiences lived by Muslims in Mecca and Medina, Jakarta, Paris,

Bradford or Detroit, there are certain core elements of the religion and its history which would be recognized as such wherever and in whatever circumstances the faithful happen to find themselves.

THE FAITH

The basic article of faith to which all Muslims adhere states the following: 'There is no God but God, and Muhammad is the Prophet of God.' This statement of belief is known in Arabic as the *shahada* and, however else Muslims may differ in their interpretations of the faith in different parts of the world, there can be no compromise on this fundamental bearing of witness to belief in the One God (also the God of Jews and Christians) and in His Prophet.

The founder of the religion, the Prophet Muhammad, is revered by all Muslims, although it is important to stress that he is revered very much as a special human being but not as a personality with any divine connotations. He was born in Mecca in present-day Saudi Arabia in or around AD 570, and the Islamic era began in AD 622 when Muhammad moved from Mecca to Medina, some 220 miles to the north. While in Medina, he established a group of believers in his new mission, and they

formed the prototype and model of a society which generations of Muslims have looked up to ever since.

Today, Mecca and Medina are considered the two most holy sites in the Islamic world, and by the time the Prophet died in AD 632, it was already clear that the religion which he had created was much more than a body of private religious beliefs: he had also brought into being a new type of community with its particular laws and institutions.

The *shahada* is the first and most fundamental of the articles of the faith which are often referred to as The Five Pillars of Islam. In addition to making the profession of the *shahada*, the pious Muslim should seek to perform the following acts of worship:

■ Prayer takes place five times a day at fixed times. This may be in a mosque, but will more usually be in places which are convenient and relatively undisturbed. Friday is the day of communal prayers and preaching in the mosques.

■ A proportion of one's wealth should be donated as a religious alms tax or *zakat*.

■ During the holy month of Ramadan, Muslims should fast from dawn to dusk.

■ At least once during a Muslim's lifetime the *hajj* or pilgrimage to Mecca should be performed – provided that circumstances permit.

If a person wishes to embrace Islam, no compromise is possible in the profession of faith or the *shahada*. The extent to which the other four of the five Pillars of Islam are observed varies greatly amongst Muslims throughout the world, but the fast during Ramadan and the *hajj* ritual do play important roles in strengthening the sense of belonging and solidarity amongst the different communities. Observance of the fast is widespread, even in Islamic countries which have long been subject to secularizing influences, while there are ever-increasing pressures of numbers each year of those who perform the *hajj*, as Muslims throughout the world take advantage of cheaper air travel.

THE SCRIPTURE

The series of revelations which Muhammad received from God forms the text of the Koran, which is the scripture of Islam and the equivalent of the Bible of the Christians or the Torah of the Jews. These revelations were received intermittently over a period of some twenty years before Muhammad's death in AD 632, and shortly afterwards they were collected and recorded by some of the Prophet's closest associates.

The Koran consists of 114 *surahs* or chapters, but its internal arrangement is quite unlike the arrangement of the chapters in any normal book. The *surahs* are of disparate length, the shortest being of no more than three brief verses while the longest contains almost three hundred lengthy verses. Apart from the opening *surah*, the remainder of the chapters are arranged according to length, beginning with the longest and ending with the shortest. Each *surah* forms a self-contained unit, and they are not designed to be read or recited in any particular order.

Some of the dominant themes of the Koran include descriptions of the judgments which await human beings at the end of their lives on earth, and assertions of the omnipotence of God and of His omniscience, as well as His infinite capacity for mercy and compassion. Muslims believe that the Koran is quite literally the Word of God and the most perfect of God's revelations to human beings. They accept that other great prophets, such as Moses and Jesus, existed before Muhammad, and such figures are accorded due respect in Islamic tradition. However, Muslims maintain that Muhammad was the 'Seal of the Prophets', or the last in the line of the Prophets who believed in the One God, a line which extended back to Abraham and ultimately to Adam. According to orthodox Islamic teaching, although Muhammad is the 'Seal of the Prophets', he was very much a human being with no attributes of divinity. In fact, it is the Koran itself, the Word of God, which is invested with divine qualities: this is because Muslims consider their scripture essentially as a manifestation of God's divine being, which is eternal and uncreated.

A WORLD RELIGION

When the Prophet Muhammad died in AD 632, his followers embarked on a series of military migrations out of the Arabian Peninsula where Islam had been born. These led to defeats inflicted by the Muslim armies on the two dominant political powers to the north, the Byzantine Empire and the Sassanian Persian Empire. This was the beginning of the dramatic territorial expansion of the Islamic world: it spread eastwards from Syria and Iraq far across Central Asia, and to the West it went from Egypt as far as Morocco. The conquest of the Iberian Peninsula was undertaken from AD 711 to 716, and the northern progress of the Muslim armies was halted only in AD 732 by the forces of Charles Martel at the Battle of Poitiers. Spain did not revert to the control of Christendom until the reconquest by the Catholic Kings, which was completed in AD 1492.

The two great Arab dynasties of medieval Islamic history are the Umayyad Caliphate (AD 661–750) and the Abbasid Caliphate (AD 750–1258). During these centuries, the Islamic world saw the rise of major civilizations: cities such as Damascus, Baghdad and Cairo were the settings for great achievements in science and learning, architecture, literature and the fine arts. They were important centres of thriving economic activity which supported lifestyles of great sophistication and refinement on the part of rulers and wealthy sectors of society. The dynasty of the Ghaznavids began the process of extending Muslim rule into the Hindu kingdoms of northern India from AD 1000, and this led to the establishment of the Sultanate of Delhi at the beginning of the 13th century, and ultimately in the 16th century to the rise of the greatest Muslim power in Indian history, the Empire of the Mughals.

The establishment of Islam in India was one of the important factors in the further spread of the faith to Southeast Asia, where it was propagated by a combination of contact with Muslim traders and with preachers and holy men who set out both from Arabia and from India to convert unbelievers and to increase the knowledge of the faithful. Malaya and the Southeast Asian Archipelago were natural stages on the

trade routes between Western Asia and the Far East and the Spice Islands of the Moluccas.

The Muslim merchants from India were as welcome in Malaya and the Archipelago as their former Hindu counterparts had been. As North Sumatra is the point at which the trade route from India first reaches the Archipelago, it was natural that Islam should have established its first footing there, a feature which was observed by Marco Polo in the course of his return from China to Persia in AD 1292. Malacca (now Melaka), the main trading centre of the area in the 15th century, became the most important point of Muslim influence, and it was from there that the faith was disseminated along the trade routes northeast to Brunei and Sulu, and southeast to the northern ports of Java and the Moluccas.

THE LAW, STATE AND SOCIETY

In addition to the basic articles of the faith and the scripture, a central element of Islam is the sacred law, known in Arabic as the *shari'a*: ideally, this should control the actions of individuals and governments in an Islamic society.

The Koran contains a certain amount of legal material, and these texts were the starting point for the development of a remarkably detailed legal system, although the *shari'a* is much more than a legal system in the Western sense of the term. In the most traditional Islamic societies, it provides detailed guidance which regulates the life and death of the believer. It provides Muslims with the rules of conduct towards their fellow men, their rulers and the opposite sex. It gives detailed prescriptions for the law of personal status, criminal law and commercial practice. It gives guidance on dietary habits and modes of dress, and organizes the division of a Muslim's estate after death.

For much of the 20th century in many countries of the Islamic world, the scope of the *shari'a* was gradually reduced by the encroachments of legal systems derived largely from Western models. However, since the 1970s a number of countries, such as Egypt and Pakistan, have chosen to re-emphasize the role of the *shari'a* in laws governing personal status, and some have begun to establish systems of Islamic banking.

The countries in which the *shari'a* plays the most prominent role in public and private life are those in which the political systems are derived directly from Islamic tradition and political principles. At the moment there are two very different models of such states in the world of Islam: the Kingdom of Saudi Arabia and the Islamic Republic of Iran. The former is a monarchy which regulates its state and society according to a particular view of Islamic tradition, while the latter is a republic with a constitution of significant complexity which is once again based on interpretations of Islamic legal, social and political theory. Both are undoubtedly Islamic political systems, but of very different kinds.

The extent to which the lives of individual Muslims are governed by the *shari'a* varies greatly throughout the infinite variety of the world of Islam: while the Kingdom of Saudi Arabia, the other countries of the Arabian Peninsula and the Islamic Republic of Iran continue to attach the highest importance to comprehensive observance of the *shari'a*, the

government of Turkey, for example, continues to seek to uphold the secular principles on which its constitution is based.

The complexity and diversity of the circumstances in which Muslim women live throughout the world is a good example of how difficult it is to generalize about their social situations. In the 20th century, the secularizing influences which affected countries such as Turkey, Tunisia, Egypt, Syria or Iraq also granted women significant degrees of emancipation in their legal status, habits of dress and general social customs, but, not surprisingly, this process was much more rapid in cities than in the countryside. There is little in common between Muslim women who are nomads, villagers, poor city dwellers, middle-class citizens or members of Westernized elites. It is difficult to be dogmatic about the extent to which their lifestyles are affected by Islam or by the general cultural, social and economic circumstances in which they live.

The veil, or *hijab*, which many Muslim women wear varies greatly in both form and extent. The most complete versions of the veil are found in Saudi Arabia and other parts of the Arabian Peninsula, while elsewhere it resembles the equivalent of an attractive and fashionable headscarf. On the other hand, nomadic women engaged in tough work in the fields or tending flocks usually go unveiled. Women in towns and cities may wear a veil as a sign of status, as a statement of modesty and respectability, as a declaration of cultural self-assertion, or they may not wear the veil at all.

In spite of the fact that such a large proportion of the peoples of the world are Muslims and that there are large and permanent Islamic communities in Europe and the USA, the importance of mutual understanding and tolerance increases rather than diminishes with time. The appalling attacks which struck New York, Washington and Pennsylvania on 11 September 2001 have added an acute and poignant urgency to this problem. Even in the aftermath of scarcely imaginable terrorist atrocities, it is vital not to lose sight of the fact that Islam is responsible for great cultural traditions and great civilizations. It has close affinities with the monotheistic tradition which shaped the societies of Western Europe and North America, it belongs to the triad of monotheistic religions – Judaism, Christianity and Islam – and it shares their geographical and cultural origins.

Too much of the history of Islam and the West has been marked by perceptions and realities of confrontation rather than symbiosis: the Crusades; the age of colonialism and imperialism from the 18th to the mid-20th centuries; the Palestinian–Israeli conflict which continues to disfigure the land and the holy places which are sacred to Jews, Christians and Muslims alike; the Gulf War; and, most recently, the war in Afghanistan. These negative phases of our mutual history must never obscure the much more important fact that Islam inspires Muslims throughout the world with values which we all recognize: compassion, mercy, forgiveness, charity and a great concern for the welfare of the members of our community as a whole.

ROBIN OSTLE

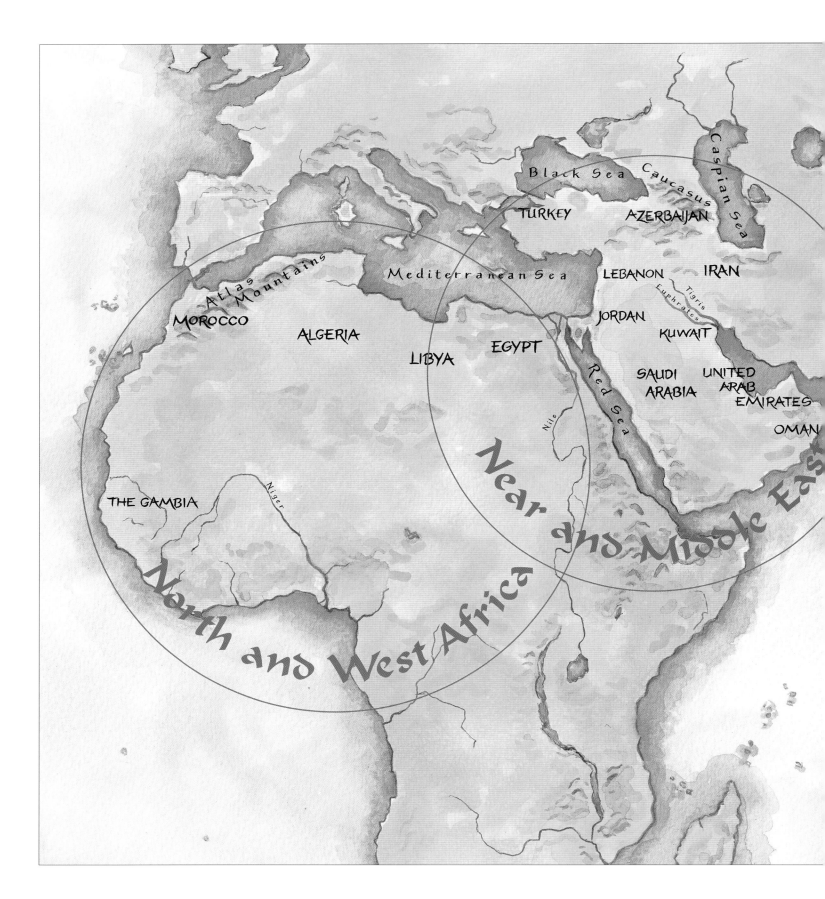

Black Sea

Caucasus

Caspian Sea

TURKEY

AZERBAIJAN

Mediterranean Sea

LEBANON

IRAN

Atlas Mountains

Euphrates

Tigris

MOROCCO

JORDAN

ALGERIA

KUWAIT

LIBYA

EGYPT

SAUDI ARABIA

UNITED ARAB EMIRATES

Red Sea

OMAN

Nile

THE GAMBIA

Niger

Near and Middle East

North and West Africa

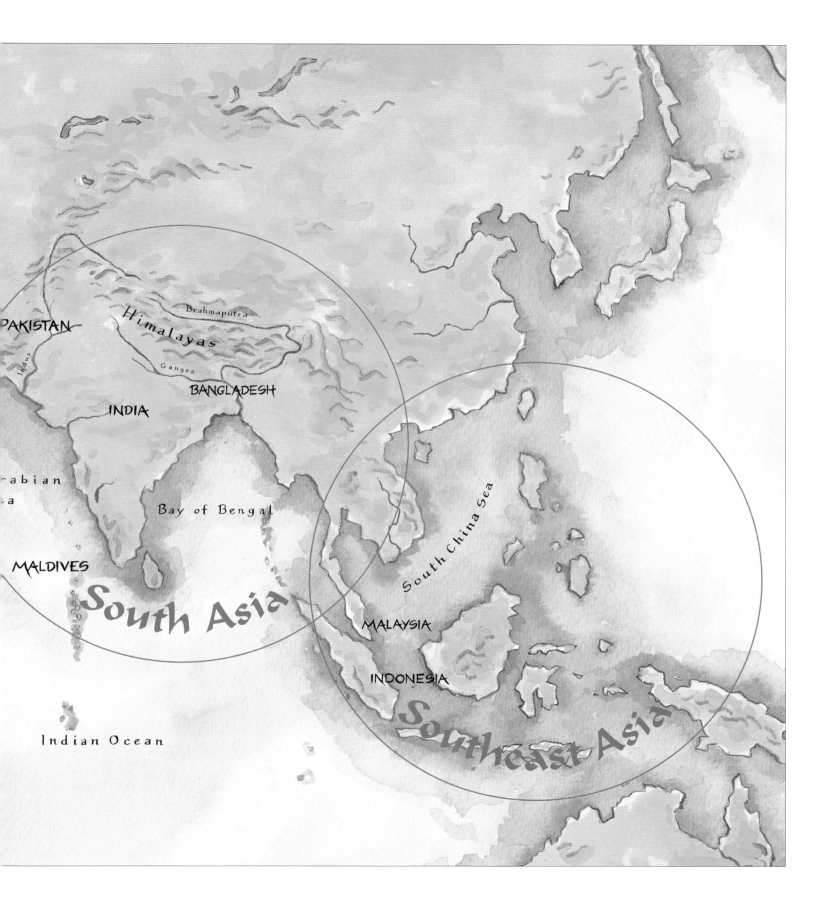

PAKISTAN

Himalayas

Brahmaputra

Ganges

BANGLADESH

INDIA

Indus

Arabian Sea

Bay of Bengal

MALDIVES

South Asia

Indian Ocean

South China Sea

MALAYSIA

INDONESIA

Southeast Asia

North and West Africa

The death of the Prophet Muhammad in AD 632 signalled a rapid and far-reaching expansion of Islam that was breathtaking in its achievement. From its origins in Arabia, the faith spread westwards through Egypt and the Maghreb to Morocco. The tribal people of North Africa's deserts and mountains – the Berbers – embraced Islam eagerly, blending it with their culture and customs. Within a hundred years, Islam had reached Spain.

Across modern Africa, the prominence of Islam varies from country to country. In Egypt, a combination of secular and Islamic influences controls both government and society at large. While the constitution holds that the *shari'a* (Islamic law) be the guiding influence, it is by no means the final legal arbiter. However, some would have it so and religious observance is on the increase, not just in the numbers attending mosque but in many areas of everyday life. And extremist elements have resorted to violence.

Algeria, rich in oil and gas, has had more than its share of violence since the military stopped an election in 1992 which looked certain to bring the Islamic Salvation Front to power. And while superficial observations might indicate a clear battle between Muslim extremists and the government, closer inspection suggests that it may not be that simple.

In Libya, Mu'ammar Gadhafi has forged a blend of Arab socialist Islam financed by the country's generous reserves of oil and gas. Foreign languages are banned from official use in favour of Arabic. Alcohol is banned too. Yet women are given equal status with men and have even been recruited into an elite women's army corps.

In Morocco, Islam is the basis of the royal family's claim to legitimacy: the King claims to be able to trace his descent directly back to the Prophet Muhammad. However, while this might suggest an orthodoxy similar to that in Saudi Arabia, this is not the case. Furthermore, Sufism, the belief in the need for a kind of mystical union with God, finds fertile ground in Morocco, particularly amongst the traditions and superstitions of the Berbers.

Domes and minarets of old Cairo coloured by the polluted air of early evening. EGYPT

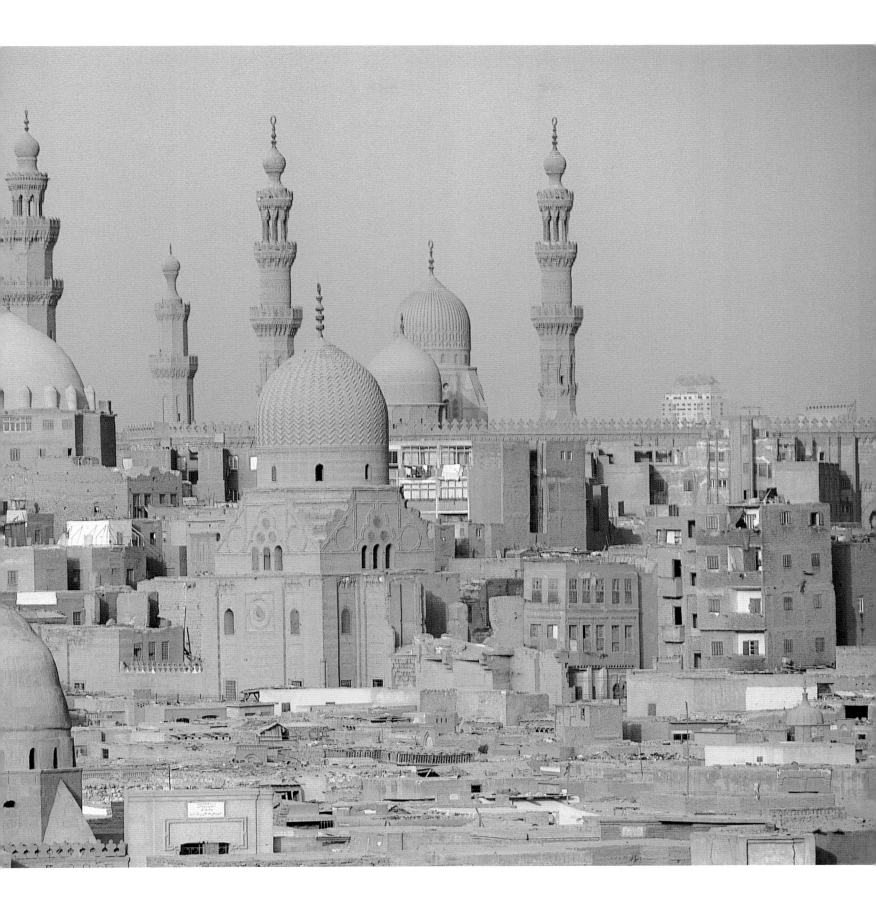

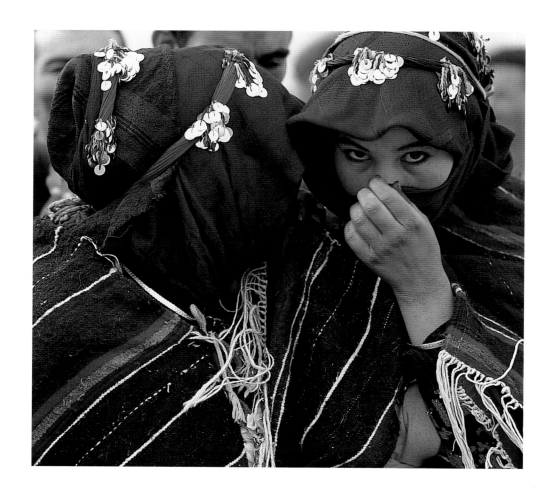

Above and opposite: South of Imilchil
in the Atlas mountains, young women
in search of husbands gather at the
beehive tomb of Sidi Muhammad,
whose spirit continues to bless
marriages. They have come for the
bridal fair of the Ait Hadiddou tribe
– Berbers who adopted Islam in the
8th century AD and blend it today with
tribal beliefs and customs. MOROCCO

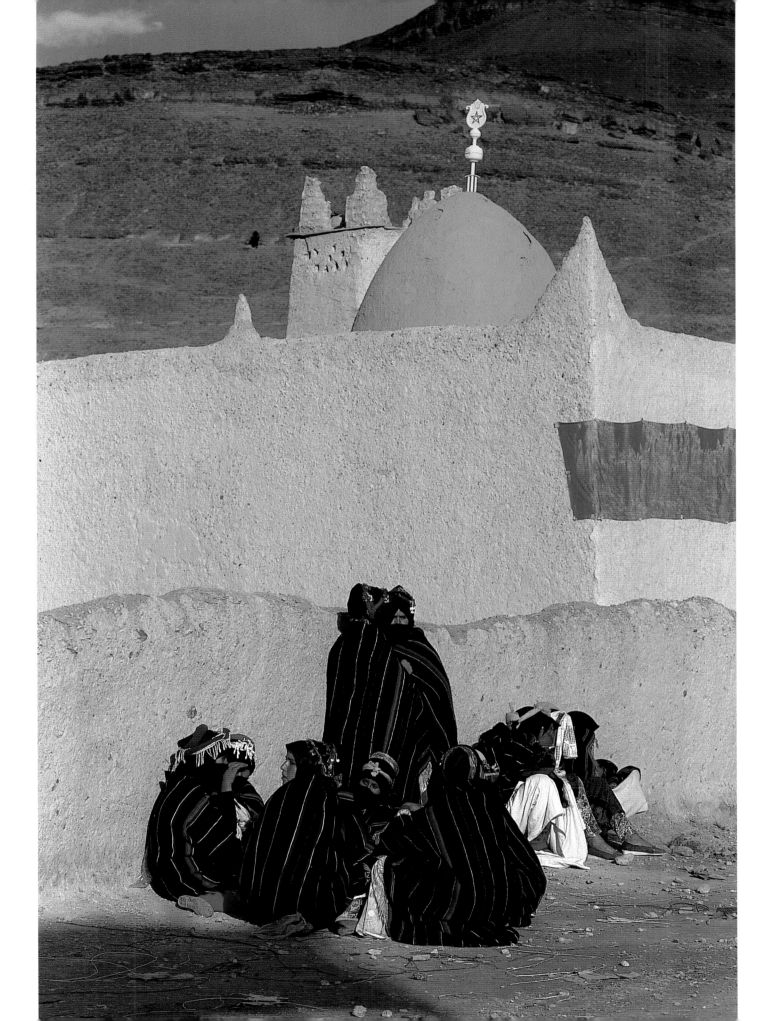

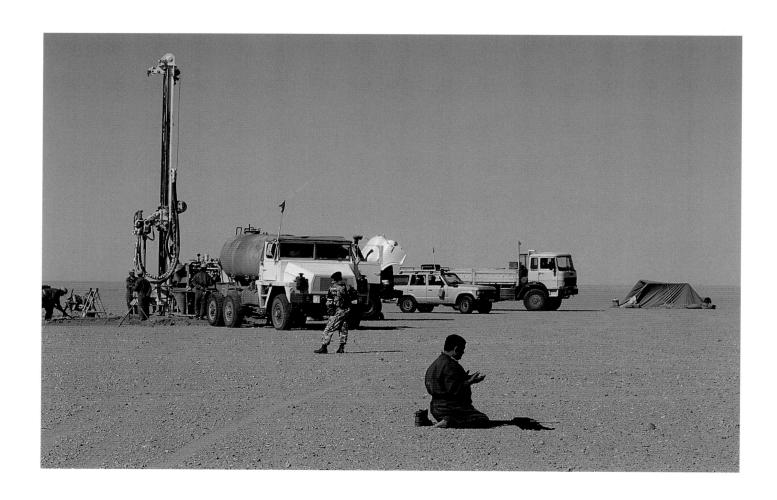

Above and opposite: Protected from
the sand and the sun, oil exploration
workers comb the barren expanses
of the southern Sahara. At midday,
prayers at the site. ALGERIA

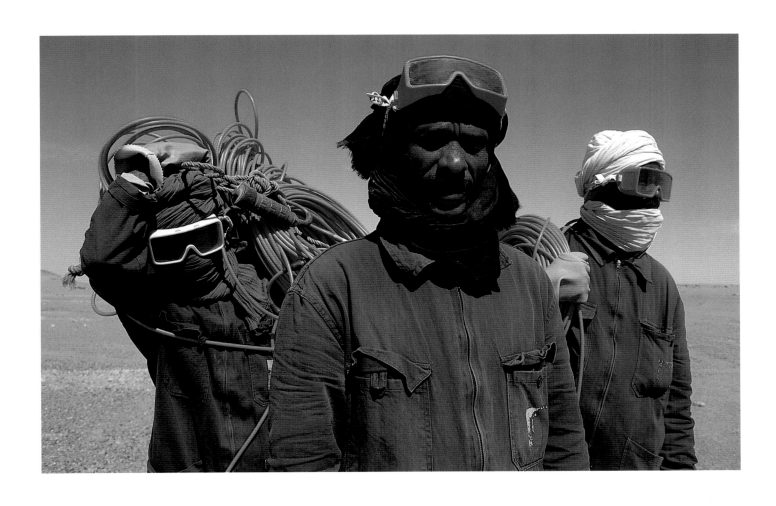

Table talk by the Suez Canal.
EGYPT

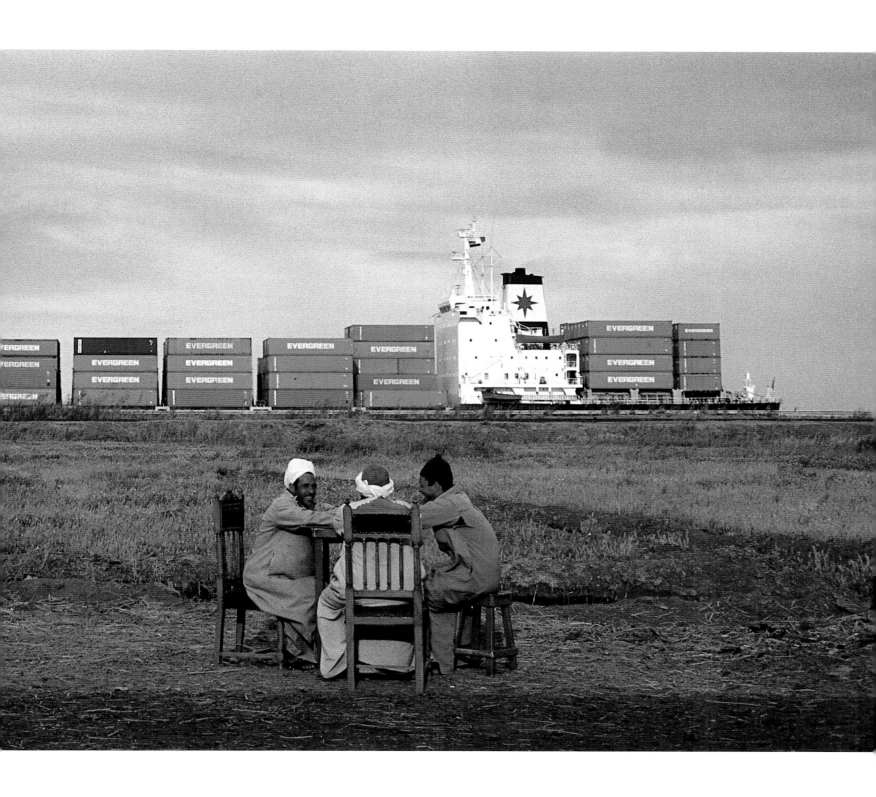

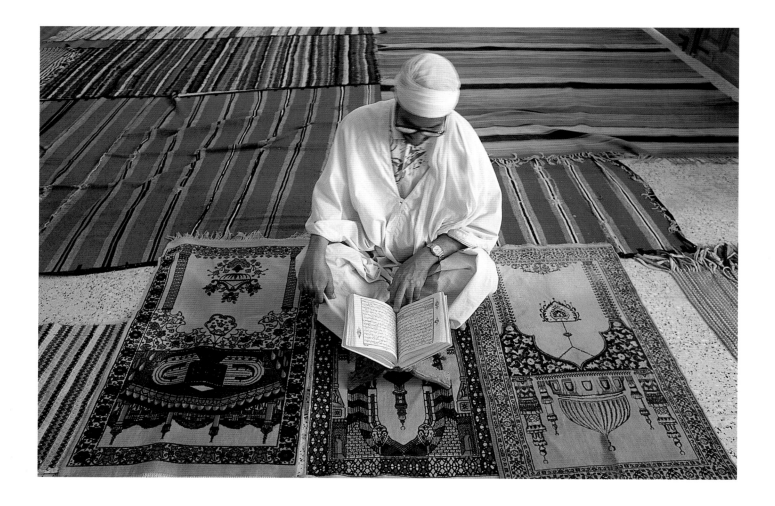

Above: A cleric studying the Koran in
the mosque at Hassi Messaoud, the
centre for oil and gas exploration.
ALGERIA

Opposite: Tiles adorn the walls of the
Ahmad Pasha al-Qaramanli mosque
inside the medina, the medieval walled
city of Tripoli. *LIBYA*

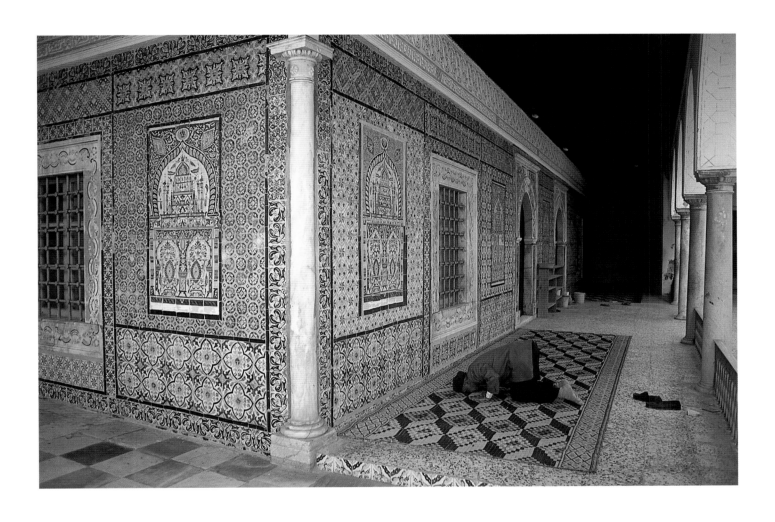

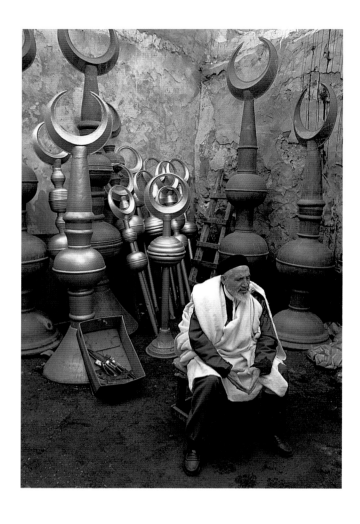

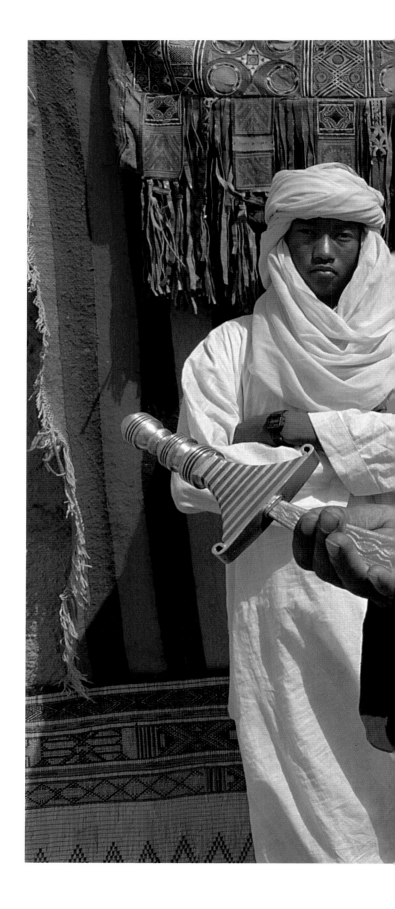

Above: Crescents destined for the
domes of local mosques crowd the
copper workshops of Tripoli's medina.
LIBYA

Right: A sword-maker at In Salah.
ALGERIA

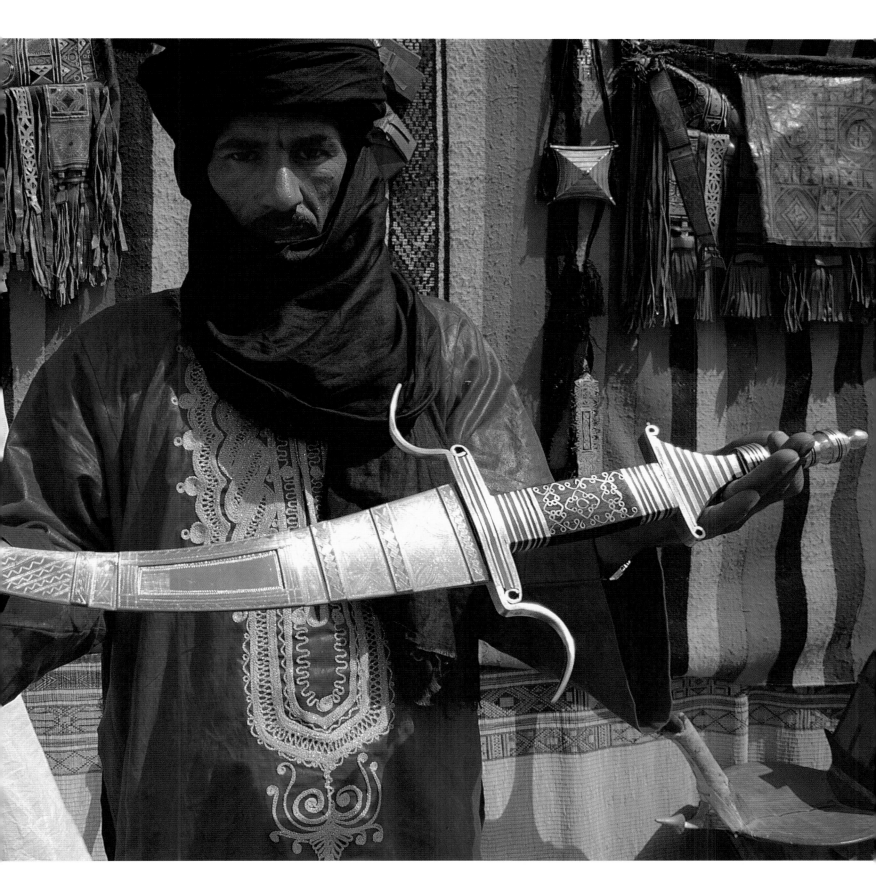

Above: Wall talk in Midelt. *MOROCCO*

Opposite: In a country whose economy
relies heavily on tourists and peanuts,
an uncertain future haunts young eyes
in Banjul. *THE GAMBIA*

Overleaf: Horsemen of the High Atlas.
MOROCCO

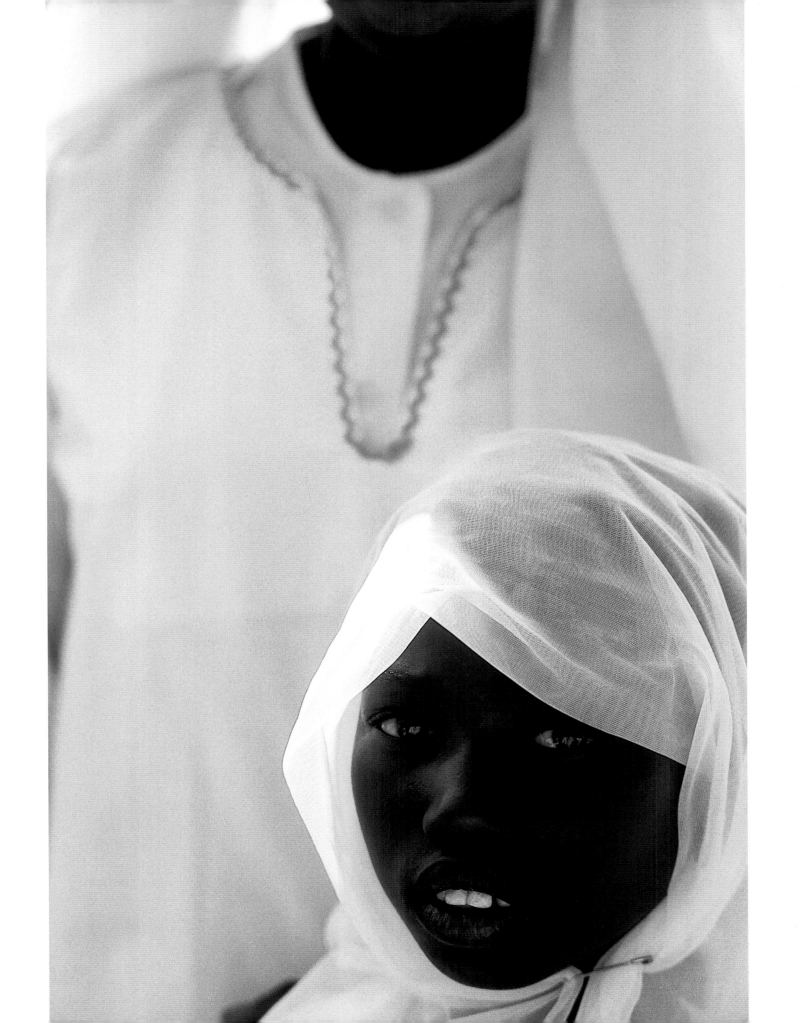

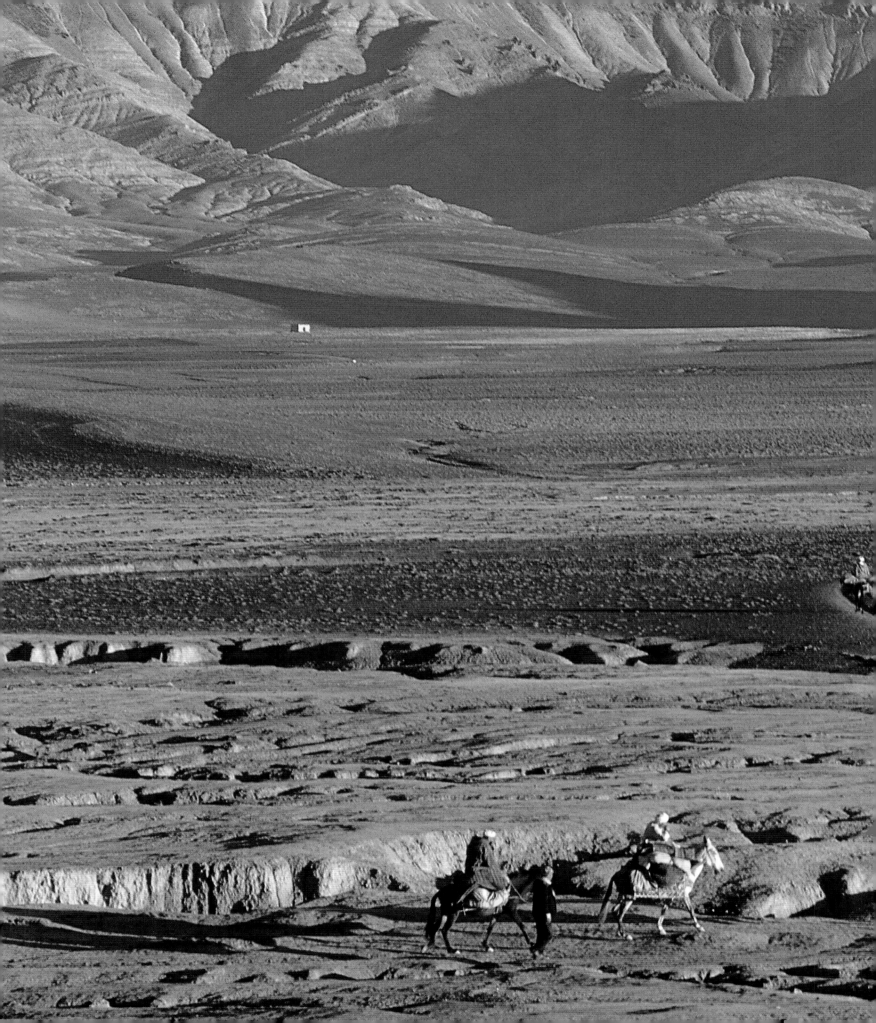

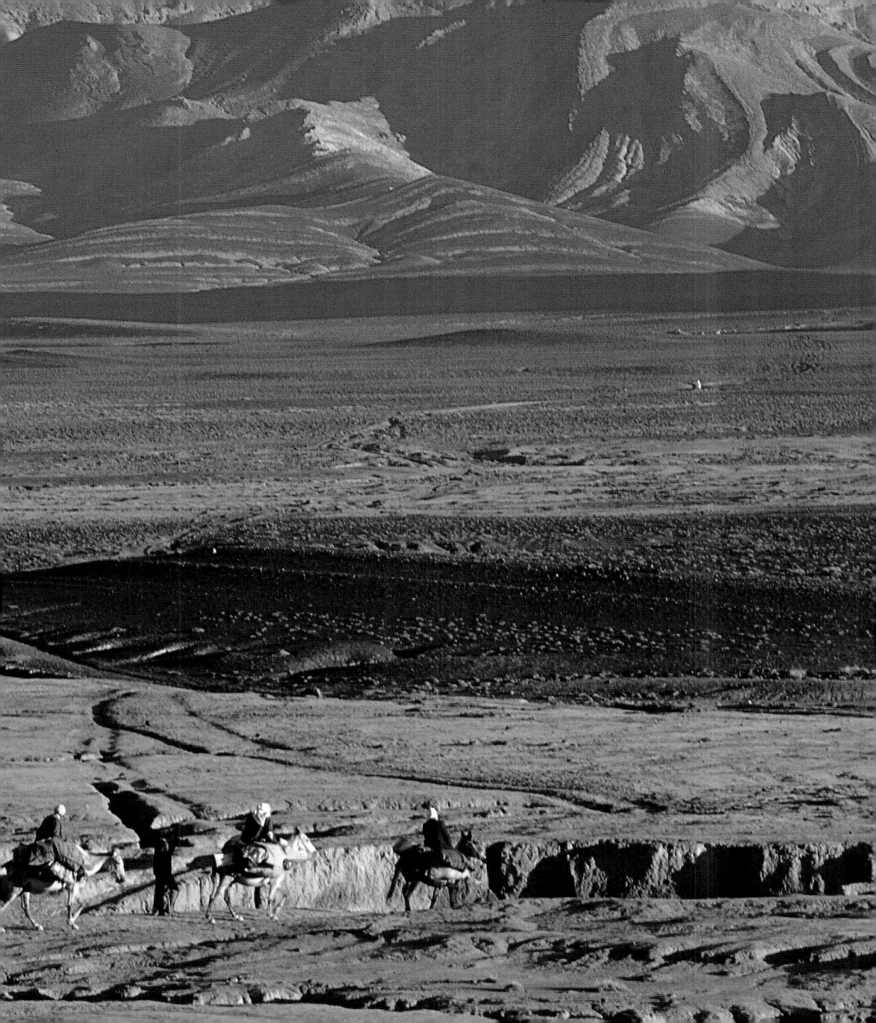

Above: Fetching water in the Cairo
slums. *EGYPT*

Right: A water-seller plies his trade
in the main square of Marrakesh.
MOROCCO

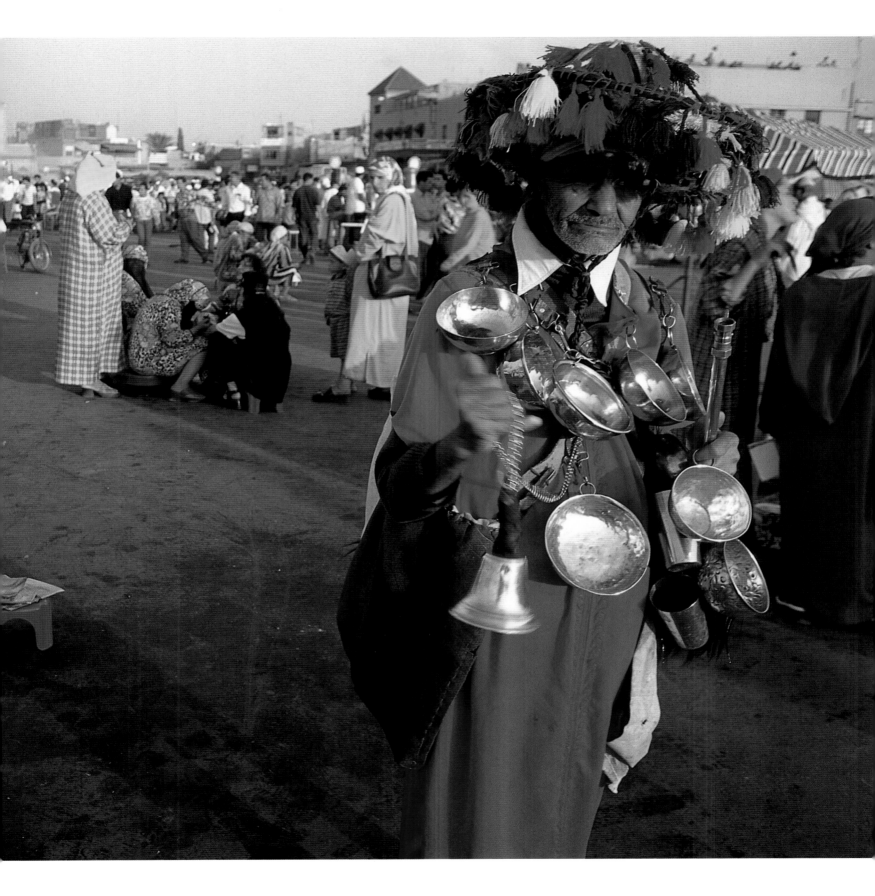

Above: In the pink in Banjul.
THE GAMBIA

Opposite: United in thought at a bus
terminus in Cairo. *EGYPT*

Overleaf: The Suq al-Gimal (camel
market) at Mohandiseen. *EGYPT*

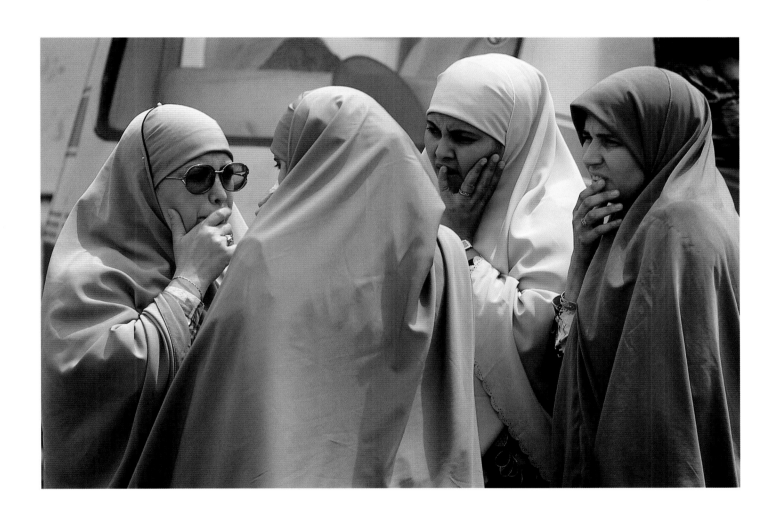

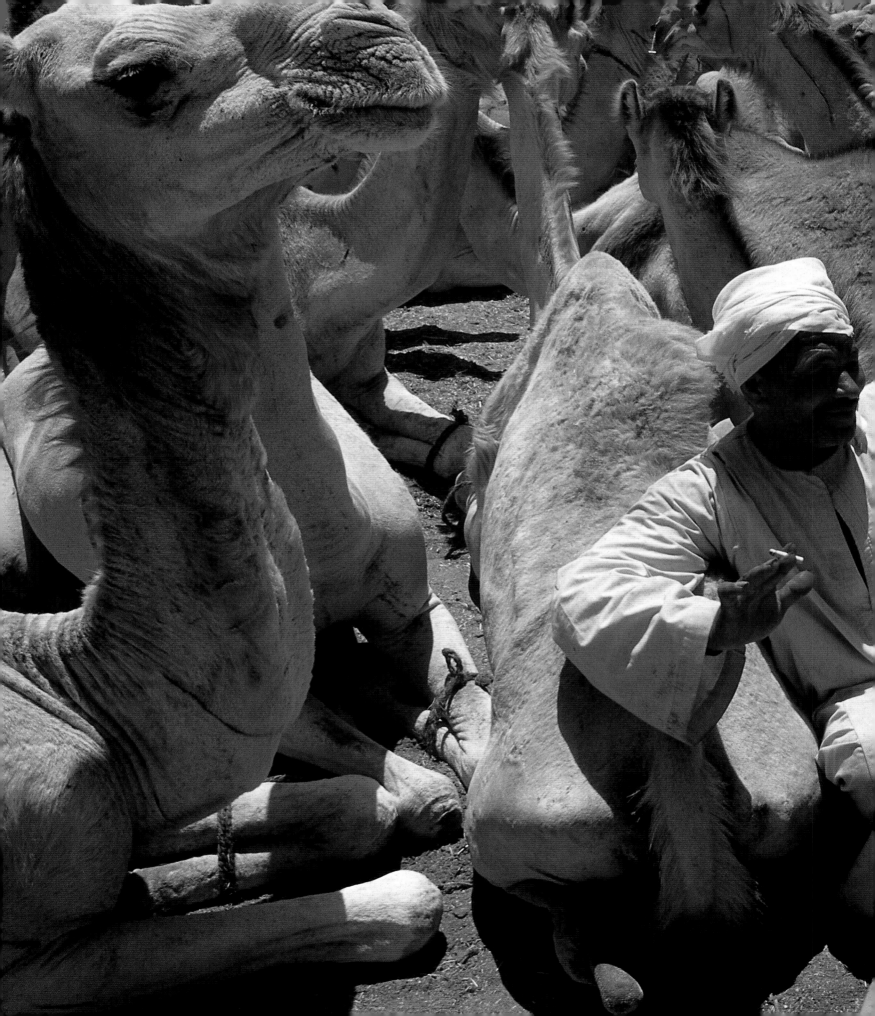

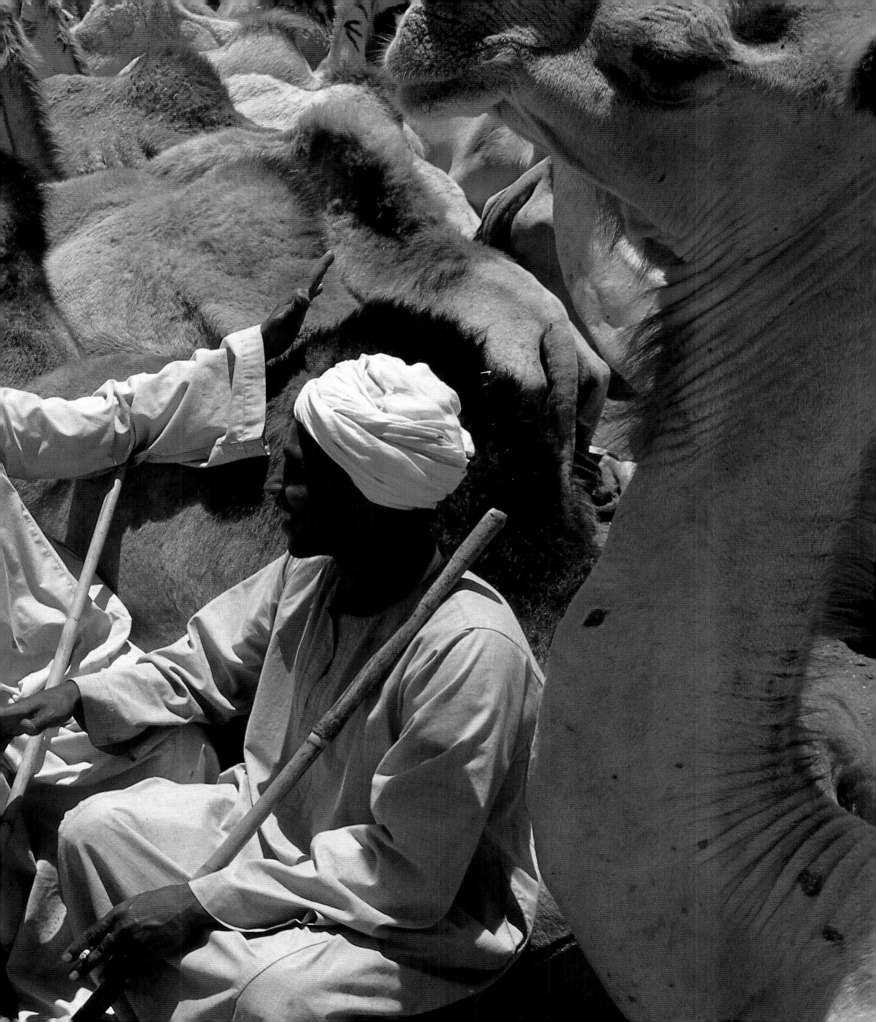

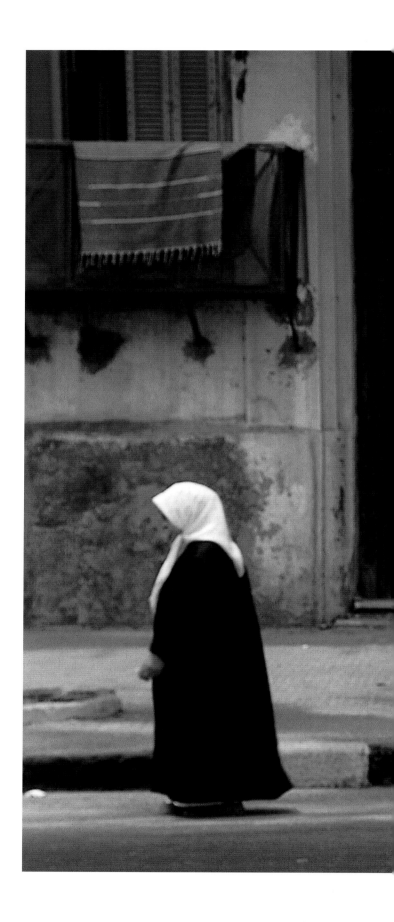

Above and right: Beyond repair in Cairo
and under cover in Alexandria. *EGYPT*

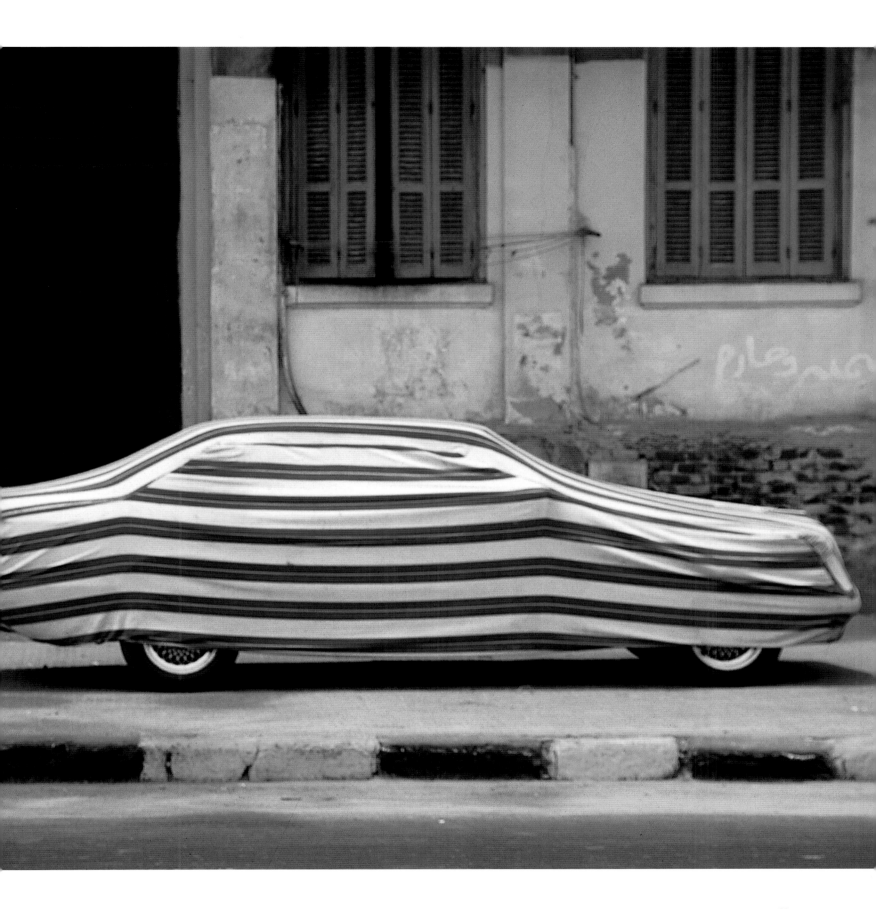

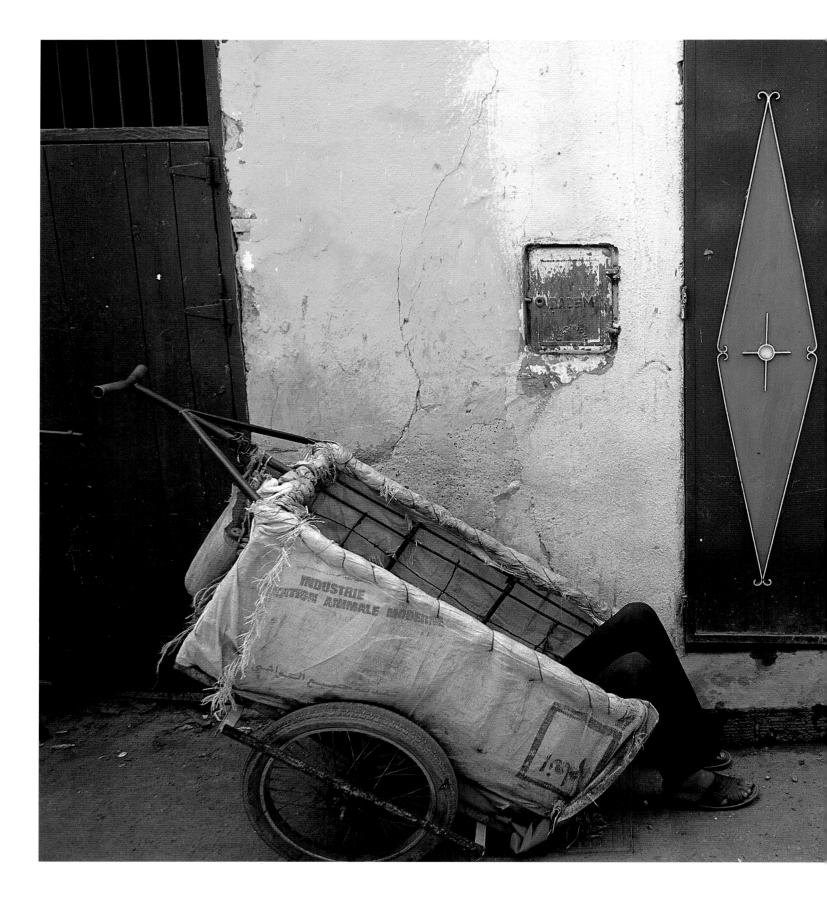

Left: Refuse cart in Marrakesh.
MOROCCO

Above: A woman outside the Naga mosque in Tripoli. Naga is an Arabic word for camel, and the mosque is so called because the citizens of Tripoli once tried to buy their freedom with a camel-load of treasures. The offer was apparently rejected and the valuables used to fund the building of the mosque. LIBYA

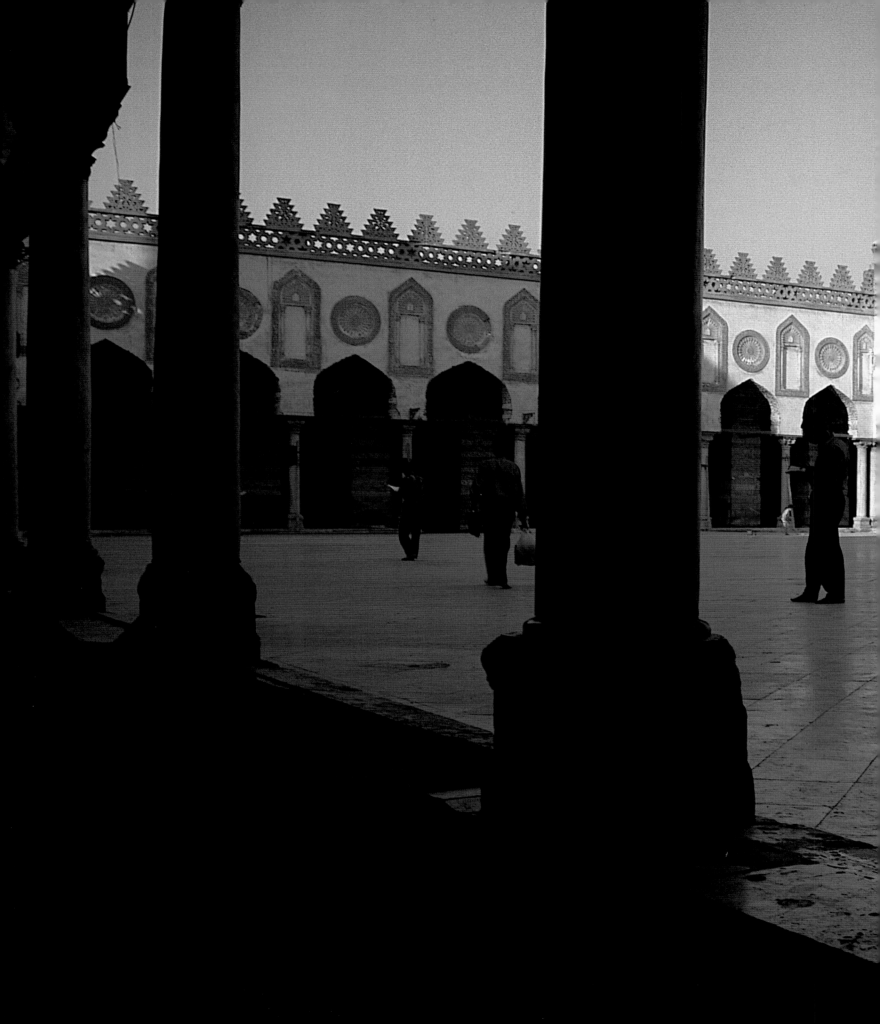

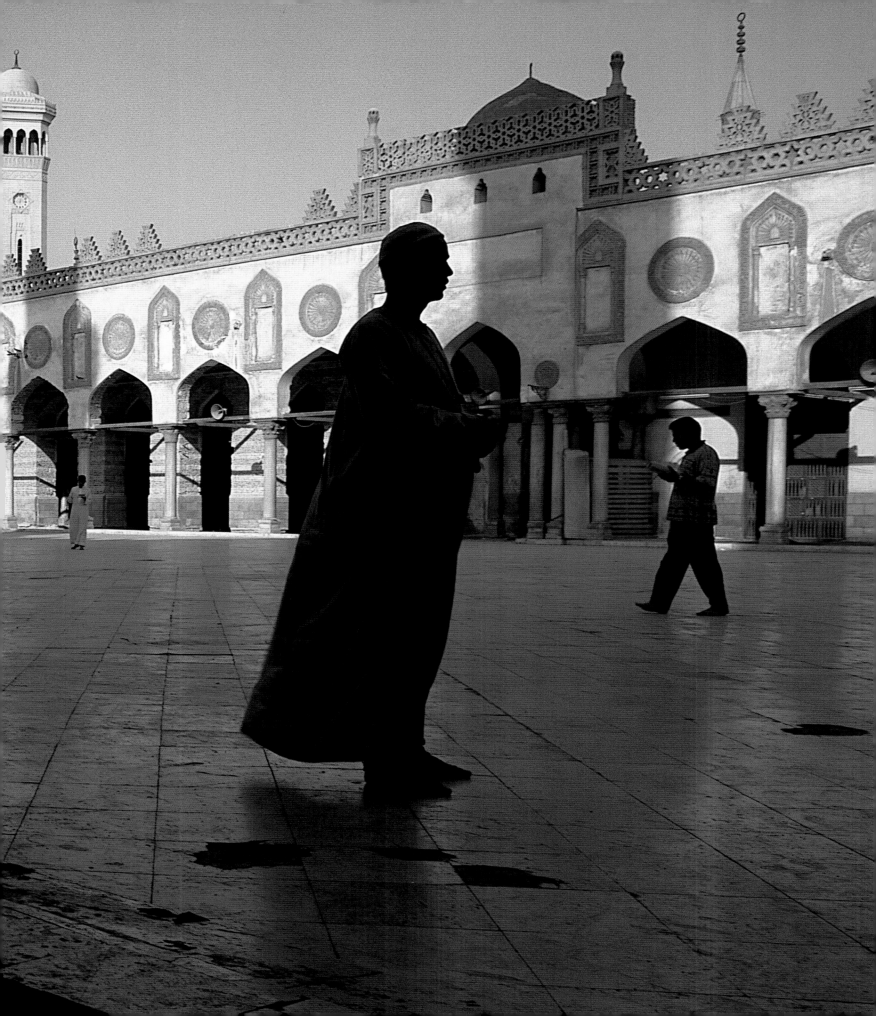

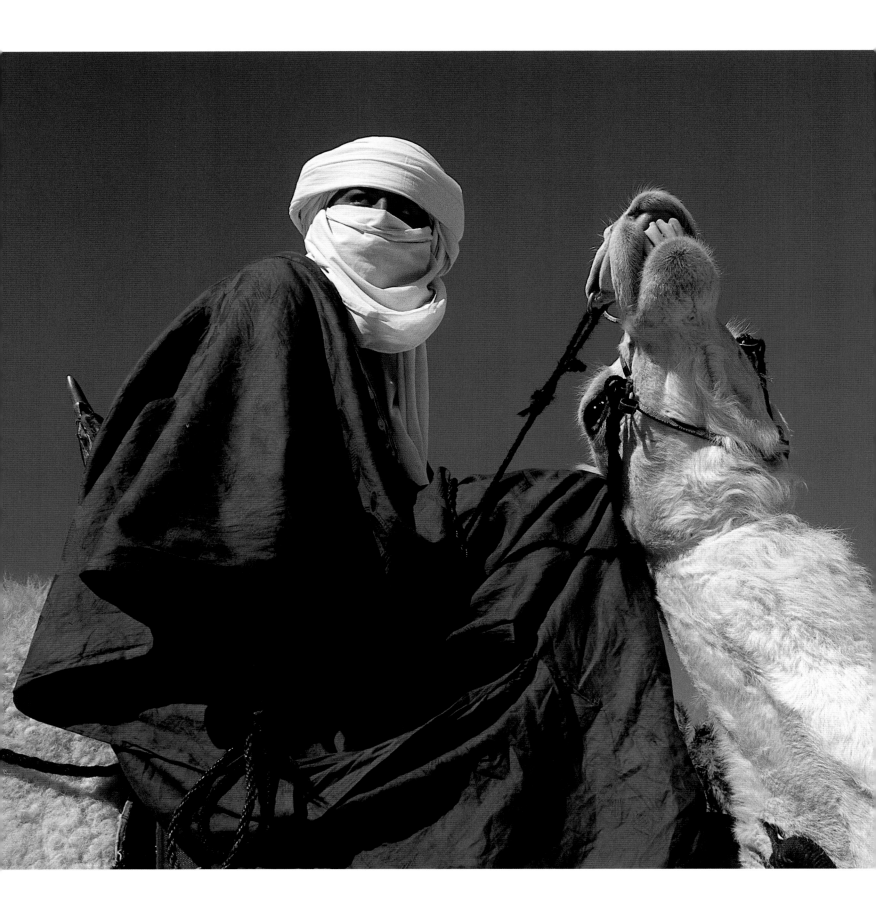

Preceding pages: The courtyard of Al-Azhar University in Cairo, Islam's oldest and most revered centre of learning. EGYPT

Left: A Tuareg horseman of the Sahara. LIBYA

Below: A street beautician in Marrakesh uses henna to decorate the hands of a young woman for Eid celebrations. MOROCCO

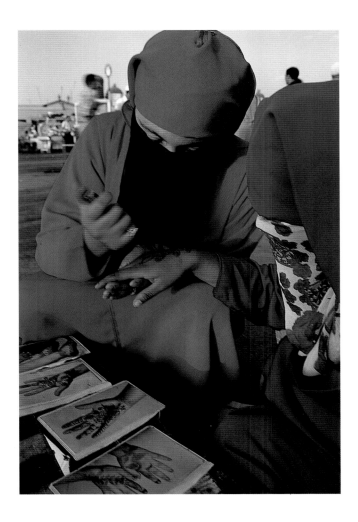

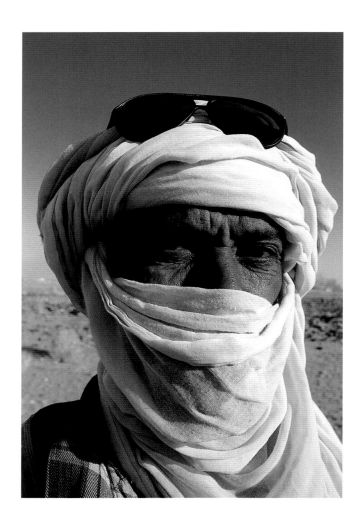

Above: A camel-driver protects his head and face against the sun and cutting sand whipped up by unpredictable winds. ALGERIA

Right: Palm fronds cast shadows across the wall of a mosque in a Berber settlement at the western end of the Jabal Nafusa, the high plateau of the Maghreb renowned for its apricots and figs. LIBYA

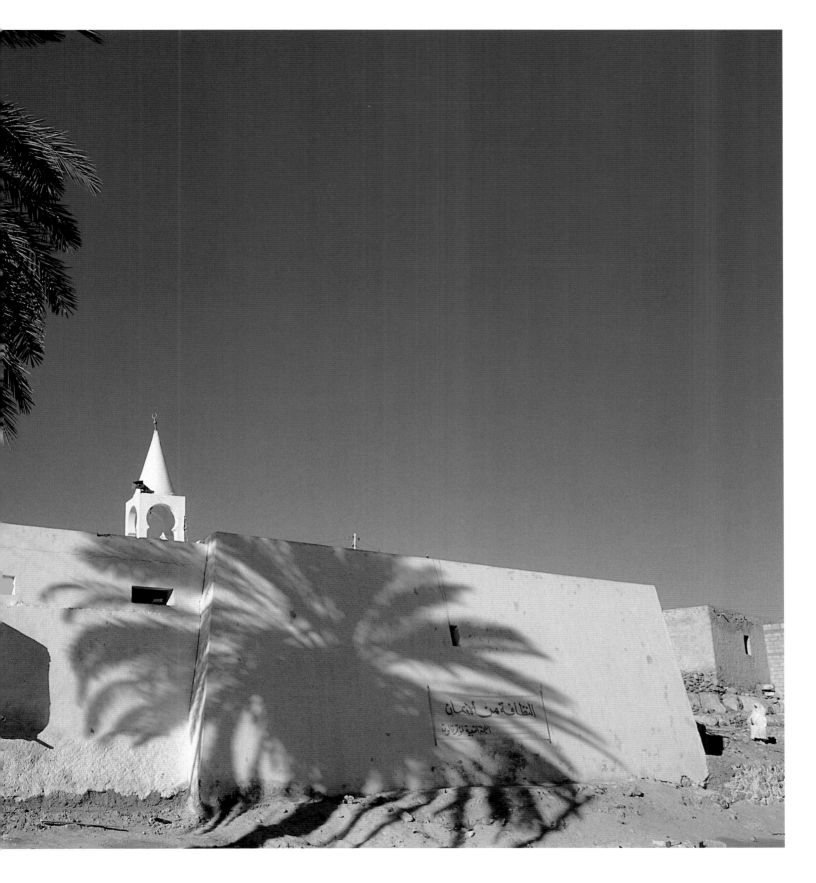

Below: Taking a back seat to work.
EGYPT

Opposite: Returning from midday
prayers, the medina, Fez. Yellow or
white leather slippers (*babouches*) are
the popular choice for men. *MOROCCO*

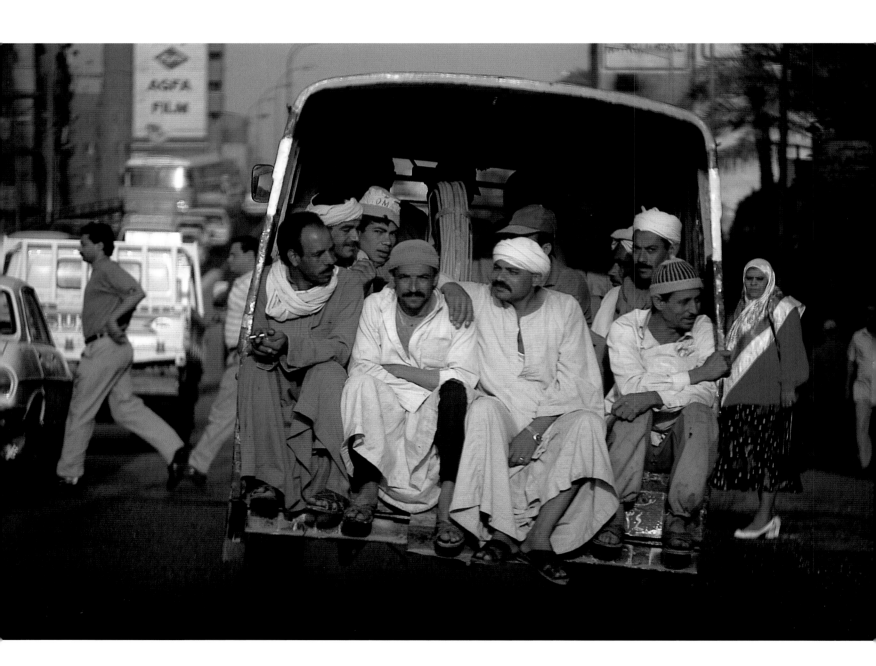

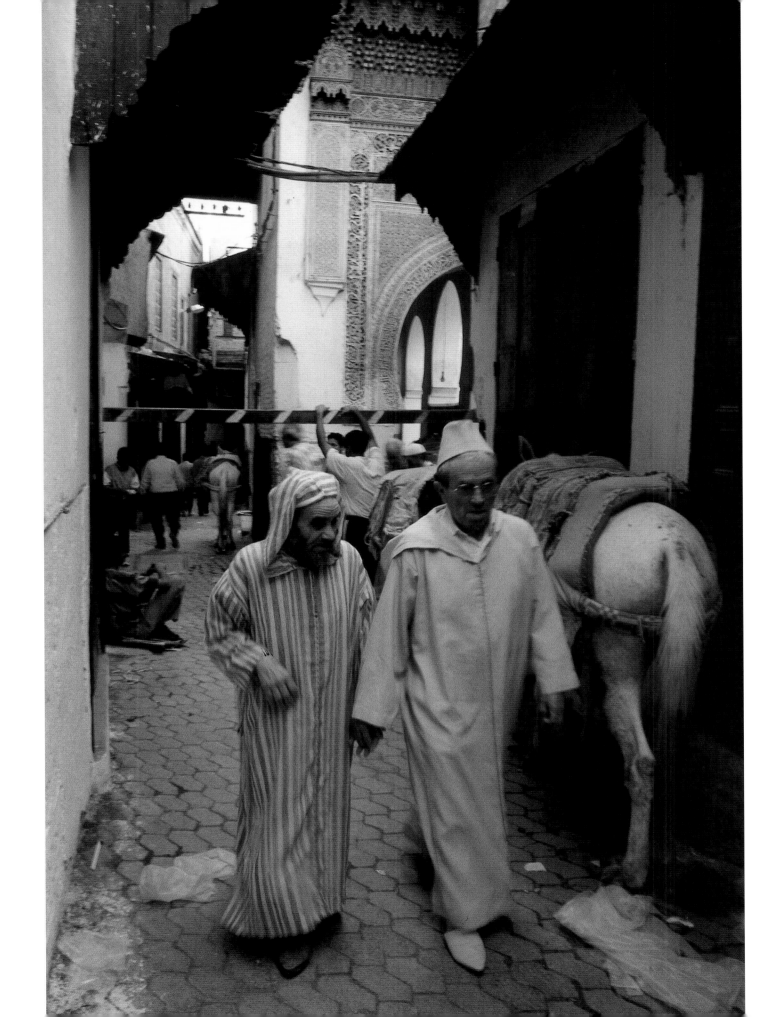

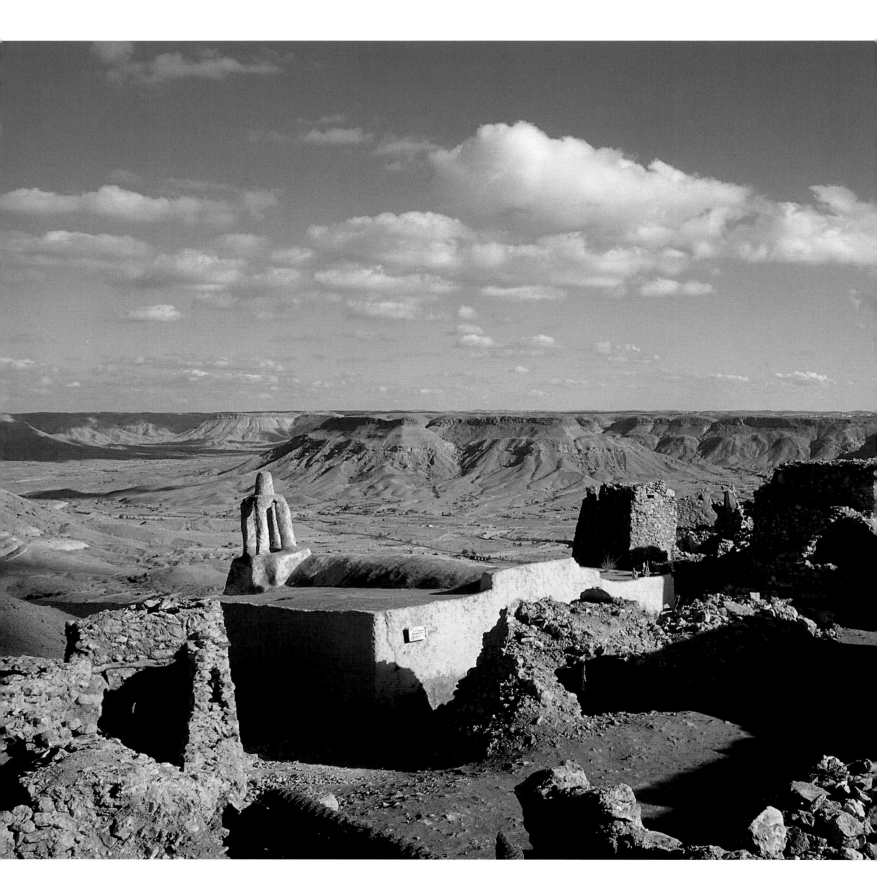

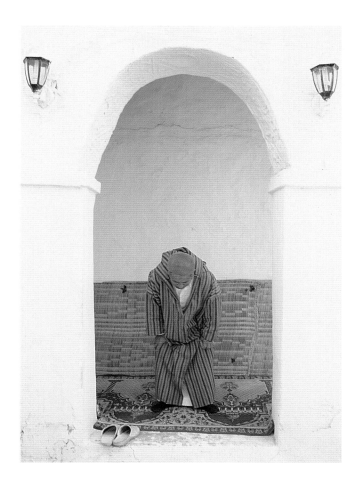

Above: Solitary prayers at a mosque
in Ghadames. *LIBYA*

Left: The restored mosque is the only
building still in use in the otherwise
deserted and crumbling original
settlement at Nalut above the Jabal
Nafusa. *LIBYA*

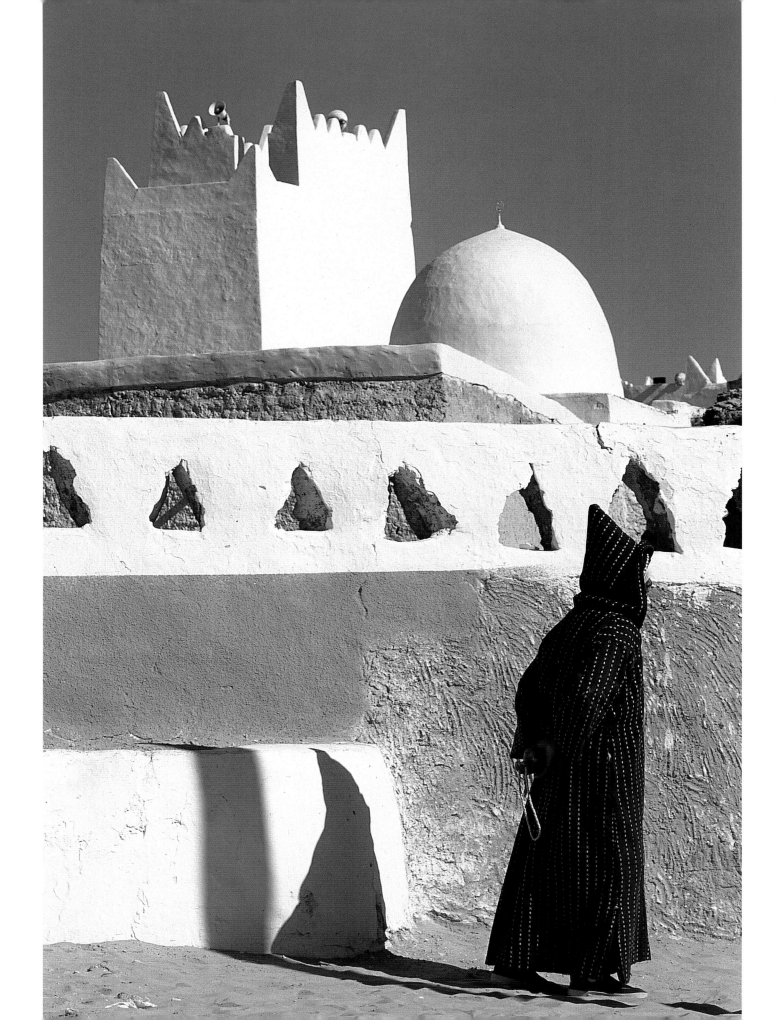

Opposite and below: Ghadames, a Berber oasis in the northern Sahara on the borders of Tunisia, Algeria and Libya, was once a halt on the trans-Saharan trade routes. Slaves and ivory, gold and ostrich plumes, silks and spices passed through the town on long camel trains. Today the old town is largely deserted, but its restored mosques and cool shaded passages have made it popular with local men for Friday prayers. *LIBYA*

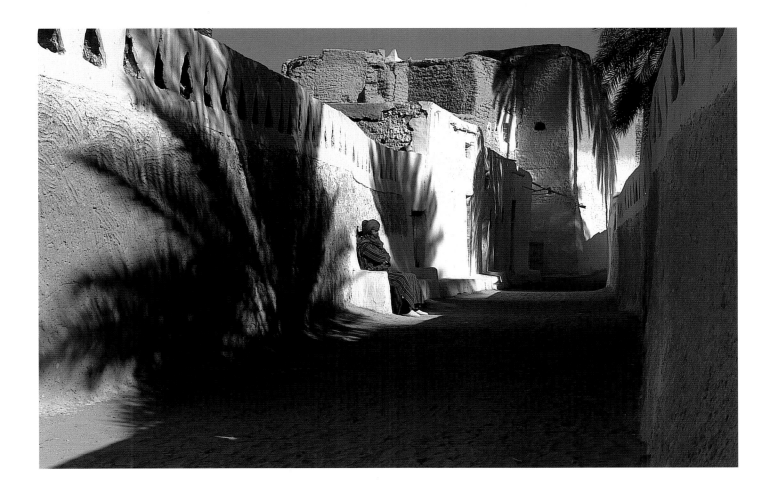

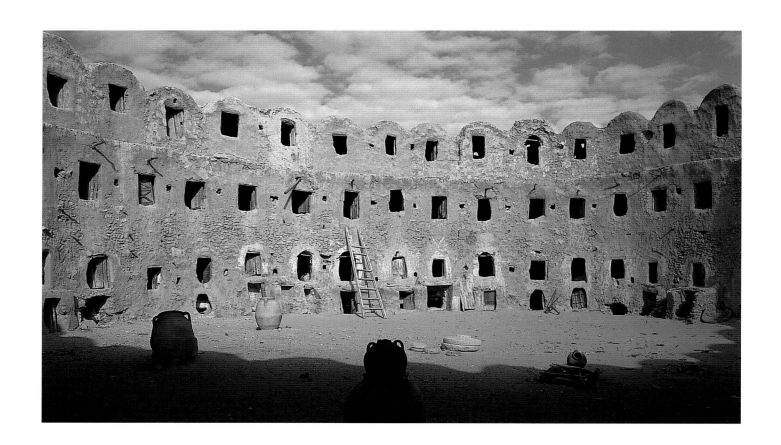

Above: The 800-year-old granary at
Kasar al-Hag has 114 storerooms – one
for every *surah* (chapter) in the Koran.
LIBYA

Opposite: The country's open-door
policy towards its neighbours has
brought thousands of immigrants to
Libya in search of work. This man from
Mali is waiting hopefully outside the
offices of a fishing company in Tripoli.
LIBYA

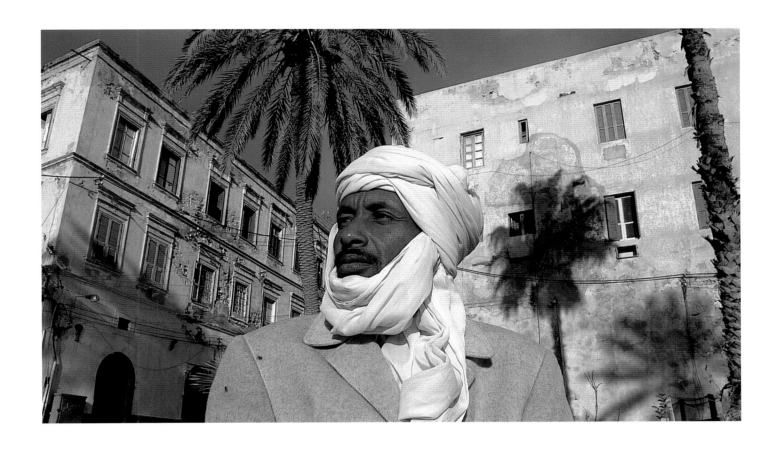

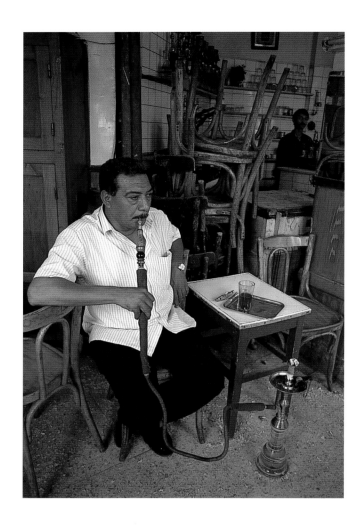

Above and right: Cairo's more
conservative café society gathers
at a coffee house in the Khan
al-Khalili bazaar while a café owner
in Alexandria relaxes after shutting
up shop. *Sheeshas*, or water pipes,
are rented for a nominal sum. EGYPT

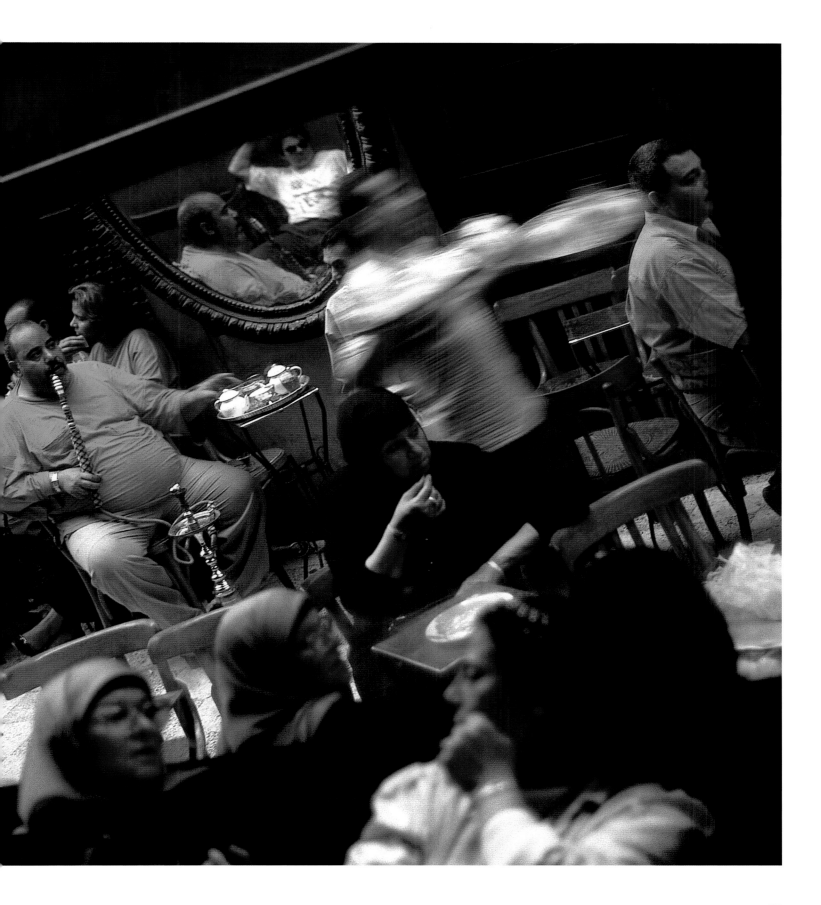

Near and Middle East

It is not surprising to find the most orthodox and puritanical forms of Islam in Saudi Arabia, for it was here in the 7th century AD that Islam had its beginnings. Nor is it surprising that the lowest level of religious observance should be found in Azerbaijan, where the advanced level of education and industrial development marked it out from Russia's other Muslim territories.

The Azeris are Shi'a Muslims like their neighbours in Iran, the only country where Shi'ism is the official religion of the state. (Shi'as differ from Sunnis, who form the majority of the world's Muslims, in their beliefs about the historical leadership of the Islamic community.) While an elected reforming President is head of state, Iran's clergy retains ultimate political power, and the morals police keep an eye on people's social behaviour.

In Turkey, the Ministry for Religious Affairs has a budget that exceeds that of the Foreign Ministry. There is a mosque for every 900 men, women and children. Yet, true to Kemal Atatürk's founding reforms, the Turkish Republic is a staunchly secular state. Friday is an ordinary working day, the last conservative prime minister was a woman, and alcoholic drinks are produced locally and consumed enthusiastically.

Although the likelihood of there being a woman prime minister anywhere in the Arabian Peninsula remains remote, democratic reforms and greater equality for women are beginning to emerge. Kuwait has a fledgling parliament, albeit one that excludes women and which reviews legislation rather than initiating it. Oman has a consultative assembly, and tolerates groups that promote women's issues. And in Saudi Arabia, some women are being offered their own identity cards.

They have their political and social differences, but these nations of the Middle East have one vital thing in common – oil. A century ago, Azerbaijan provided a full 50 per cent of the world's oil needs. Today, Saudi Arabia, Kuwait, Iran and the United Arab Emirates together dominate the world's oil industry and will do so for some time to come.

In the Göreme Valley of central Cappadocia farmers have chiselled homes out of laval tuff deposited by volcanoes. TURKEY

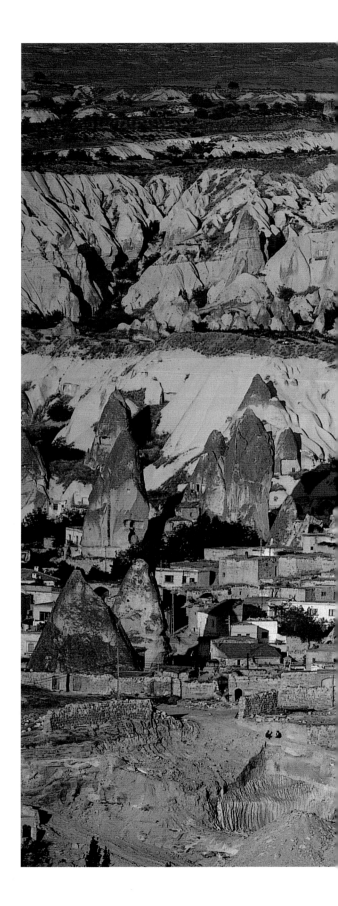

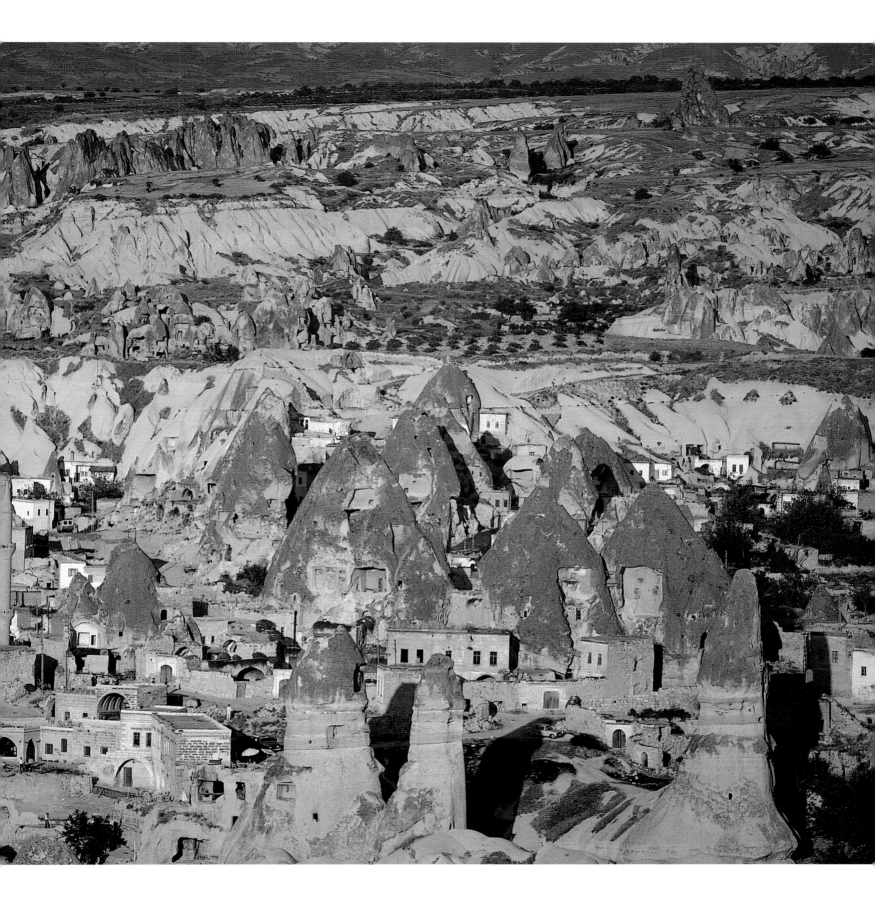

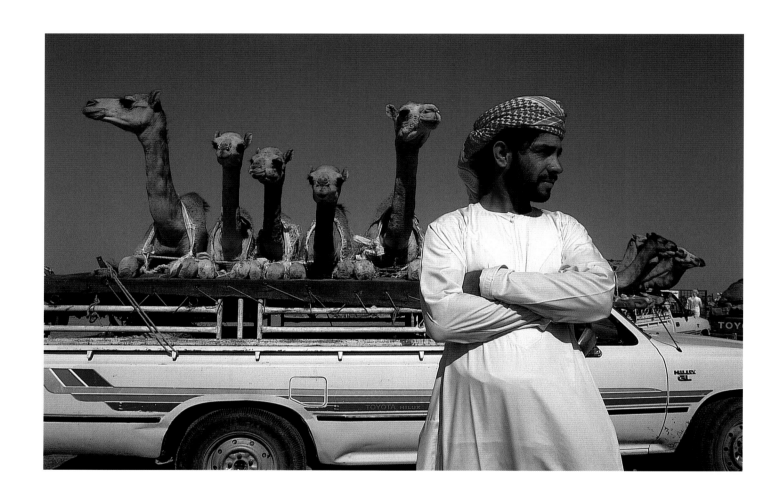

Above: The camel market at Al Ain,
Abu Dhabi. *UNITED ARAB EMIRATES*

Opposite: A delivery truck in Riyadh.
SAUDI ARABIA

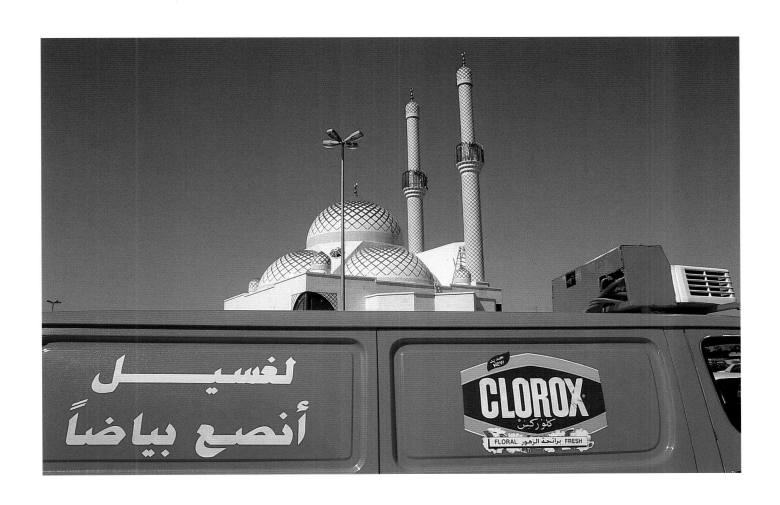

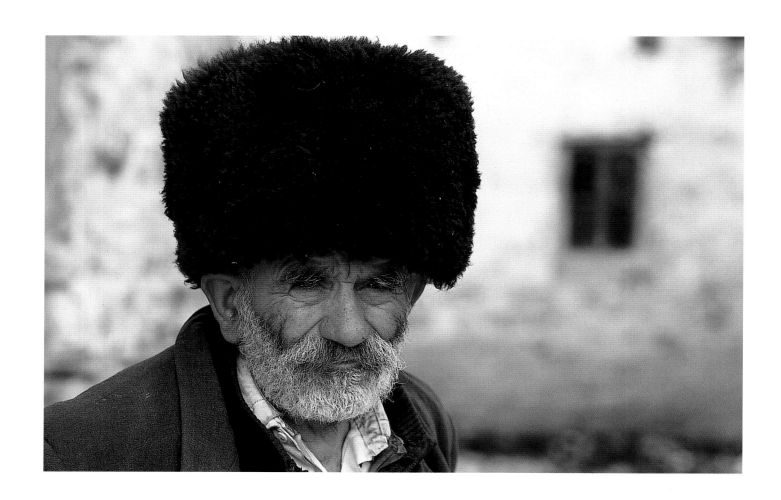

Above: Protected from the cold
mountain air, Sirac Mammadov, a
70-year-old farmer in the Caucasus
village of Susay. AZERBAIJAN

Opposite: A young Kuwaiti sports
the traditional red and white *gutra*.
KUWAIT

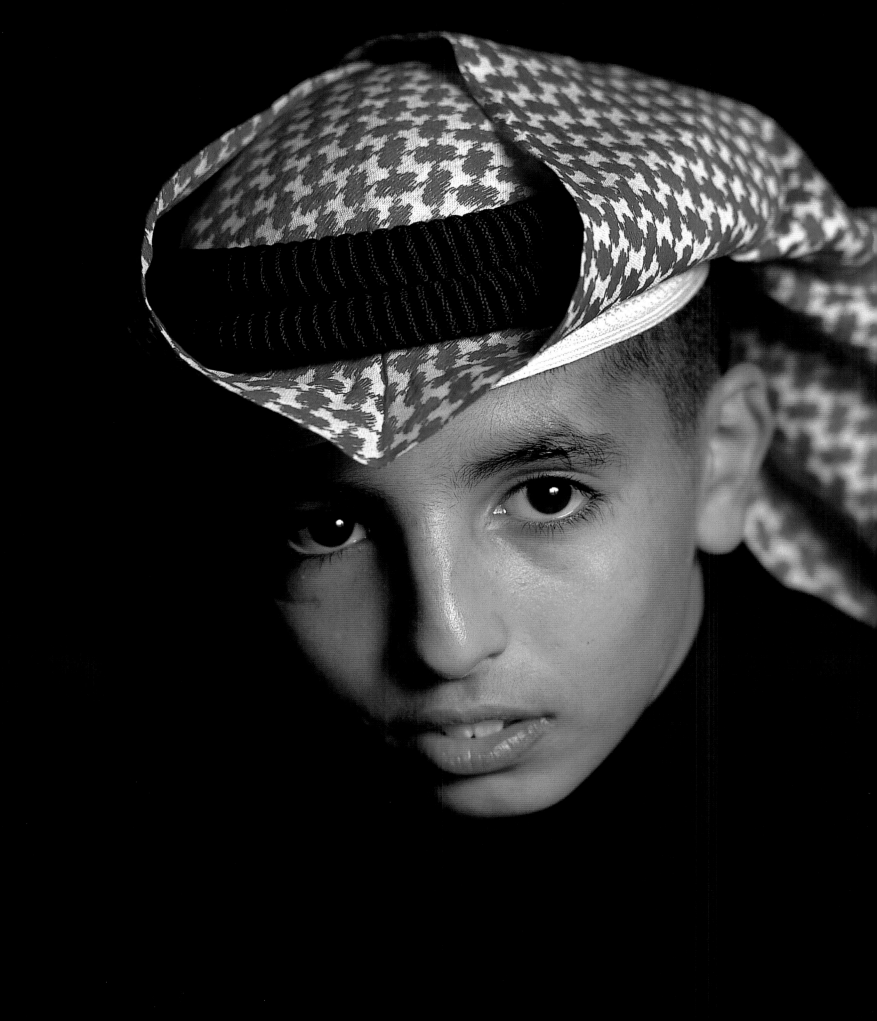

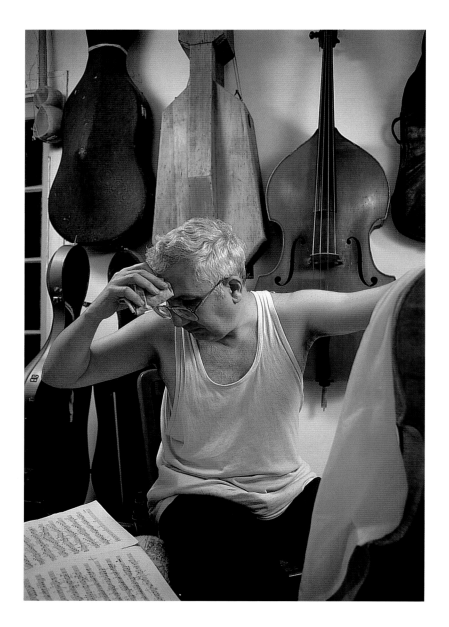

Above: Following in the footsteps of
the cellist and conductor Mstislav
Rostropovich, who was born in Baku in
1927, is Eldar Iskenderov, the eminent
Azeri cellist and professor at the Baku
Conservatoire. AZERBAIJAN

Opposite: One-to-one tuition at the
village school in Dana. JORDAN

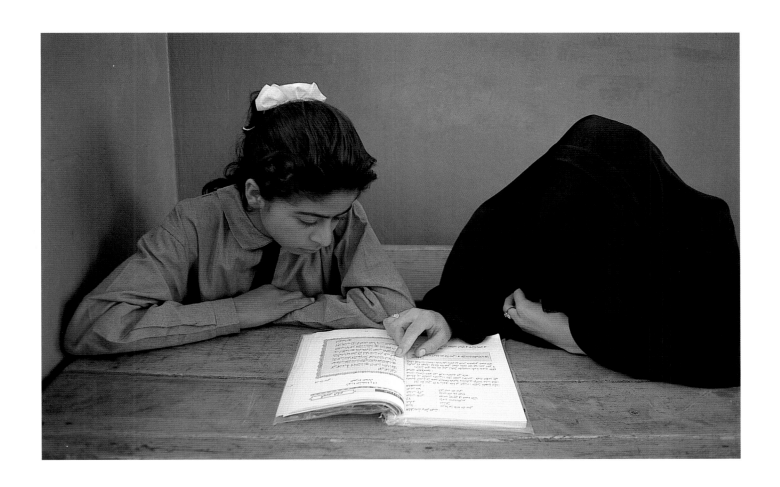

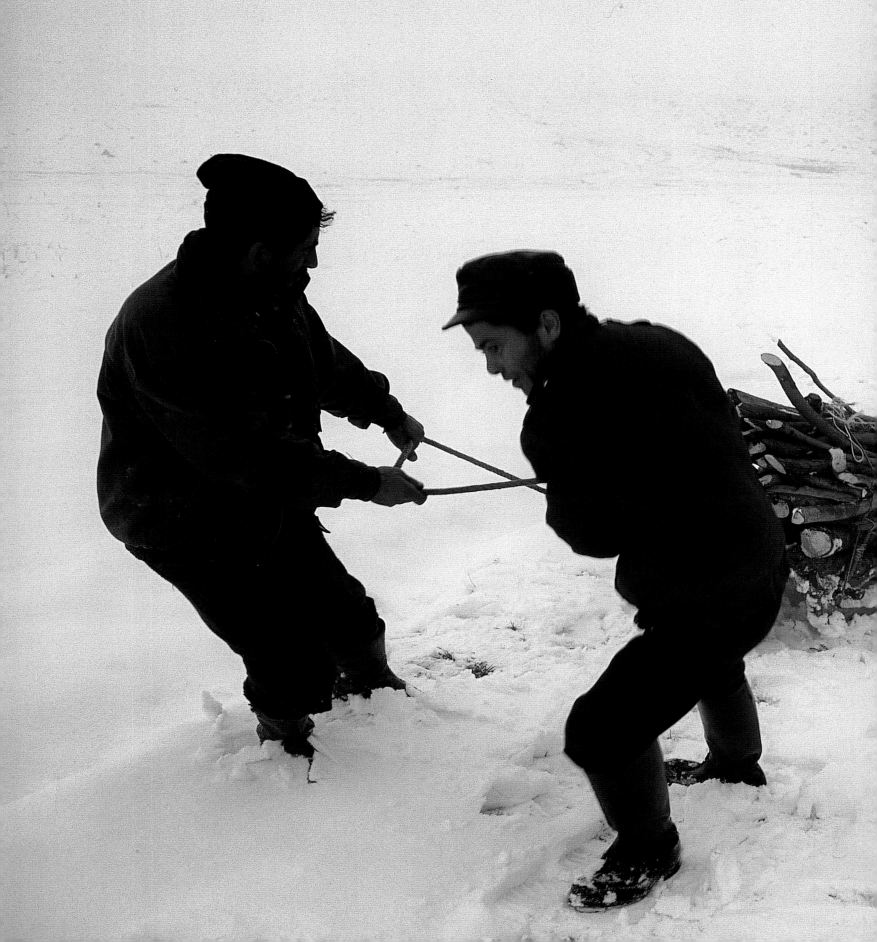

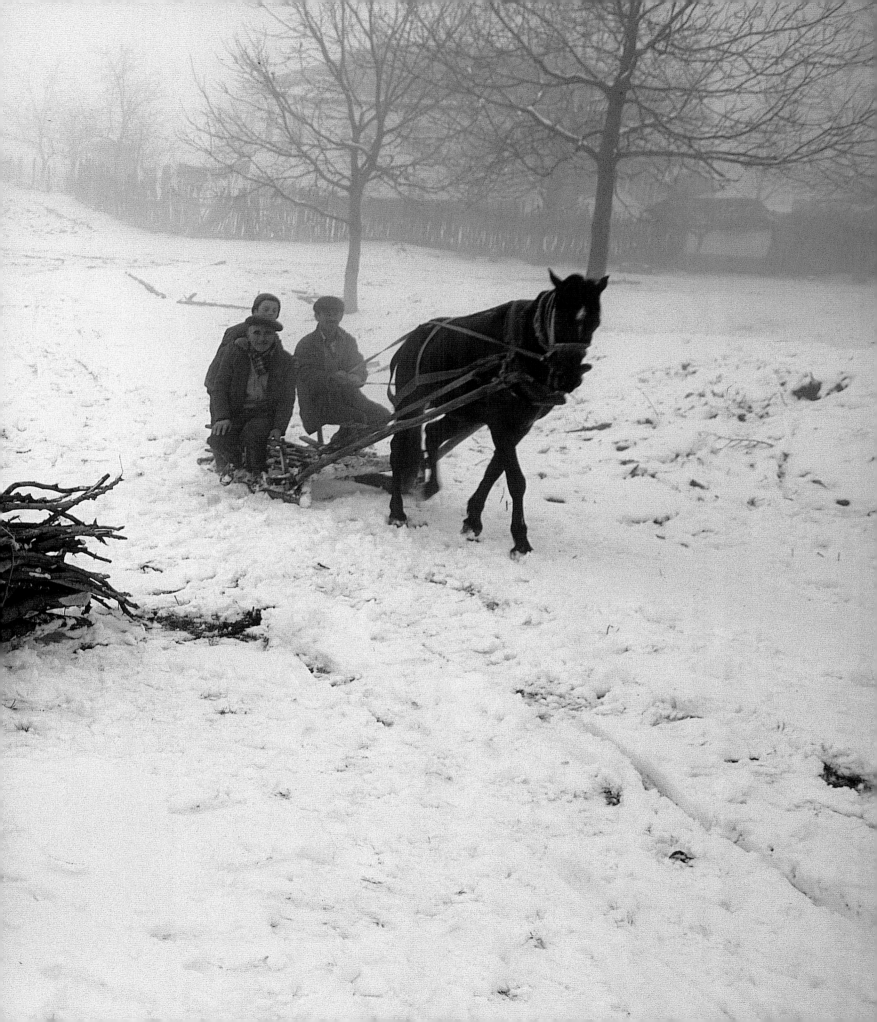

Preceding pages: Heavy snow in
Kurkun, a village in the southern
Caucasus, makes everyday life even
harder than usual. Extra firewood is
dragged from the woods while a horse-
drawn sledge is used to fetch water
from the village pipe. *AZERBAIJAN*

Above: A farmhouse in Ürgüp. *TURKEY*

Opposite: A woman at her smallholding
in Susay, a village in the Caucasus
mountains. *AZERBAIJAN*

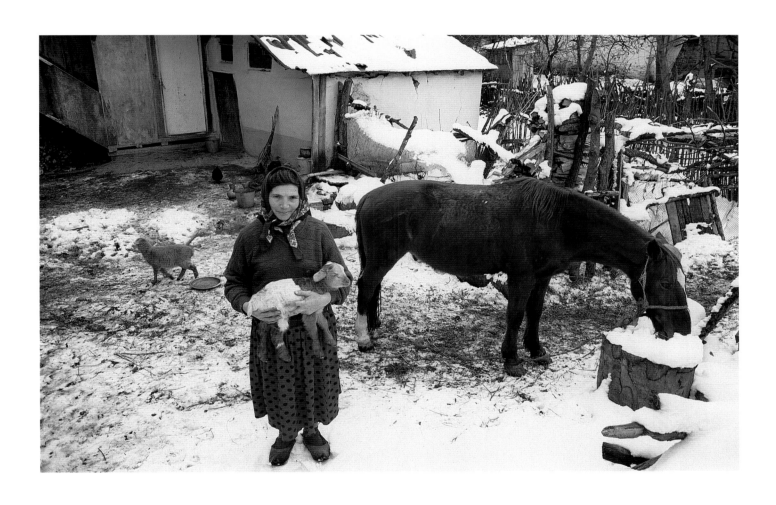

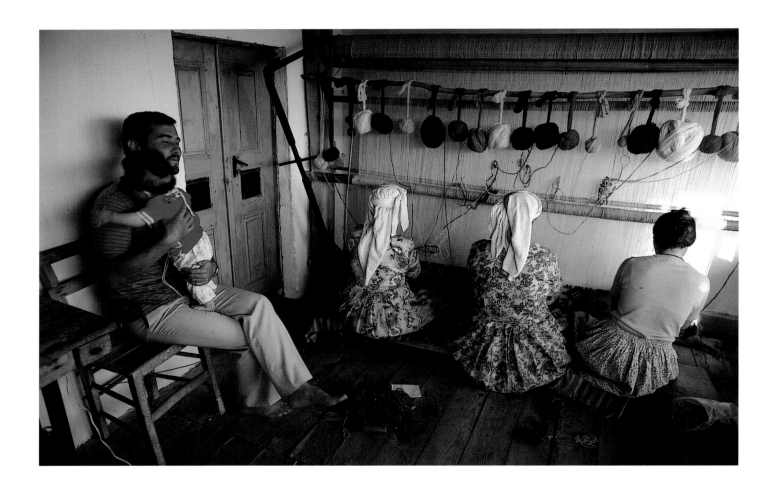

Above: Mugla, and the surrounding villages of the southern Aegean coastal region, has been a centre for carpet weaving for the past 150 years. The skills, passed from mother to daughter, include the extraction and use of natural dyes, especially a rare yellow dye from apricot leaves and a green from piren bushes. The knots in the girls' scarves denote their marital status. TURKEY

Opposite: Dozens of different designs make the choice of a wedding dress a testing time for a bride-to-be and her mother at this popular boutique. Only the groom and the female guests will be treated to the display of outright femininity. KUWAIT

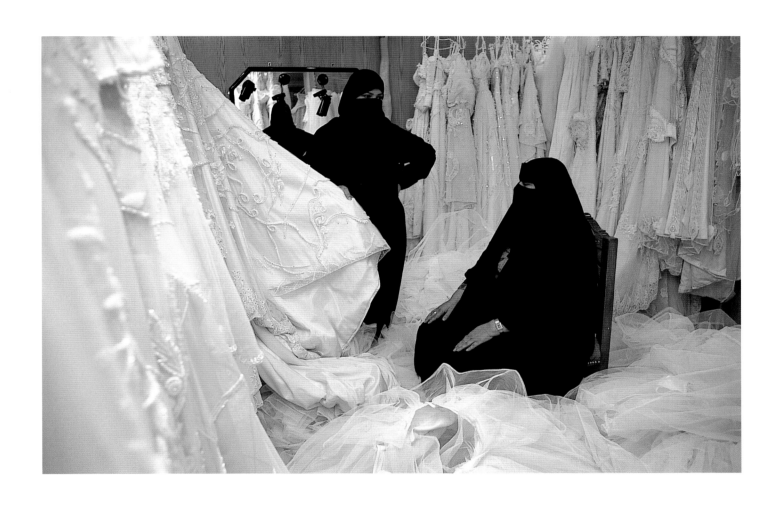

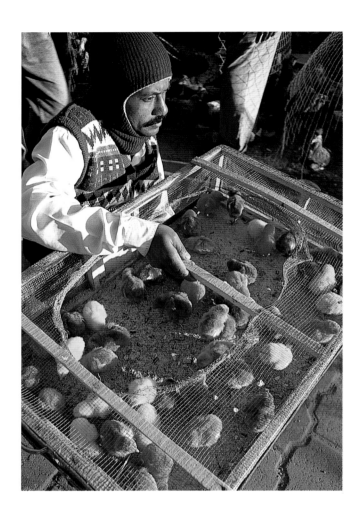

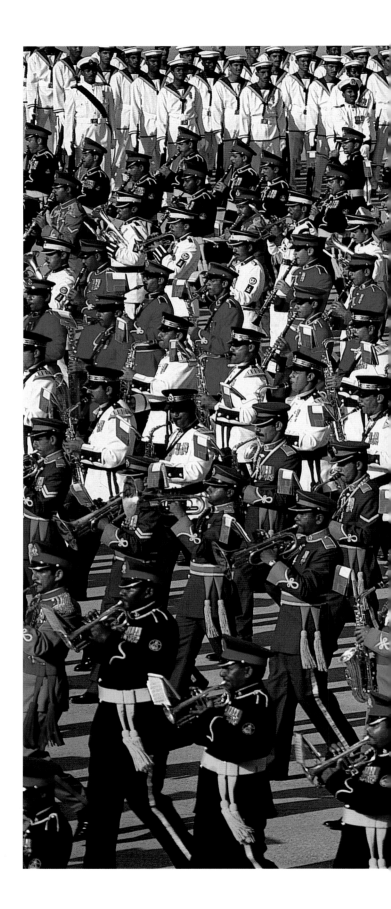

Above: For the bird fancier who has everything – chicks dyed in vivid hues at the weekly market. *KUWAIT*

Right: Massed bands parade before the Sultan on National Day. *OMAN*

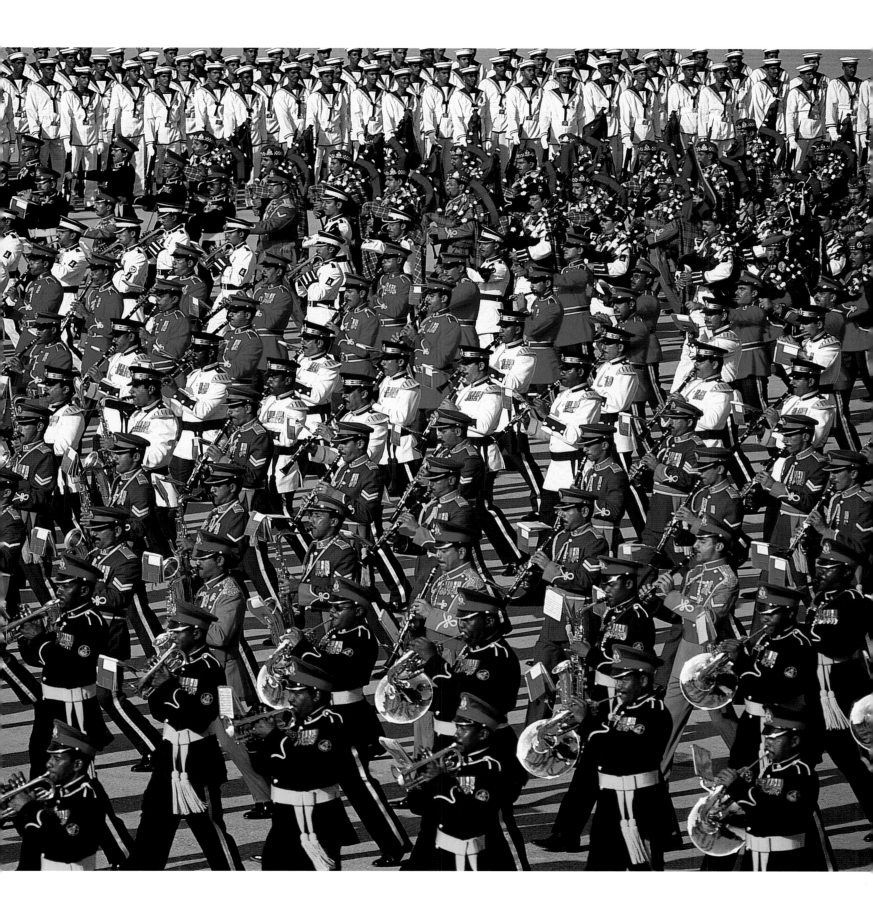

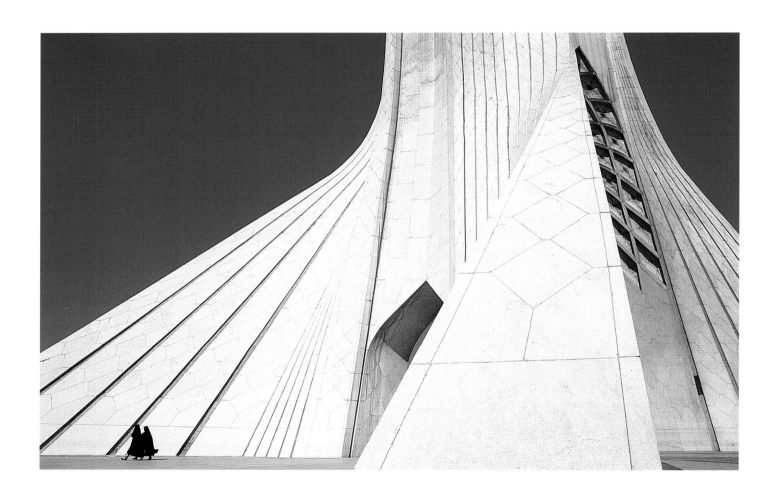

Above: The Shayyad monument,
symbol of the Pahlavi dynasty, was
completed in 1971 – less than a decade
before the revolution that brought
Ayatollah Khomeini to power. It is
now known as the Azadi Tower and
forms the gateway to Tehran. *IRAN*

Opposite: The façade of a new
shopping mall in Riyadh. *SAUDI
ARABIA*

Preceding pages: Bedu women. OMAN

Above: A student of English literature
at Kuwait University – one of a minority
of young Kuwaiti women choosing to
wear western clothes and make-up in
public. KUWAIT

Opposite: Upwardly mobile at a
pavement café in Amman. JORDAN

Above: A fruit stall in Tehran. IRAN

Opposite: A street seller with lemons
in the old city of Istanbul. TURKEY

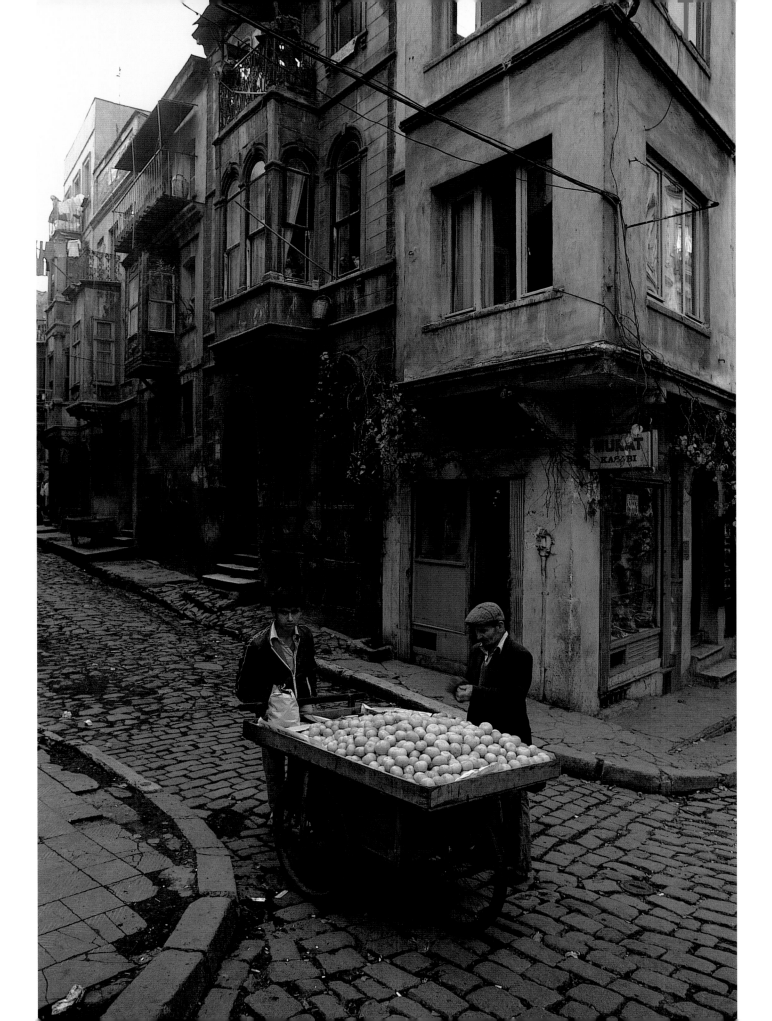

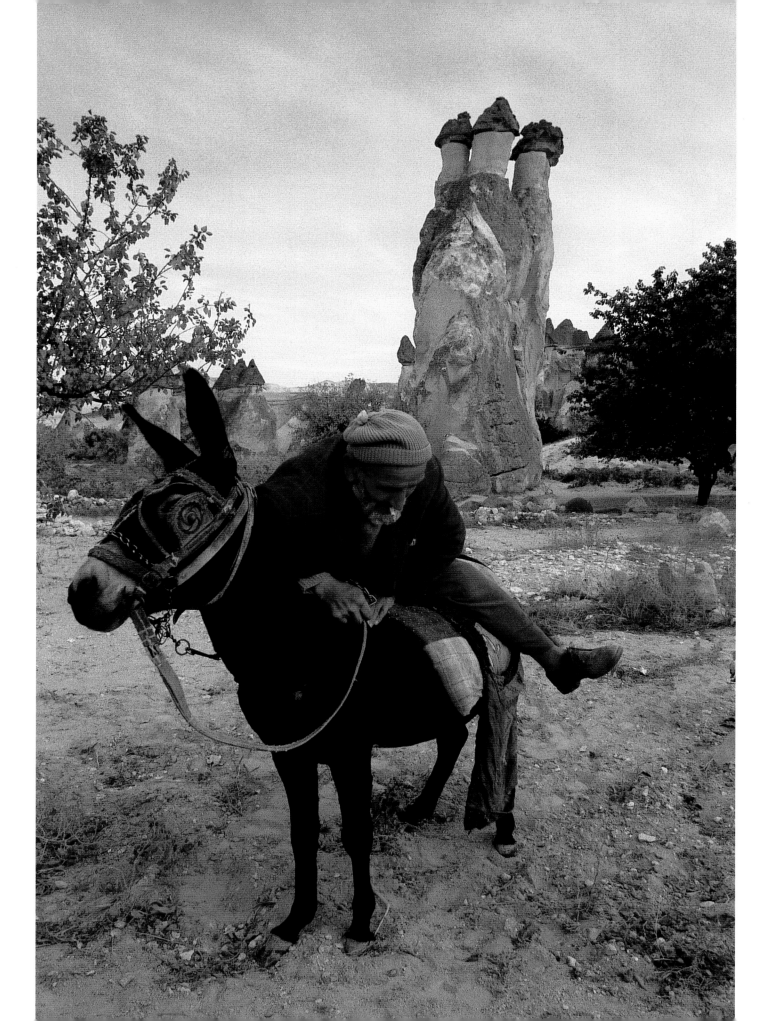

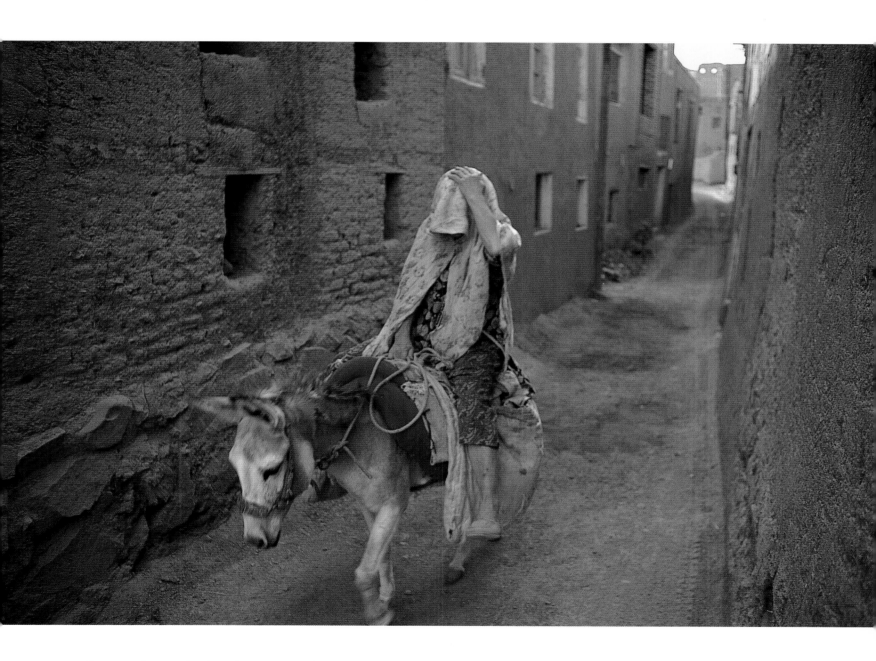

Above: A quiet street in Abyaneh. *IRAN*

Opposite: A man struggles on to his
donkey in Cappadocia. Boulders of
basalt tossed out by volcanoes millions
of years ago still sit precariously on
needles of rock in the background.
TURKEY

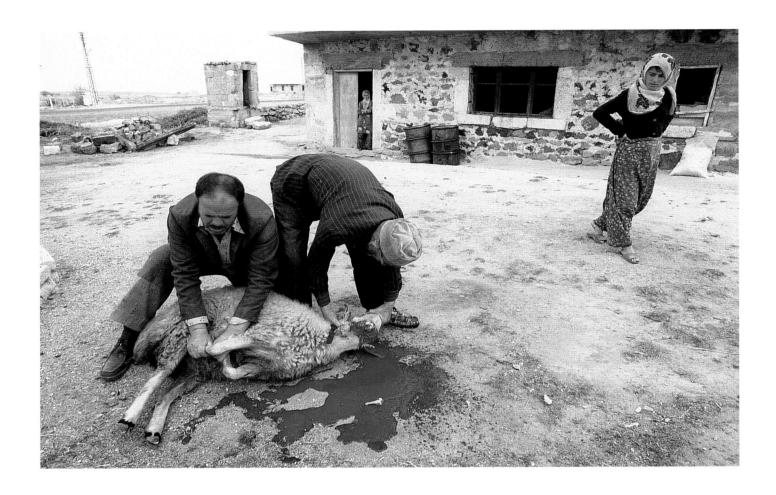

Above: The feast of the sacrifice –
Eid al-Adha – is the most important
feast in the Islamic calendar, and
marks the culmination of the
pilgrimage to Mecca – the *hajj*. For
those not taking part in the pilgrimage,
like these villagers in Central Anatolia,
communal prayer is followed by the
sacrifice of an animal to commemorate
Abraham's sacrifice of a ram as

dispensation for the intended offering
of his son, Isaac. A sheep, a camel, a
cow or a goat may be slaughtered,
using a single stroke of the knife to
sever the animal's windpipe and
jugular vein. *TURKEY*

Opposite: Members of a small farming
community at Siyazah in the foothills of
the Caucasus mountains. *AZERBAIJAN*

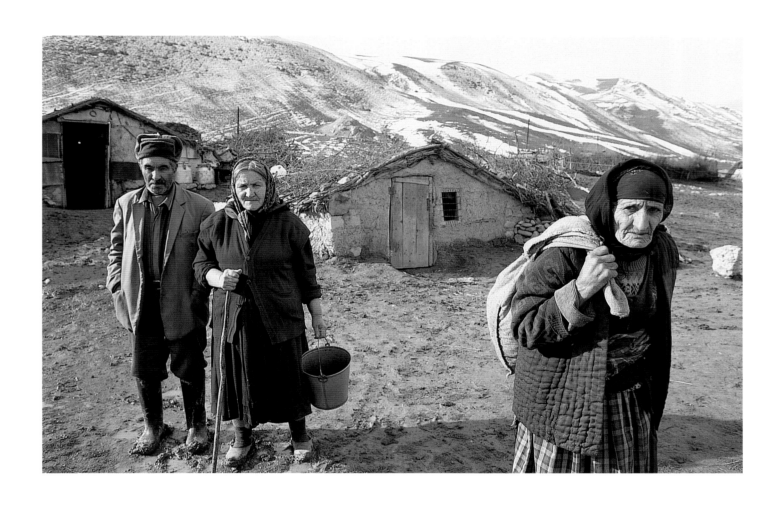

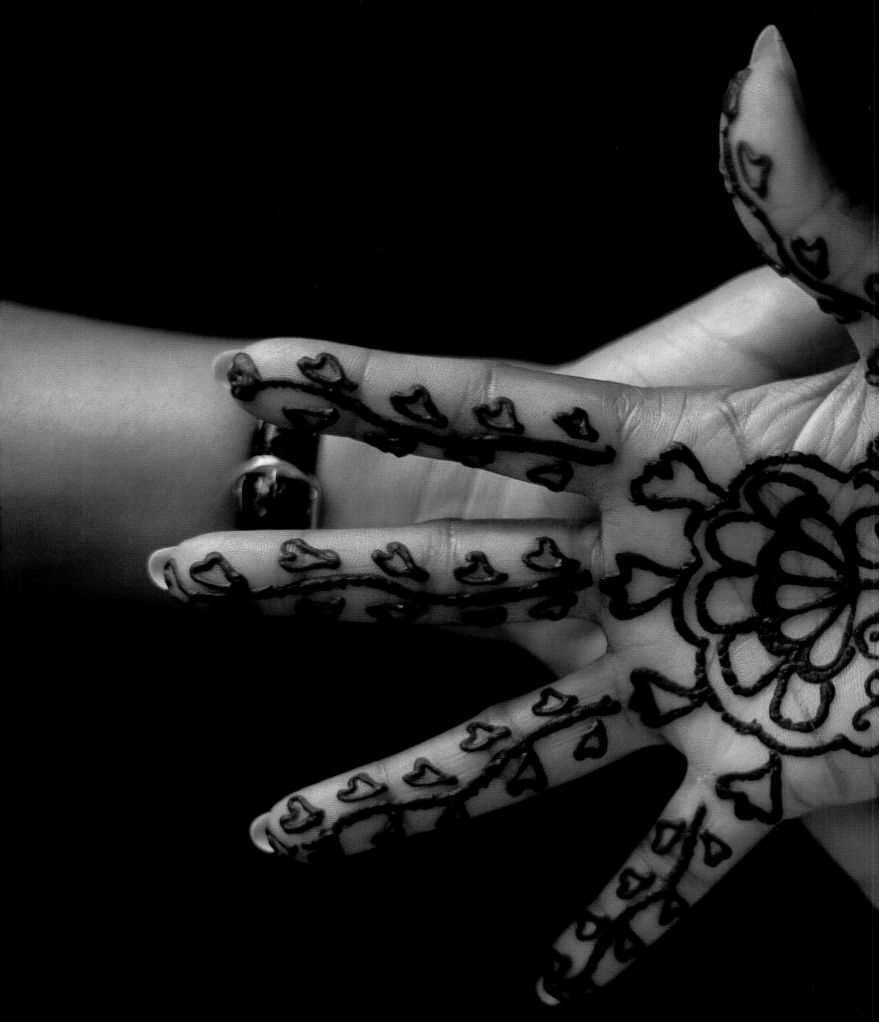

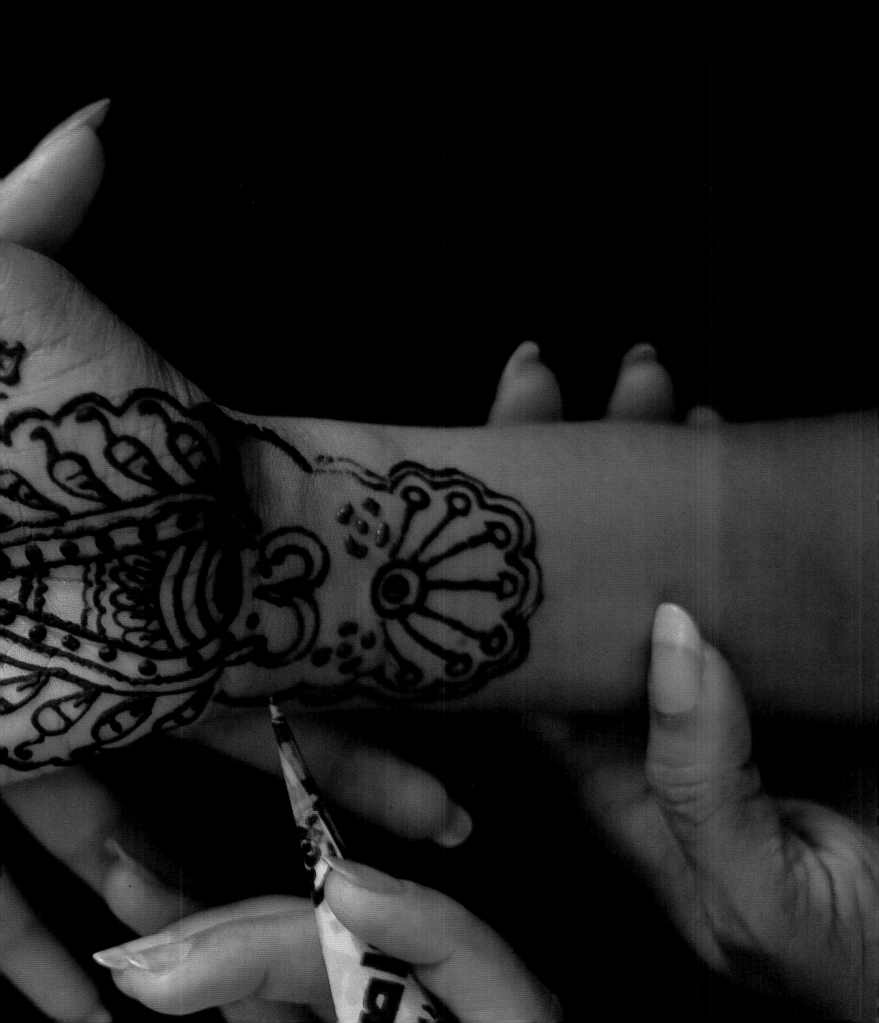

Opposite: Dressed for the races at a camel track in Dhofar. *OMAN*

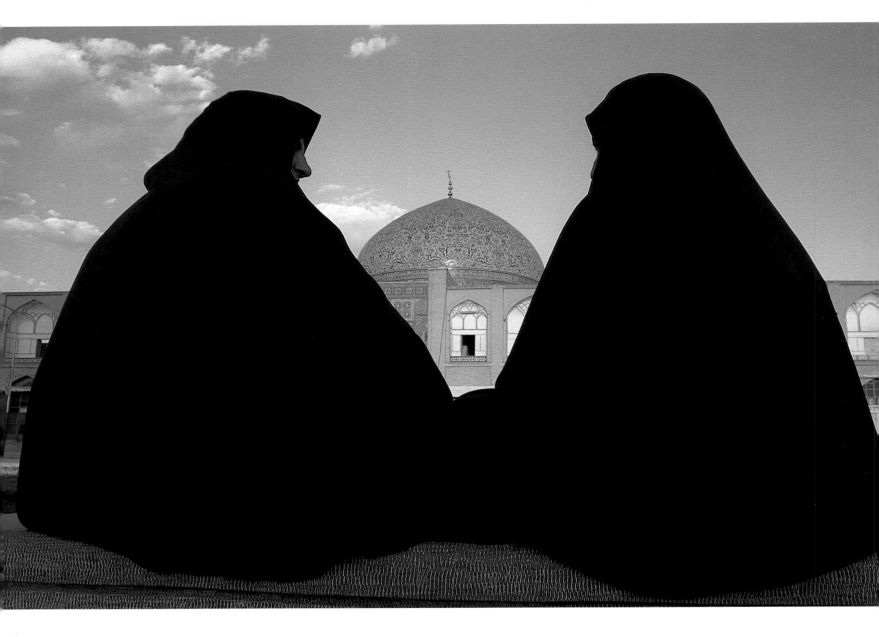

Preceding pages: Decorating hands and feet with henna (as here in Dubai) is popular in many parts of the Muslim world at times of celebration. The same henna is also used to dye hair. The Koran says nothing specific to discourage this kind of enhancement, provided it does not create false impressions. *UNITED ARAB EMIRATES*

Above: Time to gossip in front of the Sheikh Lutfullah mosque in Isfahan. The wearing of a veil – or *hijab* – is not a requirement of Islam but has more to do with culture, especially in male-dominated societies. However, the Koran does exhort women to 'reveal not their adornments' and to 'cast their veils over their bosoms'. *IRAN*

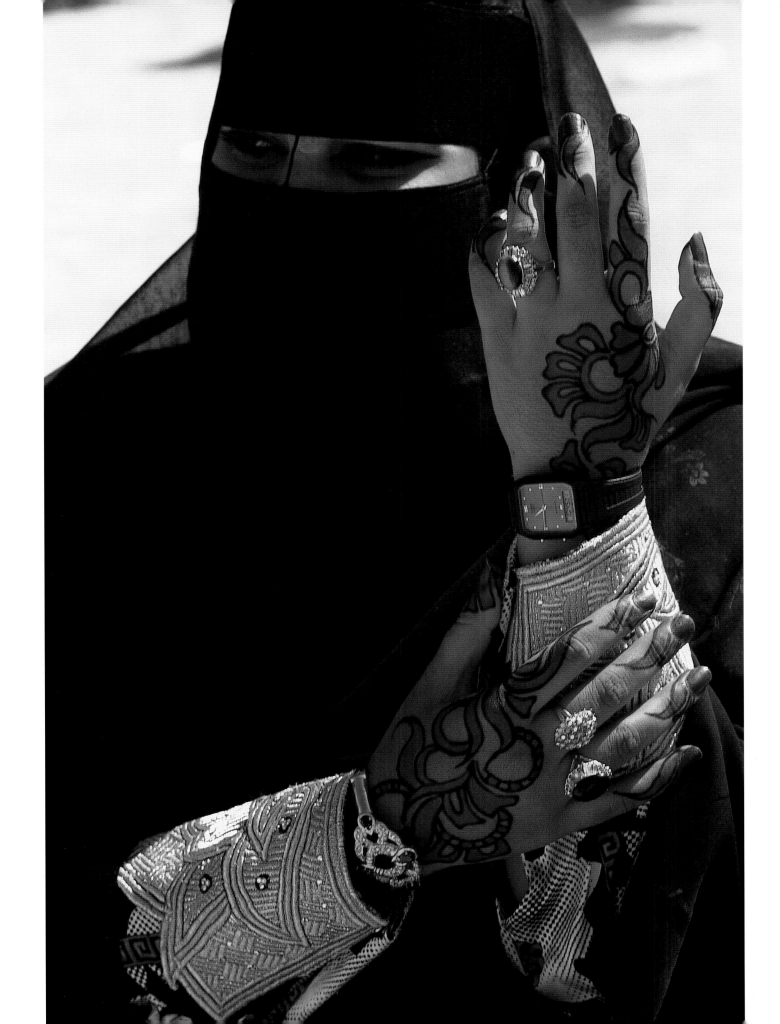

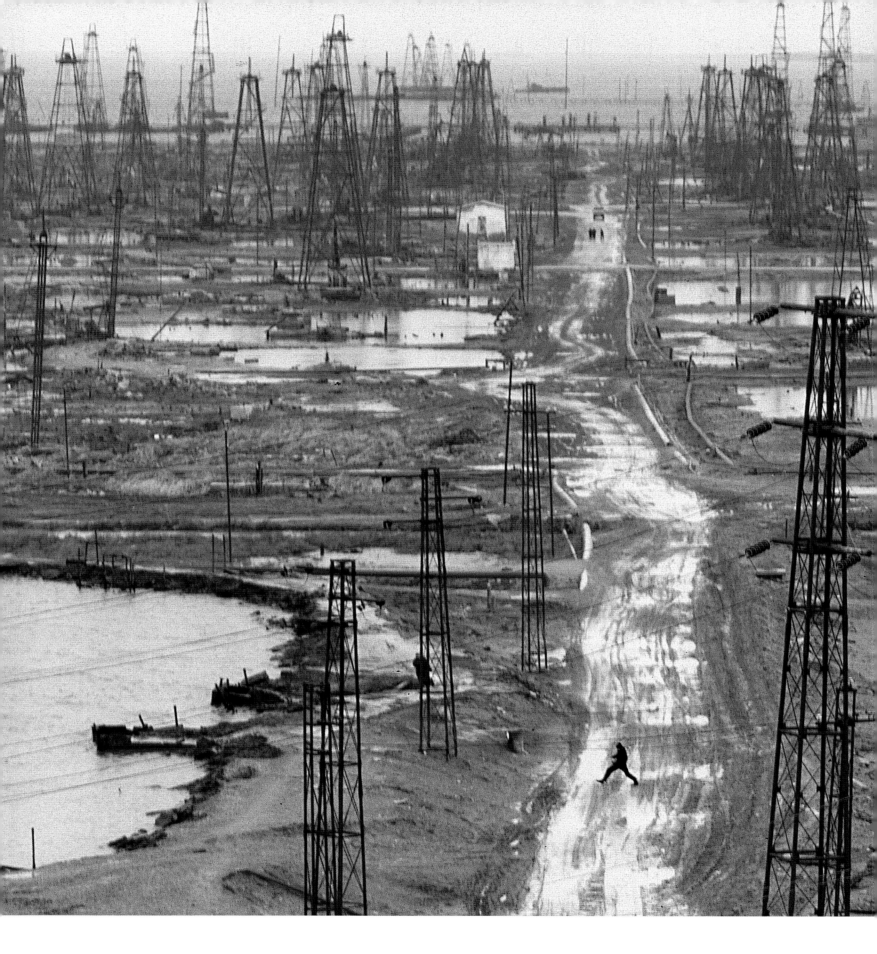

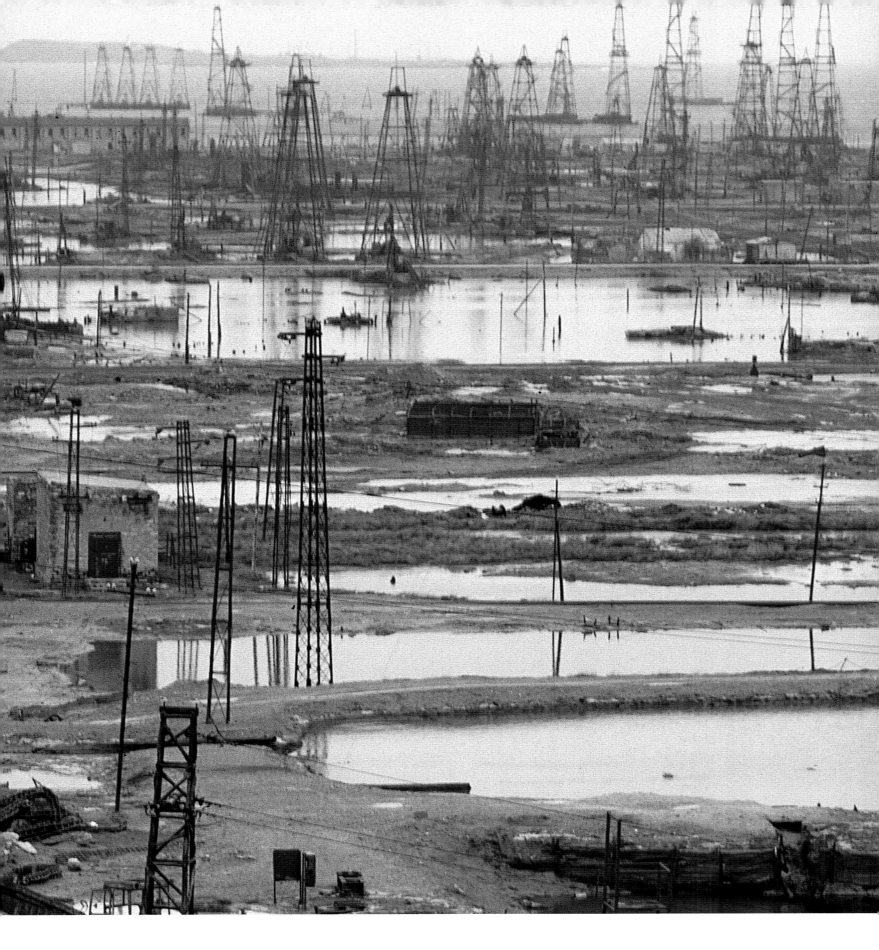

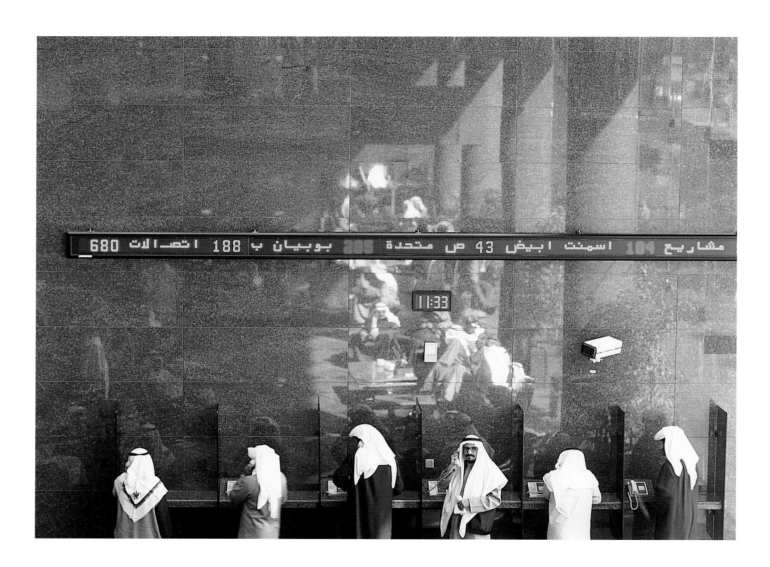

Preceding pages: Once the world's largest oil producer, Azerbaijan's capacity is now eclipsed by that of the Arab states. Nevertheless, there are considerable reserves under the shallow waters of the Caspian Sea, leaving just a few of the original land-based wells in production, and the rest in a state of decay. AZERBAIJAN

Above: After a collapse in the late 1970s, the Kuwait Stock Exchange has grown in recent years to become the Gulf's largest. Trading in the stock of 63 companies takes place in the mornings only from Saturday to Wednesday. However, business in Kuwait remains firmly in the control of a few wealthy families. KUWAIT

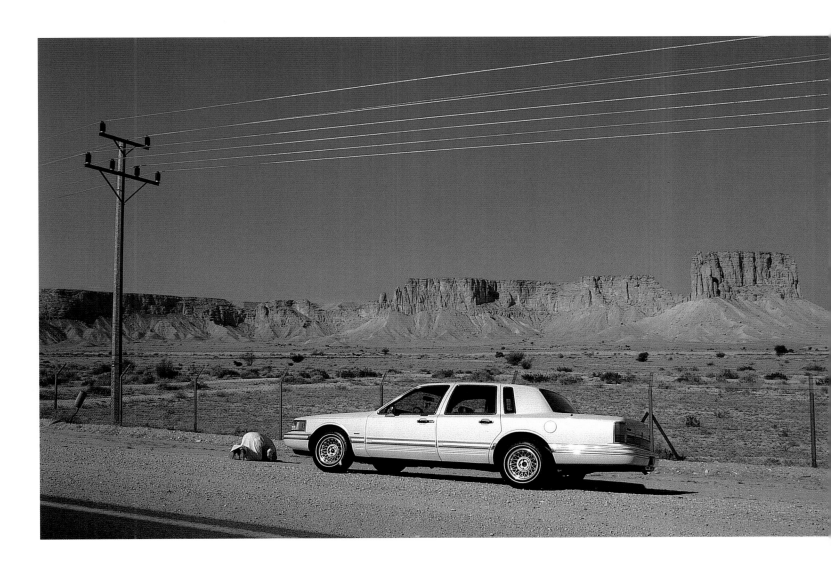

Above: Not able to reach his mosque
in time for midday prayers, a motorist
on his way to Riyadh uses his prayer mat
at the side of the road. SAUDI ARABIA

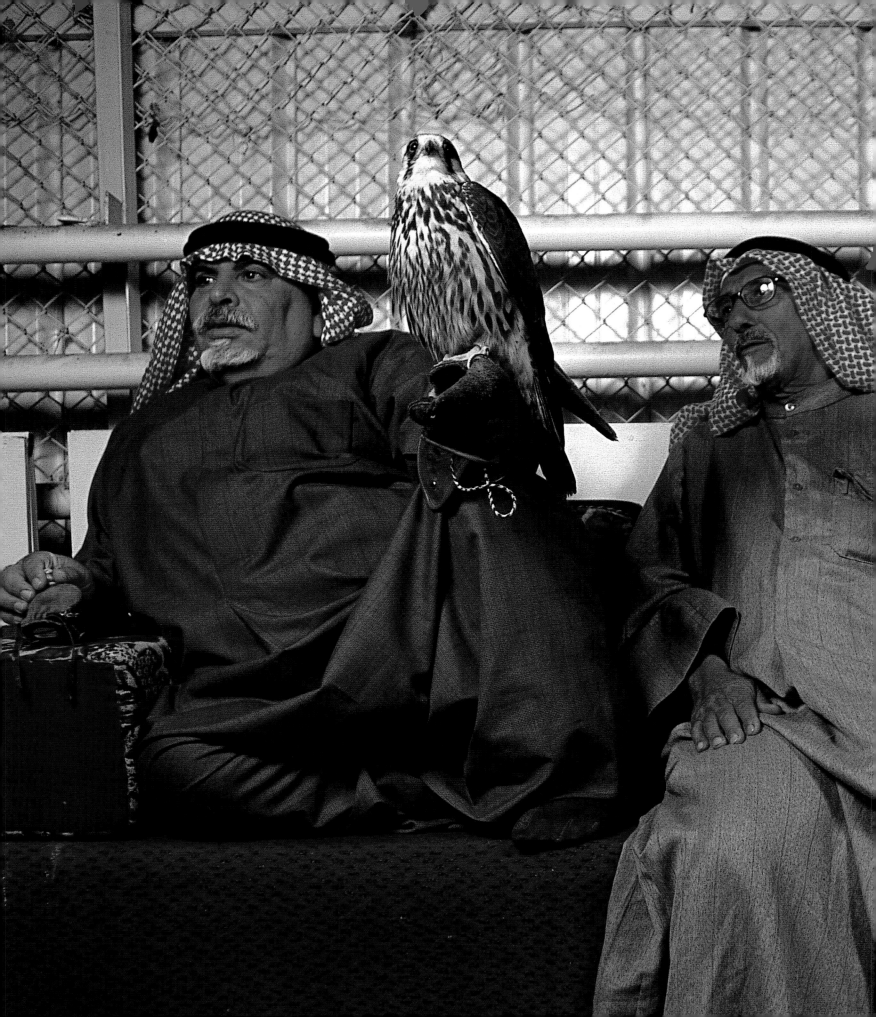

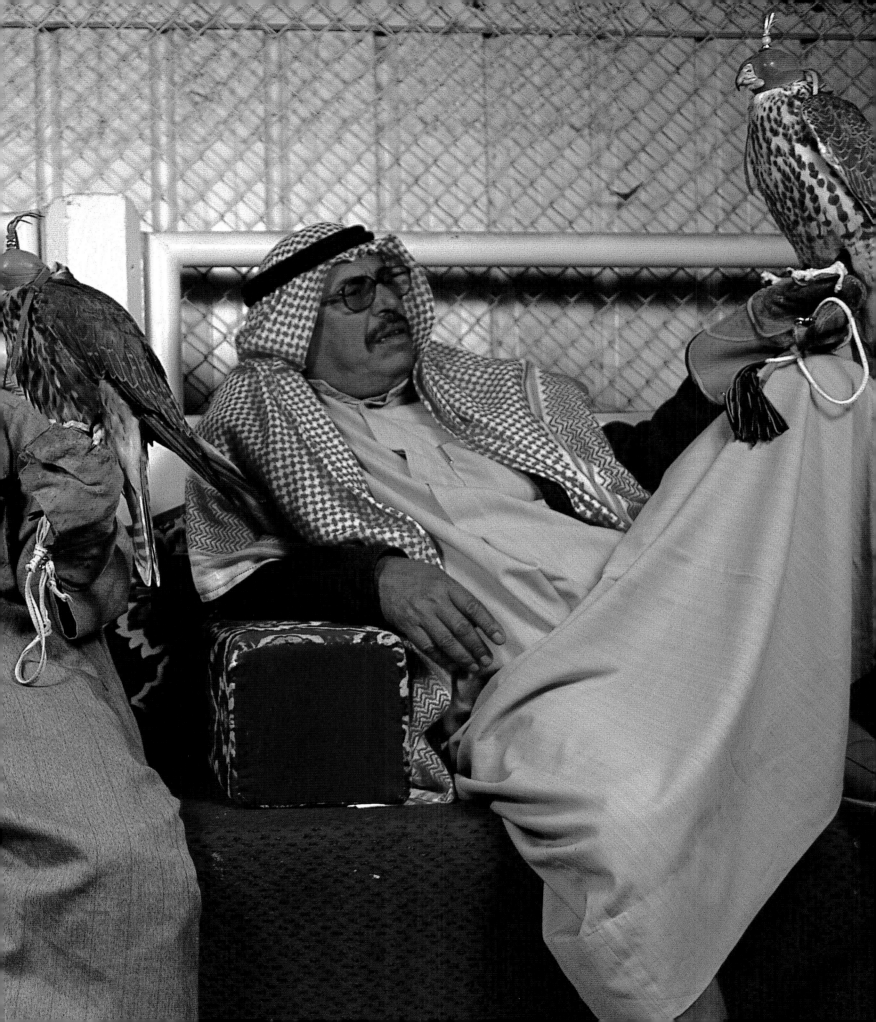

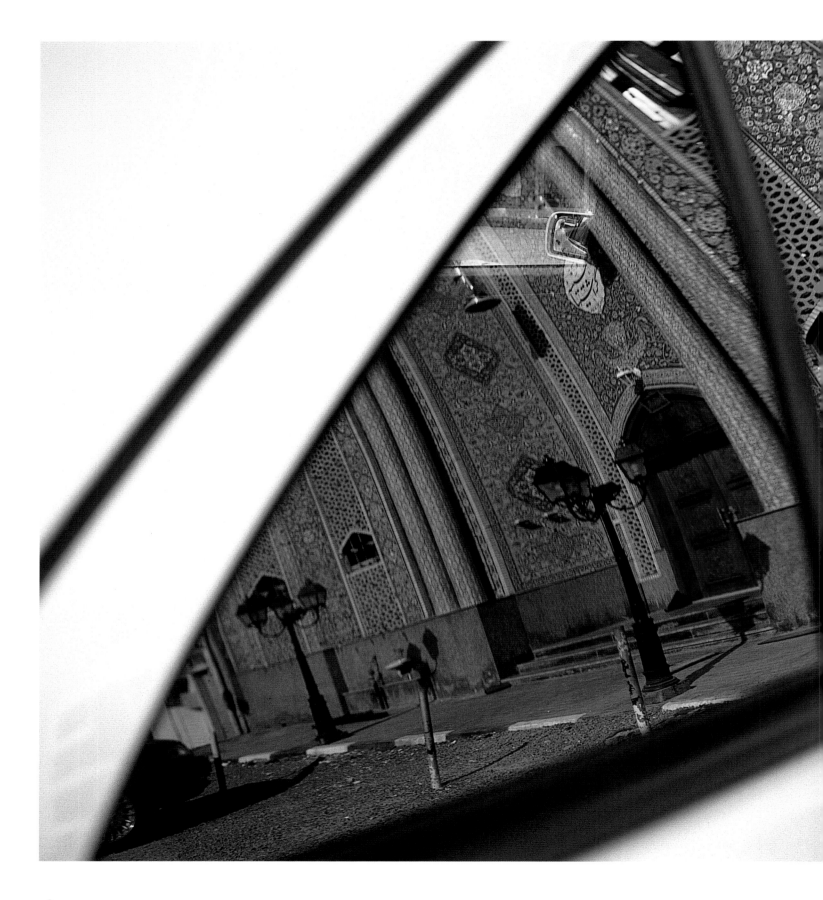

Preceding pages: Falcon breeders show off their birds at the daily auction in Kuwait. Used to hunt *habara*, a desert bird prized as a delicacy by wealthy Kuwaitis, falcons can fetch as much as US $10,000. KUWAIT

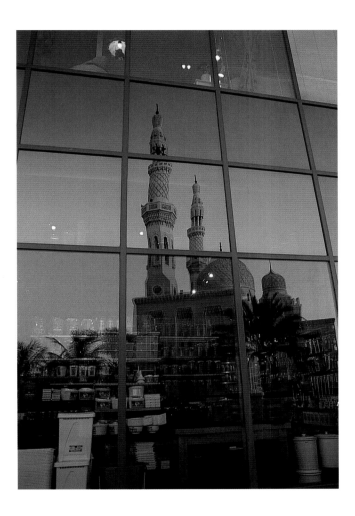

Above: The Jumeira mosque reflected in the windows of a kitchenware shop in Dubai. UNITED ARAB EMIRATES

Left: The reflected tiled façade of a mosque in Deira, Dubai.
UNITED ARAB EMIRATES

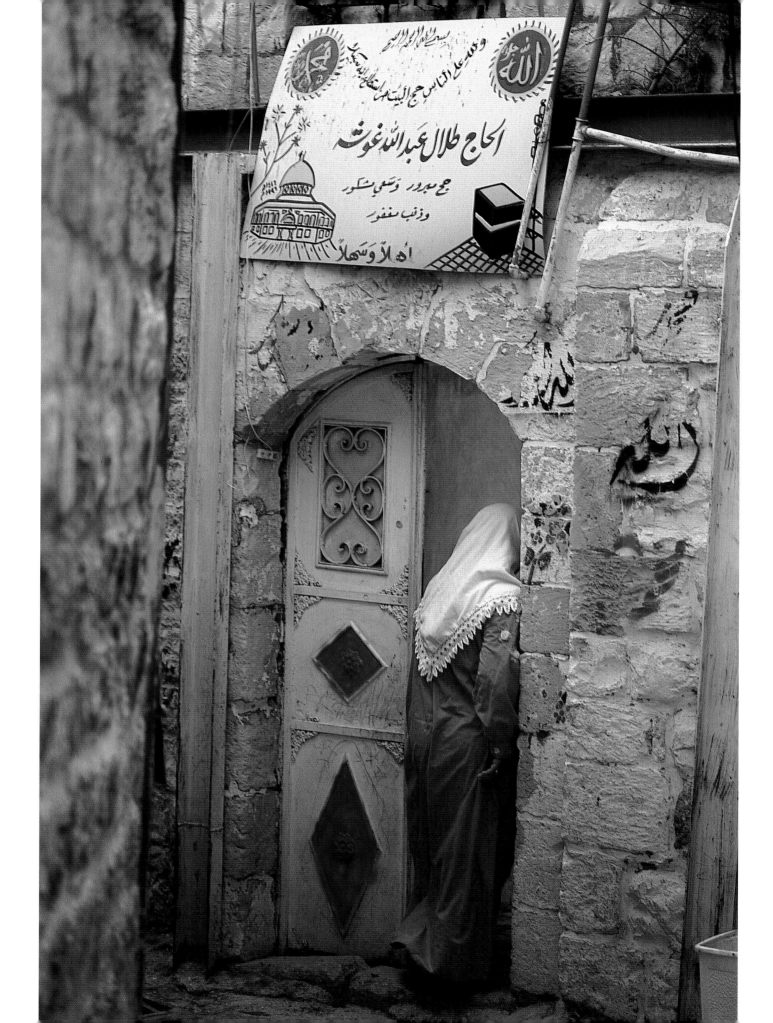

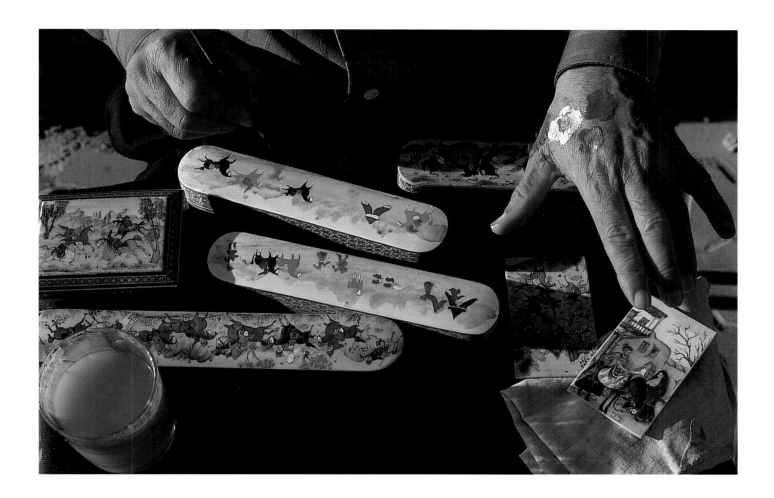

Above: The hands of Isfahan artist Reza Taghizathed as he puts finishing touches to the lids of jewelry boxes. While pictorial representation of God, the Prophet or his Companions is forbidden, the art of the miniature is encouraged as a means of telling stories about Islam's history. IRAN

Opposite: Messages of welcome for a member of the family returning from the *hajj* to Mecca decorate a doorway in East Jerusalem. JERUSALEM

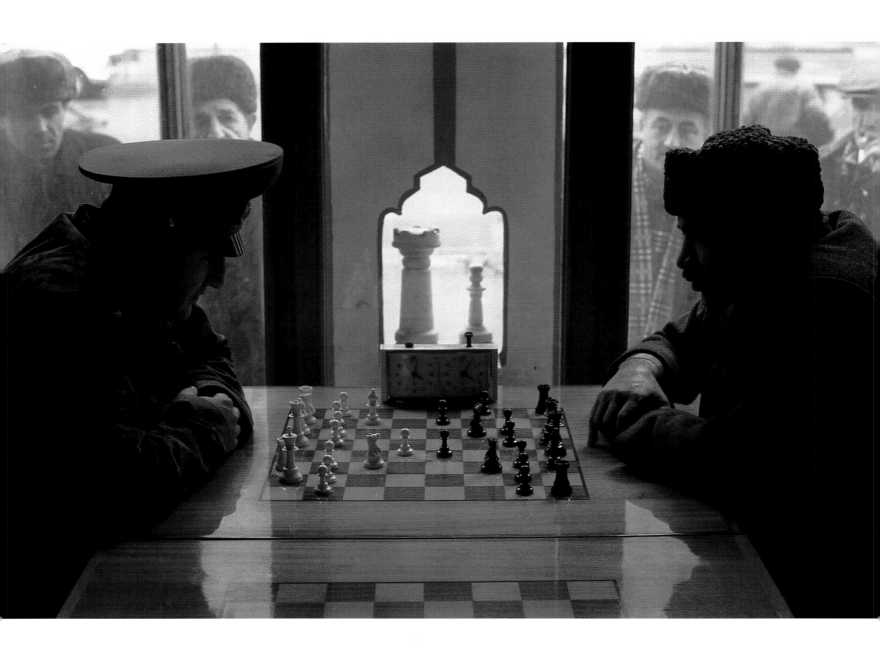

Above: Chess clubs flourish in Baku, the city that produced Gary Kasparov, who at 22 years of age was the world's youngest chess champion. AZERBAIJAN

Opposite: The washing of hands, face and feet, referred to as *wudu*, is done in order to be in the correct purified state to perform the canonical prayers. Importantly, running water or water poured from a container should be used, as here in Nevsehir. TURKEY

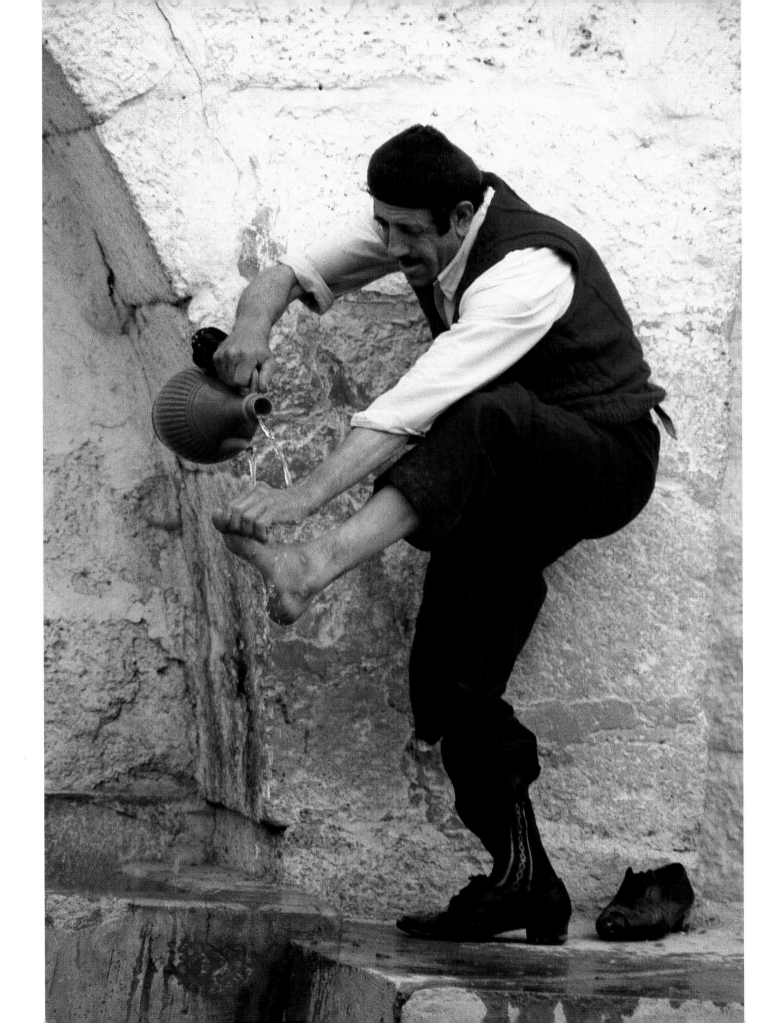

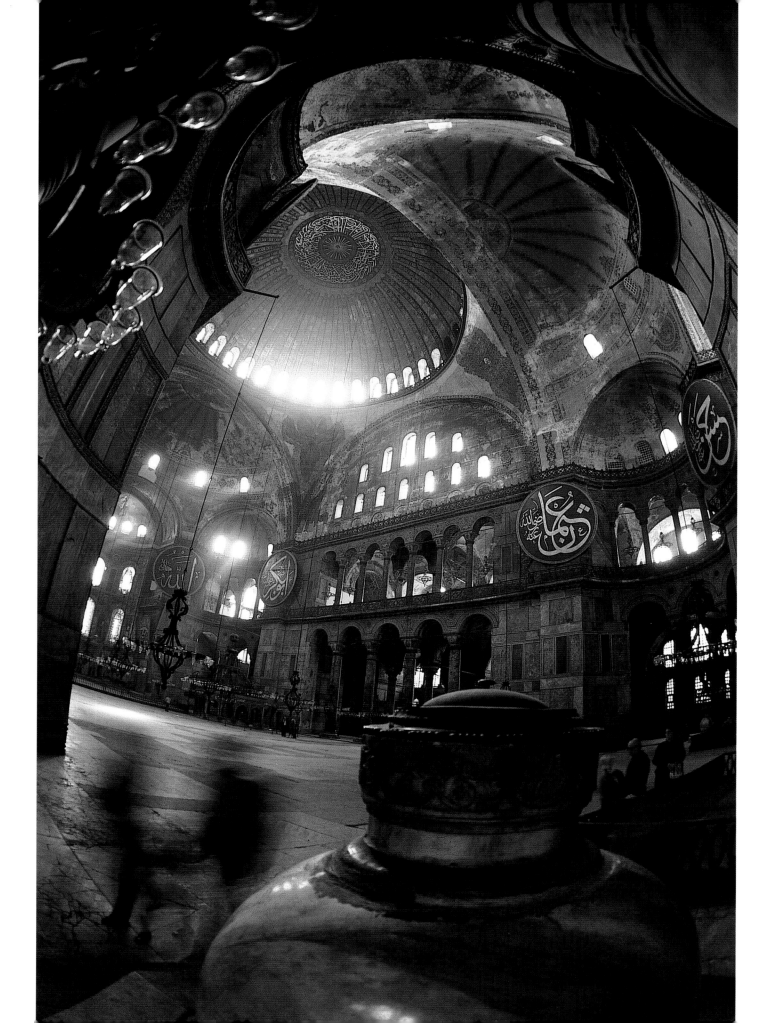

Opposite: Emperor Justinian's church of Aya Sophia in Istanbul was designed by two mathematicians and built by 10,000 craftsmen in just five years between AD 532 and 537. Minarets were added when the church became a mosque in the 15th century and visitors of all denominations have been able to marvel at its grandeur since it became a museum in 1933. The country had been turned into a secular state by Kemal Atatürk ten years earlier. TURKEY

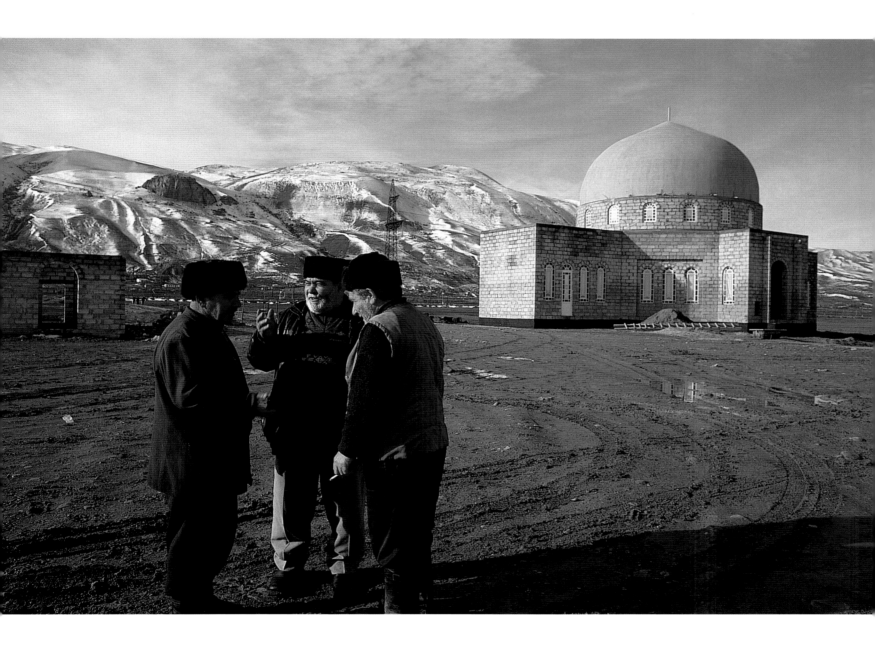

Above: The mosque at the foot of Besh-Barmag, a holy place associated with the prophet Zinda, the protector of travellers. AZERBAIJAN

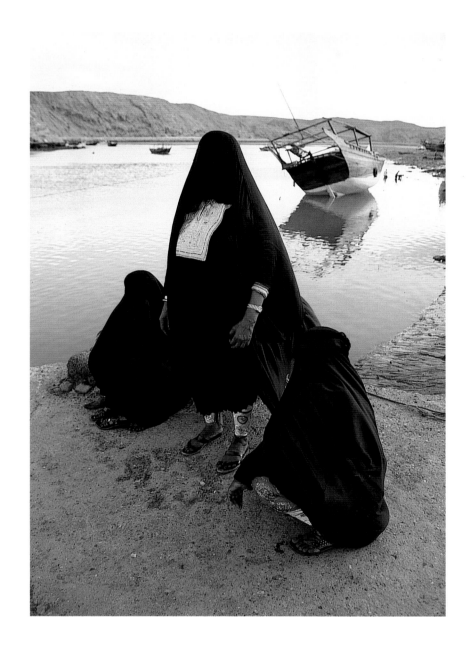

Above: Waiting for a ferry on the creek
at Sur. *OMAN*

Opposite: A staircase leads to the
minaret of a small mosque recently
renovated in Kuwait City. *KUWAIT*

Left: A woman waits outside a bakery in Diyarbakir, an ancient city on the banks of the Tigris in southeastern Anatolia. TURKEY

Below: A market porter in Istanbul. TURKEY

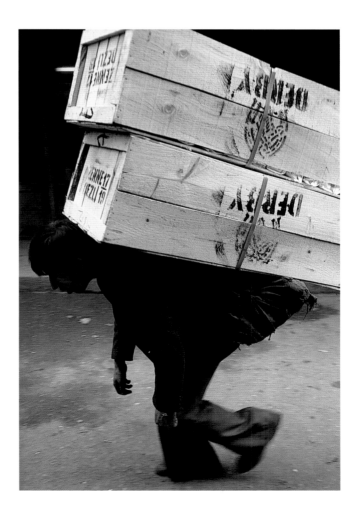

South Asia

It would be difficult to imagine two more contrasting faiths or cultures than Islam and Hinduism. Yet the peoples of these two faiths have lived side by side on the Indian subcontinent for a thousand years. From time to time, discord has erupted into terrible bloody violence, but by and large tolerance has prevailed. And what led to partition and the creation of Pakistan was more a desire for a Muslim homeland than a rejection of a nation shared with Hindus. Today, there are still more Muslims in India than there are in either Pakistan or Bangladesh.

Of course, the subcontinent has its tensions, but while partly founded in religious differences, they have much more to do with disputes over territory than over articles of faith. But it is political crises at home that have troubled Pakistan most, and from time to time cost it its democracy; while in Bangladesh, which has had its own lapses into martial law, crises brought about by nature have relentlessly added to the extremes of poverty and deprivation.

In terms of their Islamic credentials, both Pakistan and Bangladesh were conceived as secular states. Muhammad Ali Jinnah, Pakistan's founding father, carefully defined his new nation as a 'state for Muslims' rather than an 'Islamic state'. And when Pakistan's eastern province gained independence, its customs were those of the Bengali Hindus, and so it was with their Bengali heritage rather than Muslim traditions that the fledgling Bangladeshis began their new lives.

It was only after they had established their national identity that Bangladeshis began to evoke the Islamic element in their history. But that shift has been one of personal choice. In Pakistan, there has been more evidence of the state embracing Islam with attempts to impose Islamic principles through *shari'a* (Islamic law). More recently, however, while radical Islam is clearly evident in some areas of Pakistani society, there have been signs that the pendulum is swinging back to Jinnah's ideal of a country for Muslims.

Early morning on the river Jamuna just north of Dhaka (Dacca). BANGLADESH

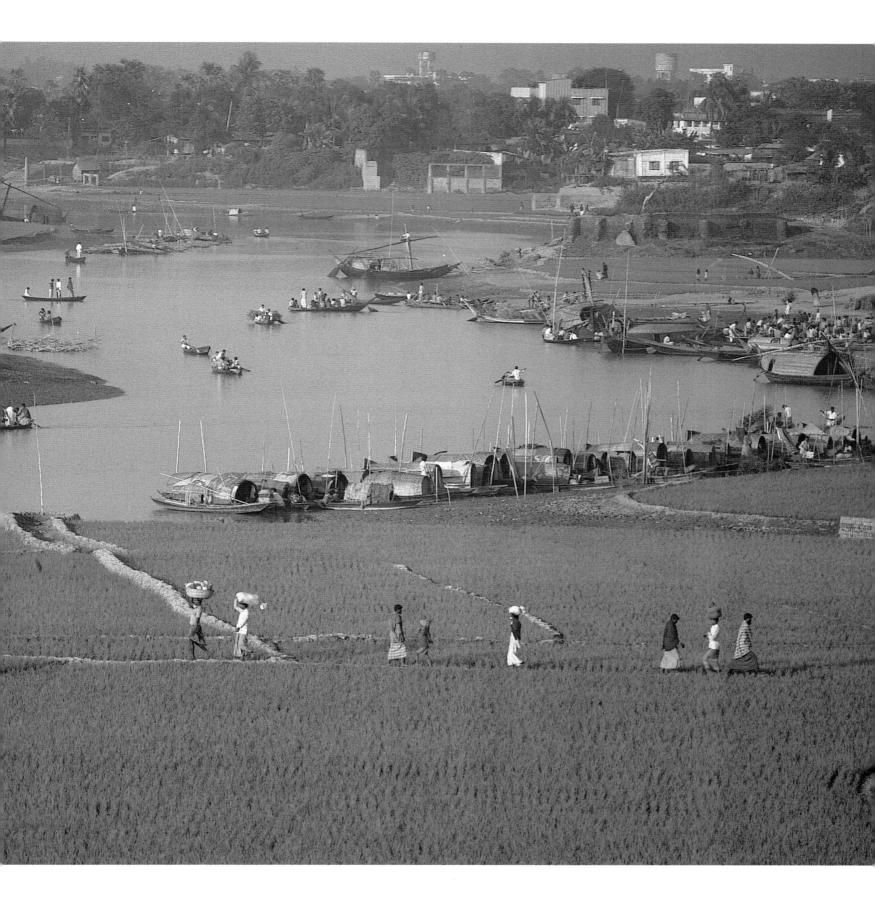

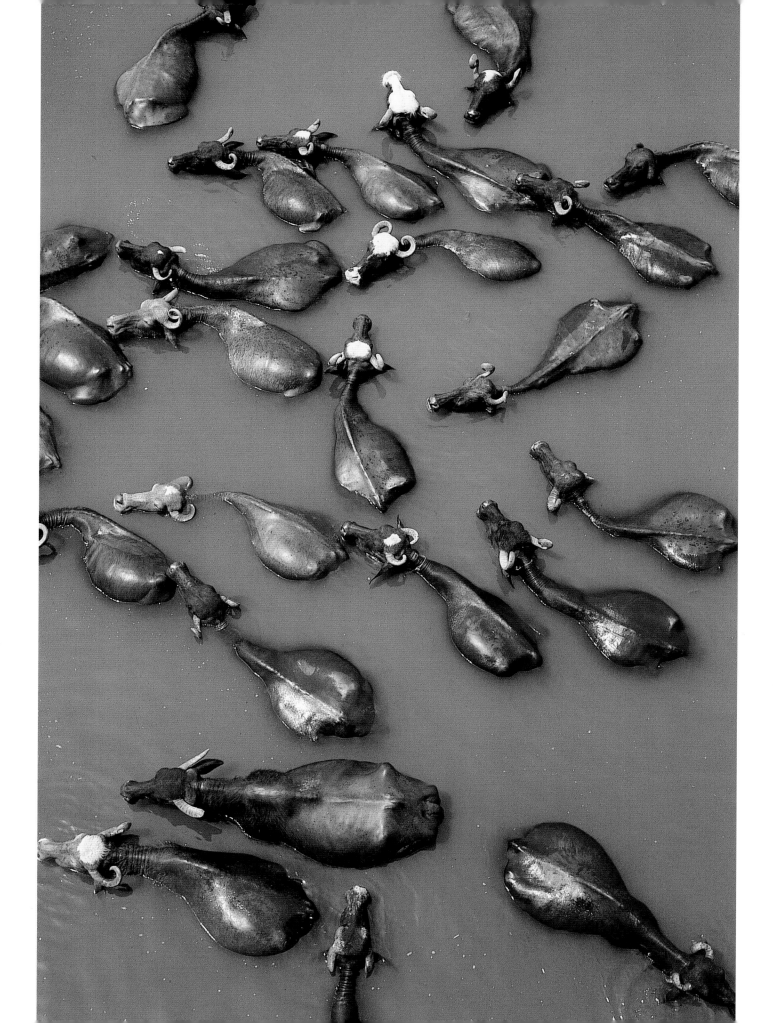

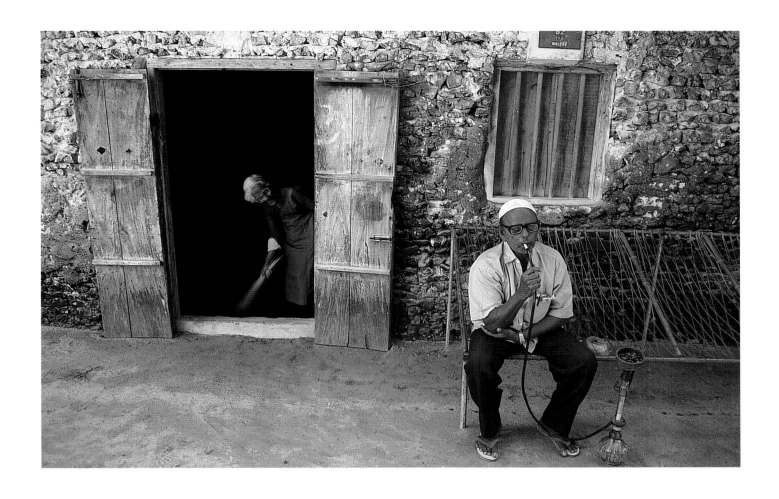

Above: A visiting imam on the tiny
island of Himmafushi relaxes with
a water pipe. MALDIVES

Opposite: Cooling off. Water buffalo
in the Yamuna river at Agra. INDIA

113

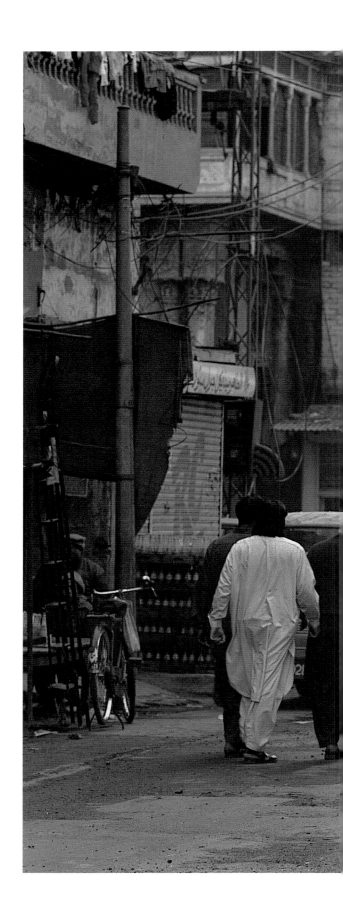

Above and right: On the streets of
Lahore. PAKISTAN

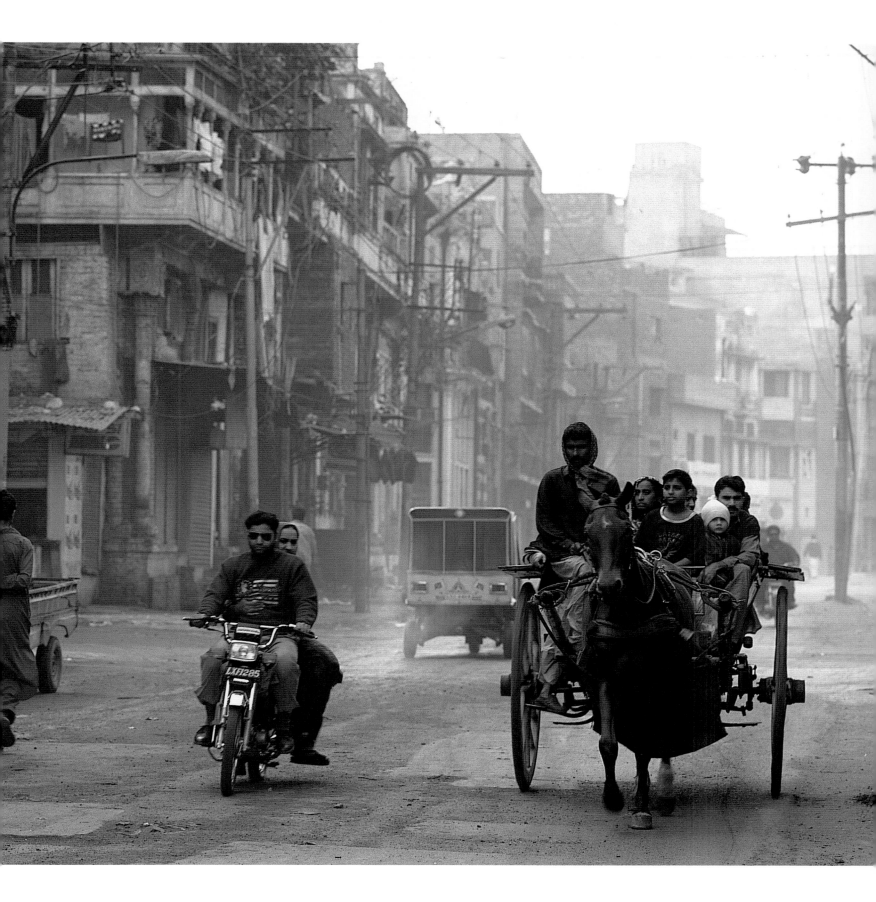

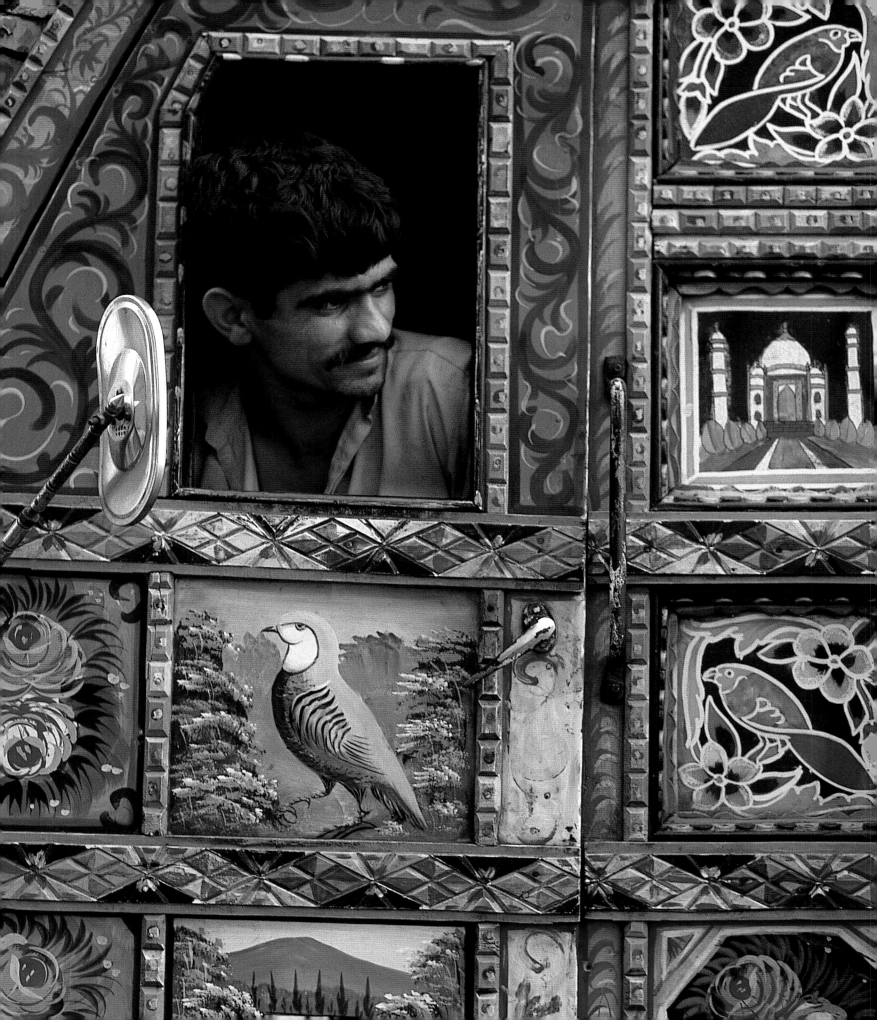

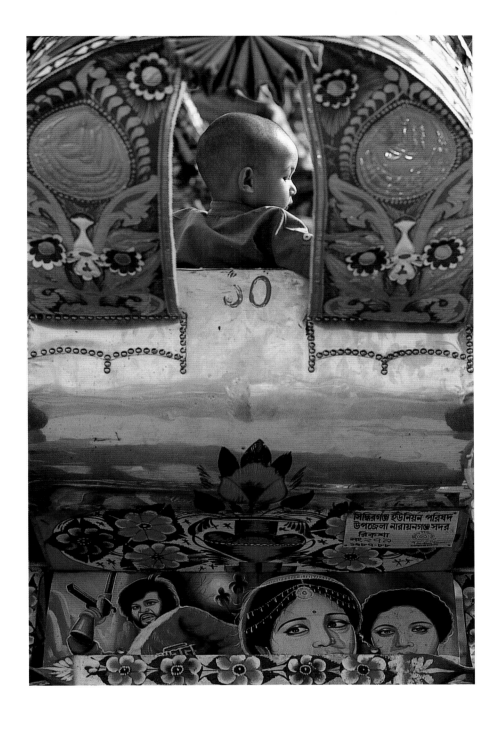

A love of bright colours is manifest in the trucks that ply the Great Trunk Road between Karachi and Peshawar. Paint shops specializing in truck art provide off-the-peg designs or, for a higher fee, follow a customer's specific requests. Popular subjects include birds, the Taj Mahal and landscapes on a trucker's routes. The moon, an important Islamic symbol, is present in many of the designs.

Opposite: A truck in Karachi. PAKISTAN

Above: A rickshaw in Dhaka (Dacca). BANGLADESH

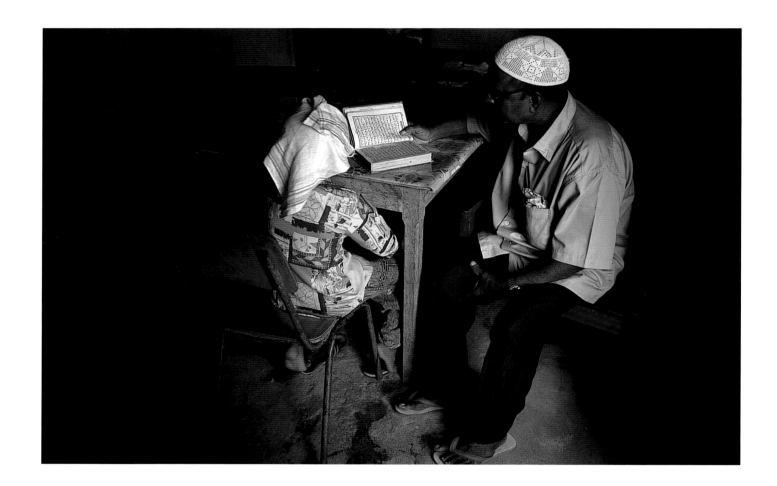

Above: His head respectfully covered
with a handkerchief, a young boy
receives lessons in the Koran.
MALDIVES

Opposite: Ashurah, the 10th day of the
first month of the lunar year, is the day
Shi'a Muslims mark the martyrdom of
the Prophet's grandson Hussain. While
moderate adherents hold processions
and stage plays, zealots flagellate
themselves with whips and chains.
PAKISTAN

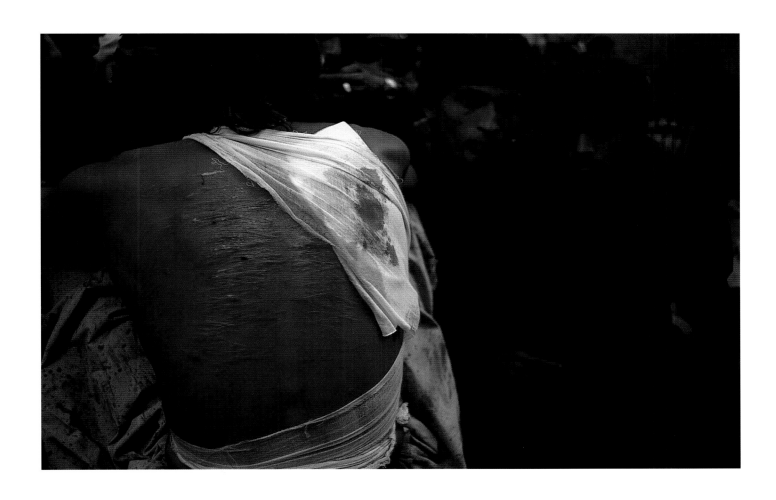

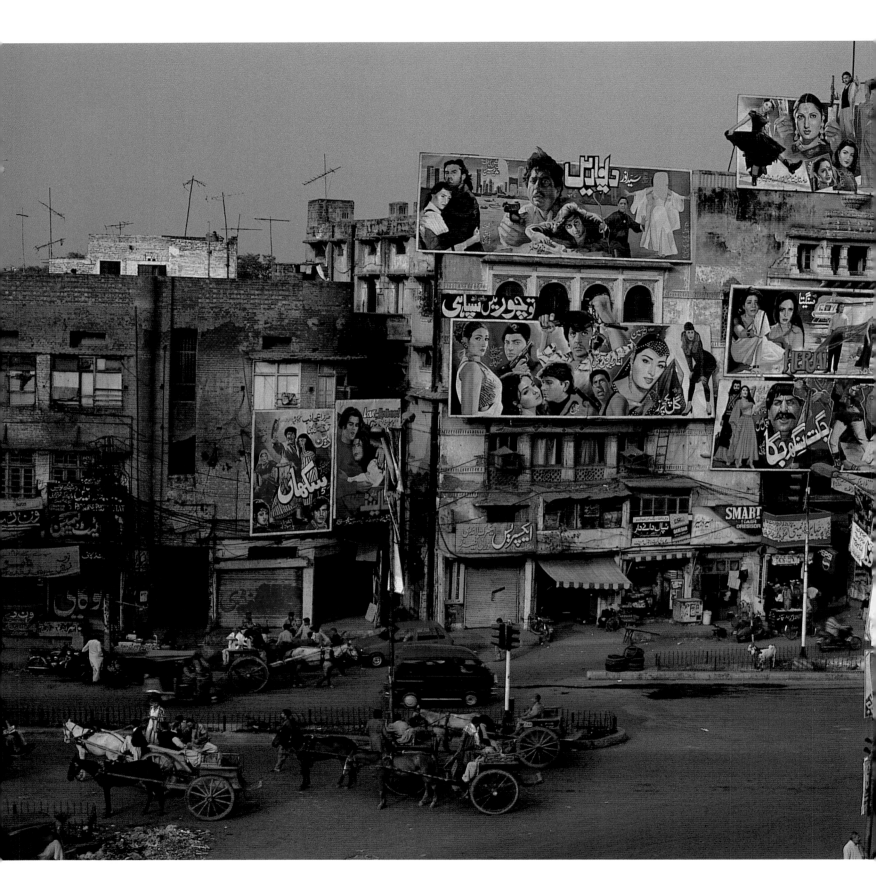

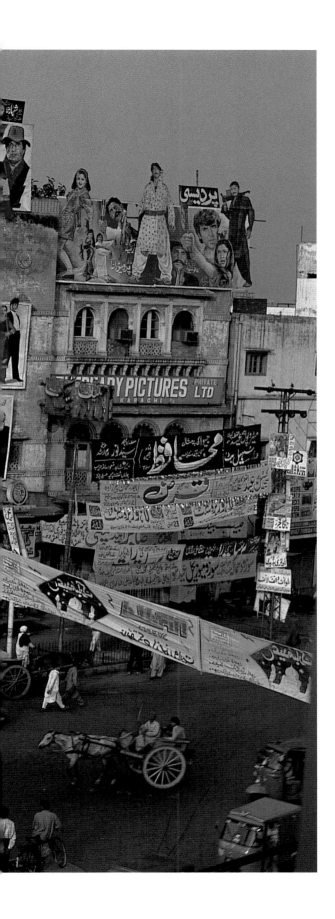

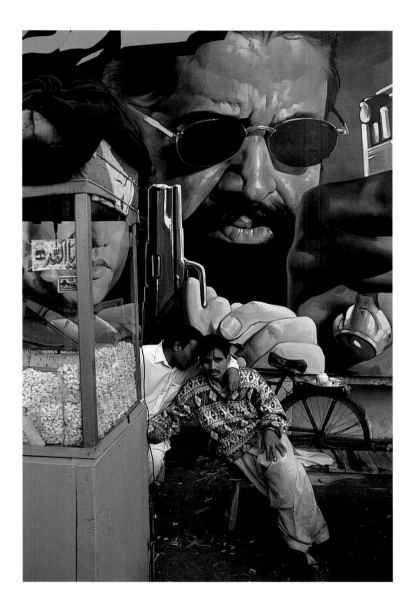

Above and left: Violence, unrequited
love and family feuds are popular
themes for a thriving film industry.
The latest offerings are advertised
here in Lahore. PAKISTAN

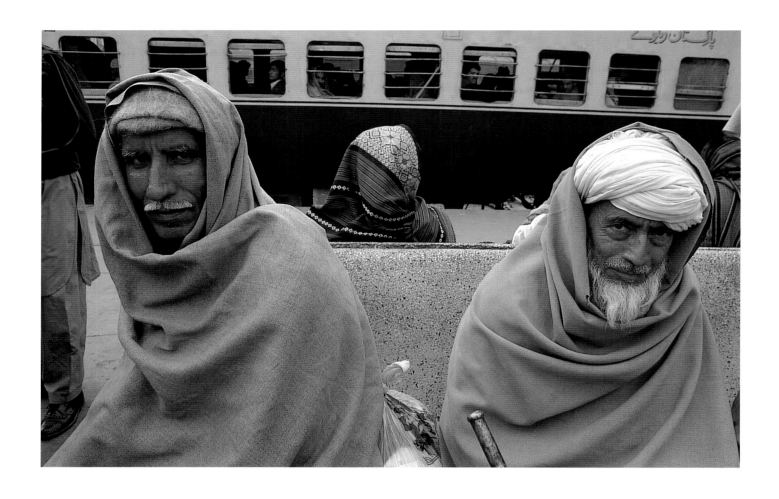

This page and opposite: While one traveller takes advantage of a platform barber, others just sit and wait at the main railway station of Lahore. PAKISTAN

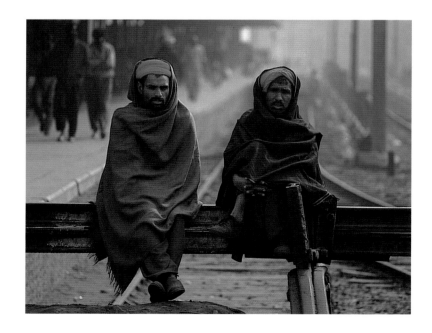

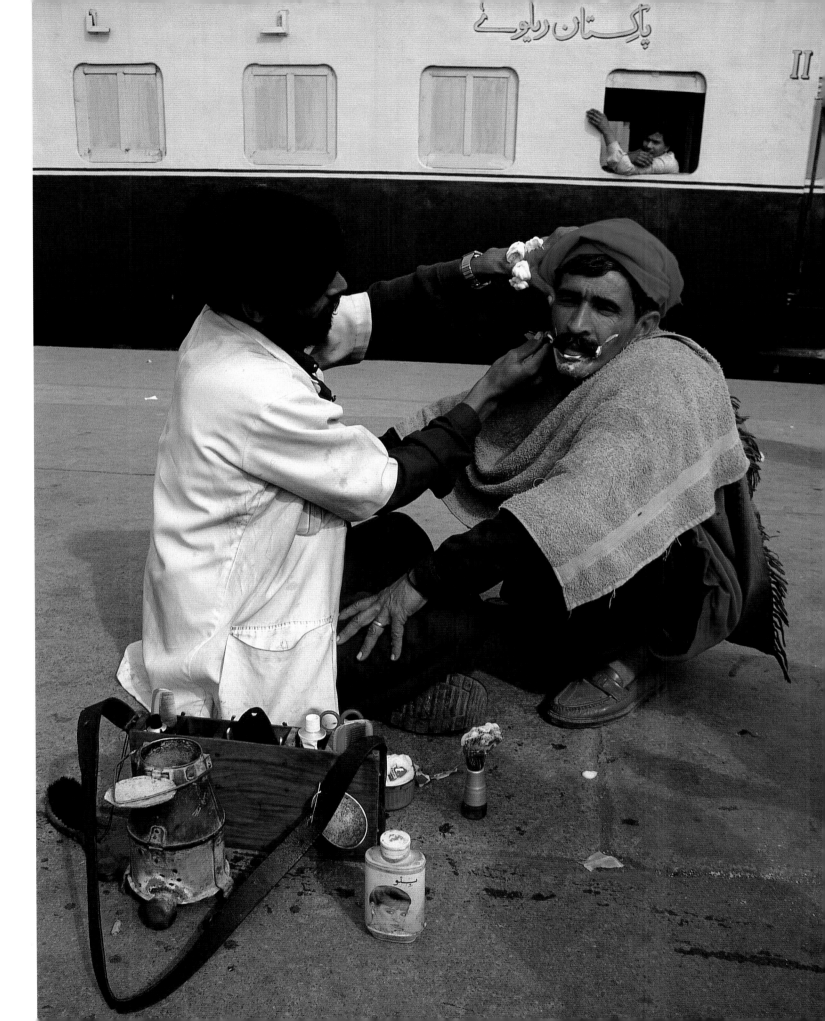

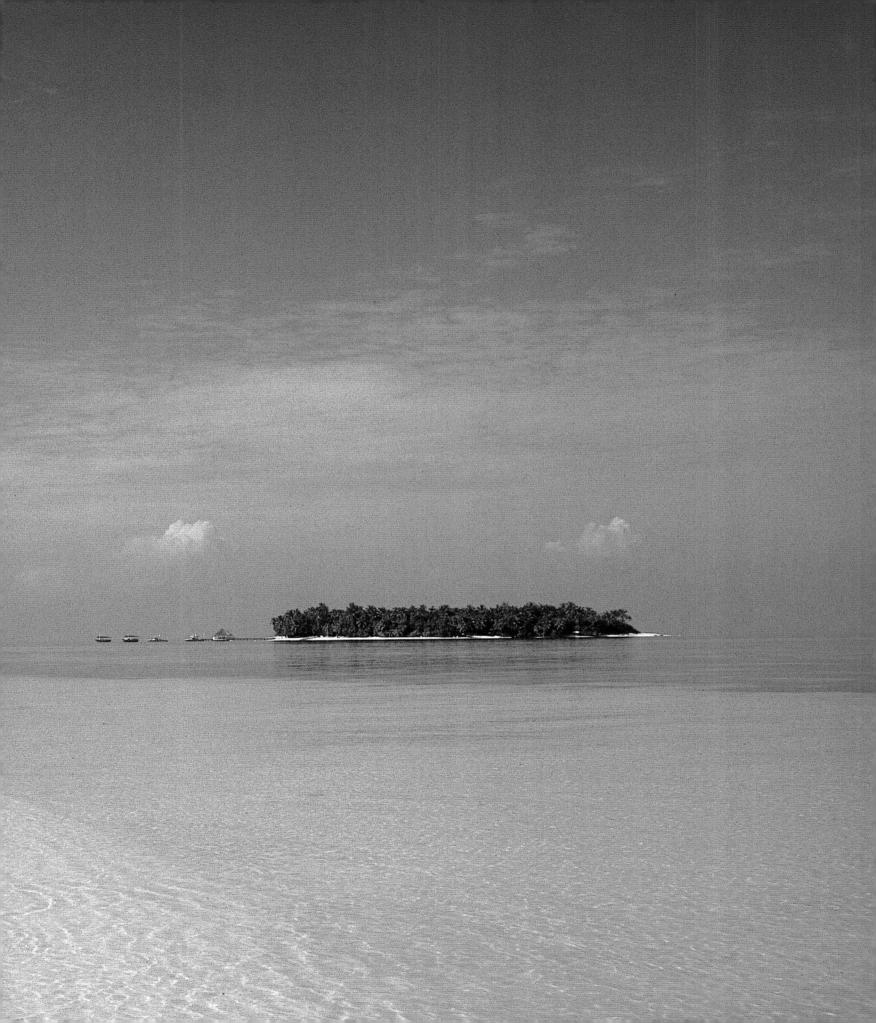

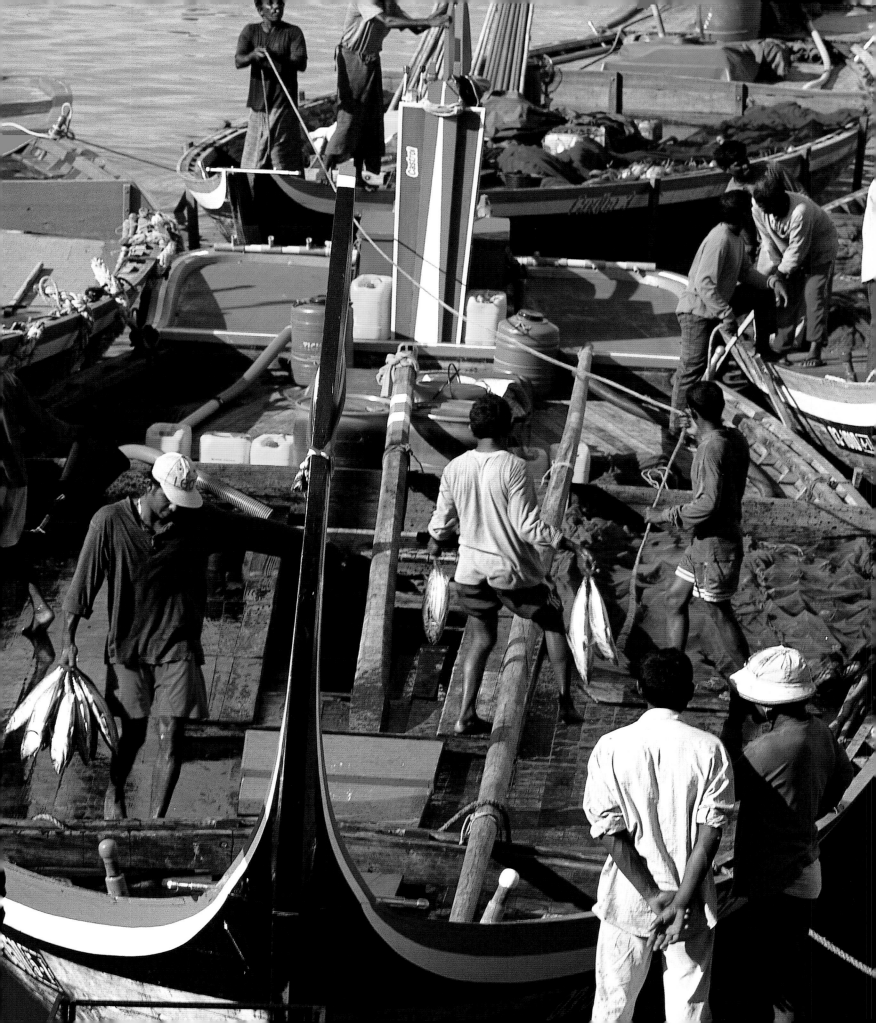

Below: Children in Khewra collect
water from the village tap. PAKISTAN

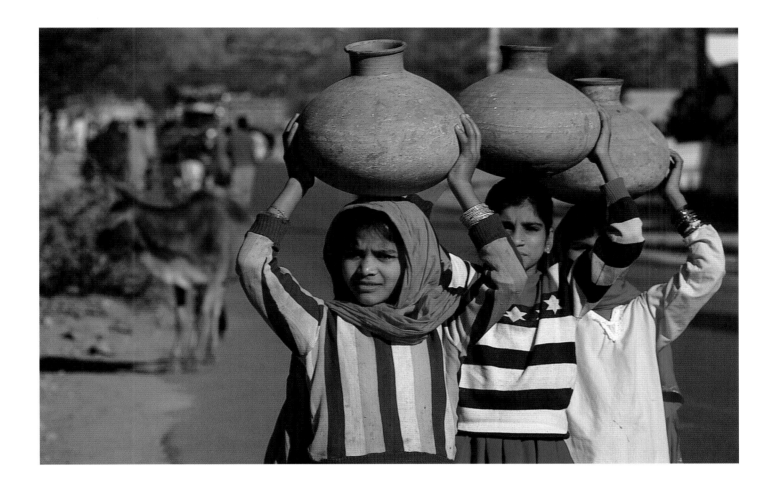

Preceding pages: The Maldives, a
collection of more than a thousand
coral atolls in the Indian Ocean
where 80 per cent of the land is less
than three feet above sea level, have
been inhabited for 5,000 years. Islam
was embraced in the 12th century AD,
and the islands remained a British
protectorate until 1965. MALDIVES

Opposite: Tourism and fishing
are the two main industries in the
Maldives. Foreign tourists are not
encouraged to mix with the locals
for fear of disturbing the traditional
culture. Resorts are built on hitherto
uninhabited islands. Here tuna is
brought ashore at the quay in Male,
the capital. MALDIVES

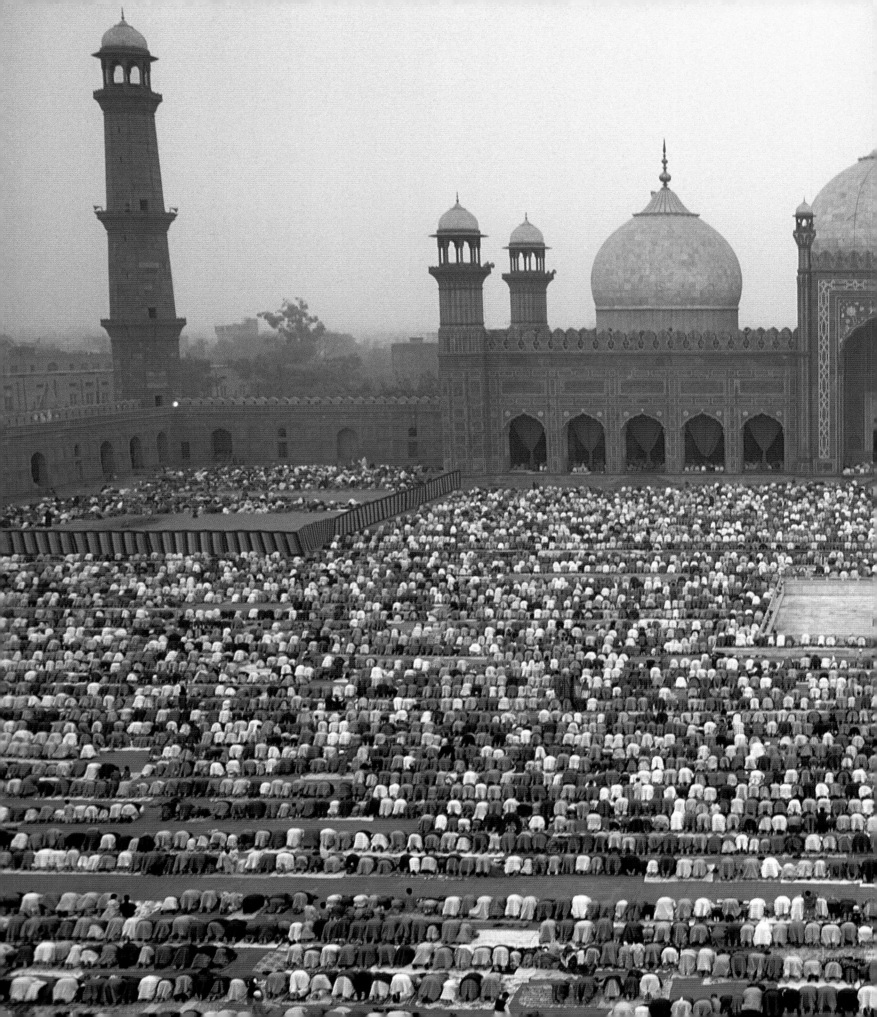

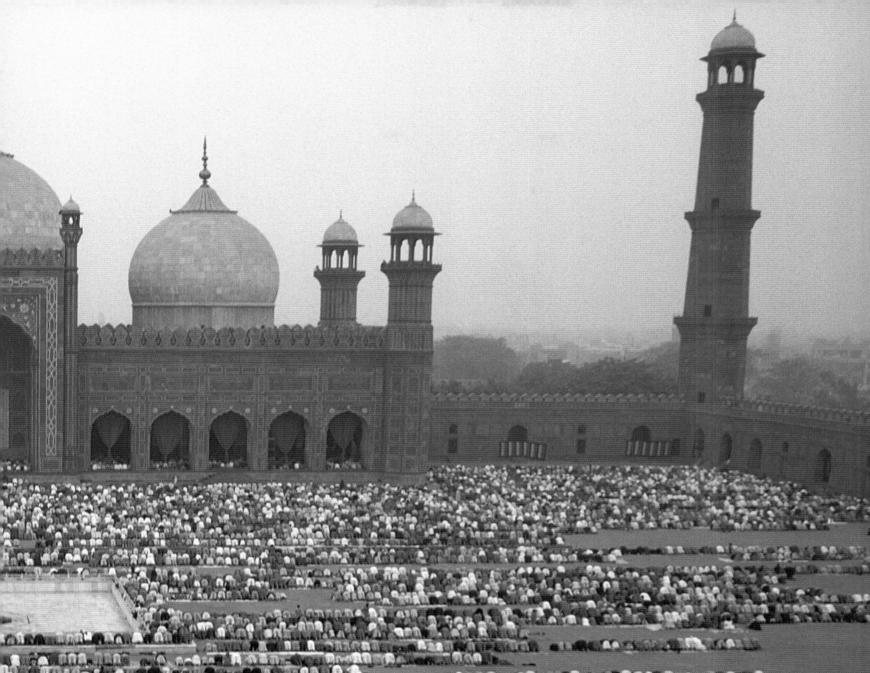

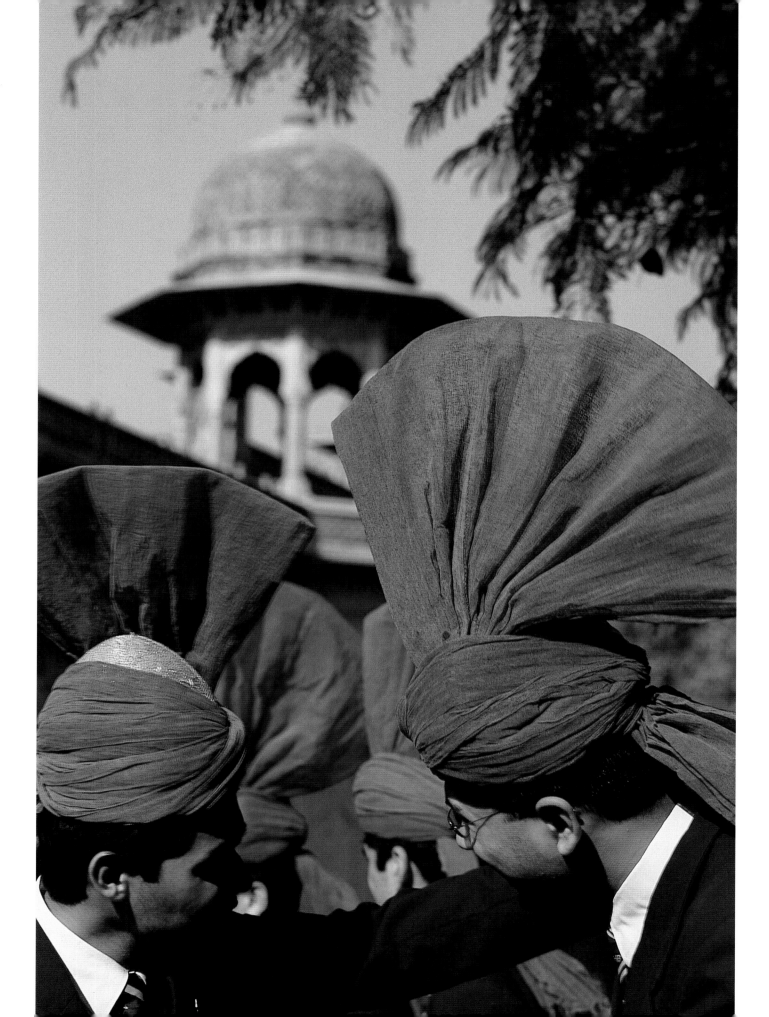

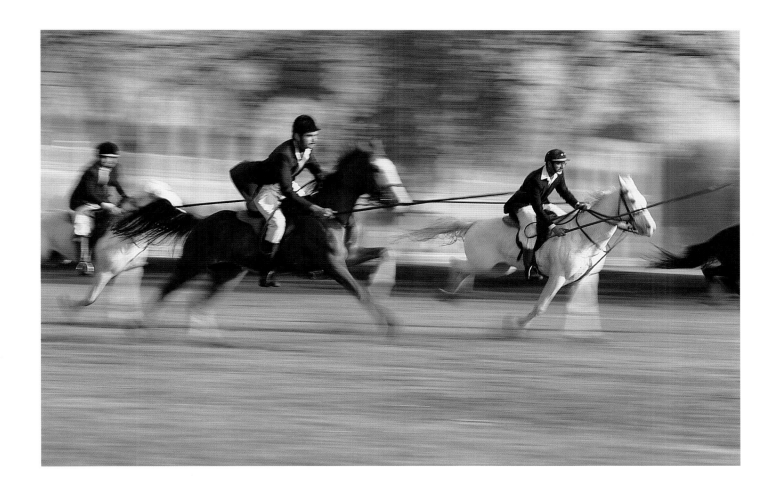

Preceding pages: Prayers at the end of
Ramadan fill the Badshahi mosque in
Lahore. PAKISTAN

Above and opposite: Aitchison College
for boys in Lahore is one of Pakistan's
leading private schools. Turbans are
worn once a week, while horsemanship
is a favoured afternoon activity.
PAKISTAN

Overleaf: Red-cloaked figures cross a
paddy field. BANGLADESH

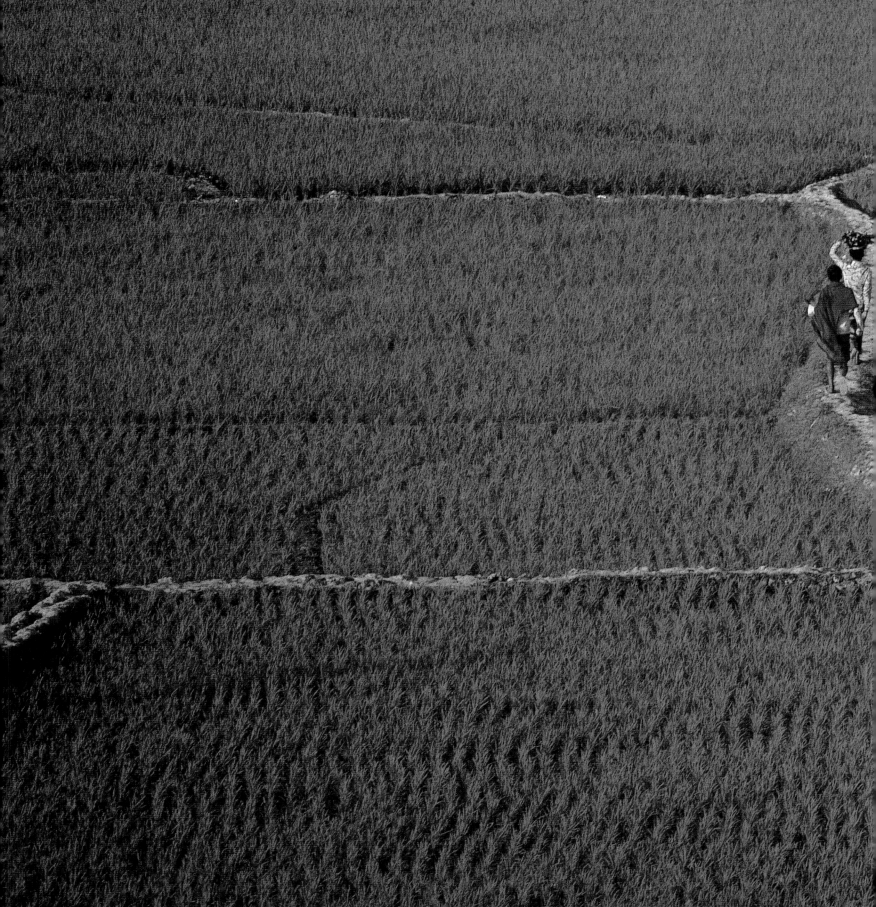

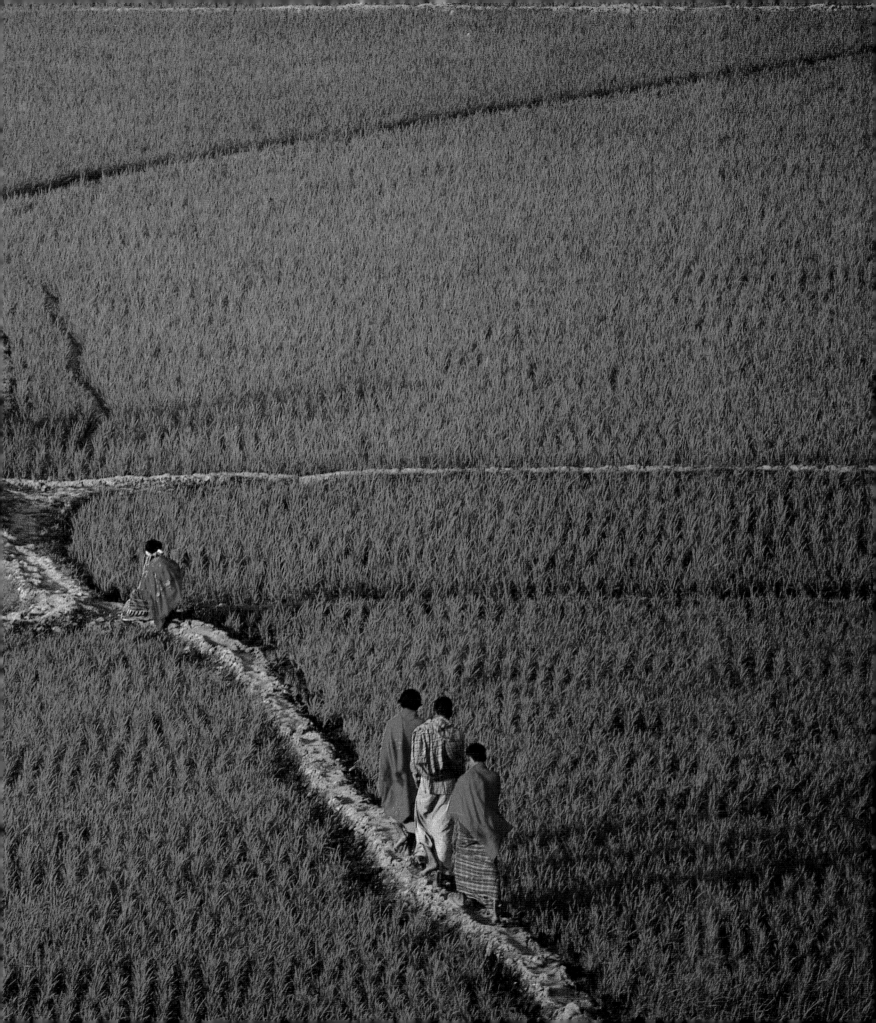

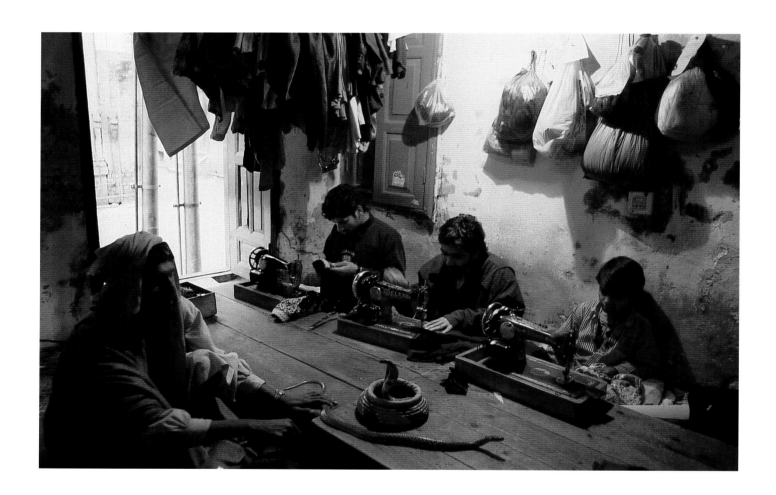

Above and opposite: A snake charmer
entertains workers in a cramped
tailor's shop, while a street trader in
Lahore sells dead chickens. PAKISTAN

Overleaf: Regularly cut off at high
tide, the tomb of Hajji Ali rests on
a rocky outcrop in the bay off Love
Grove, Mumbai (Bombay). INDIA

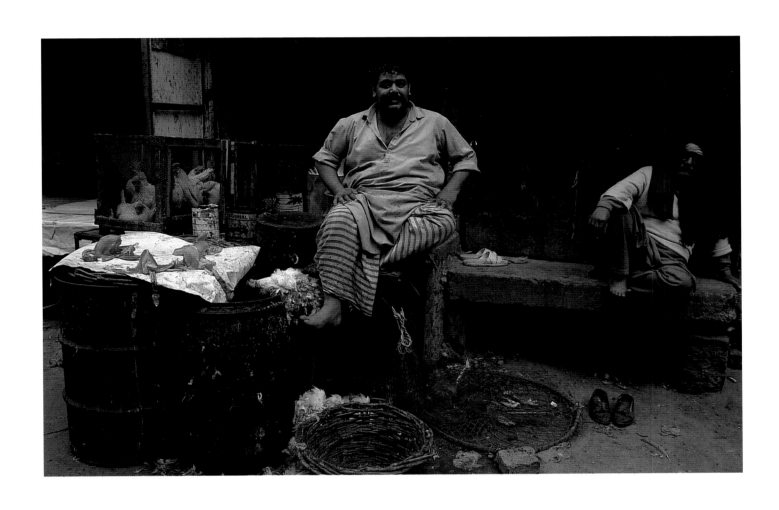

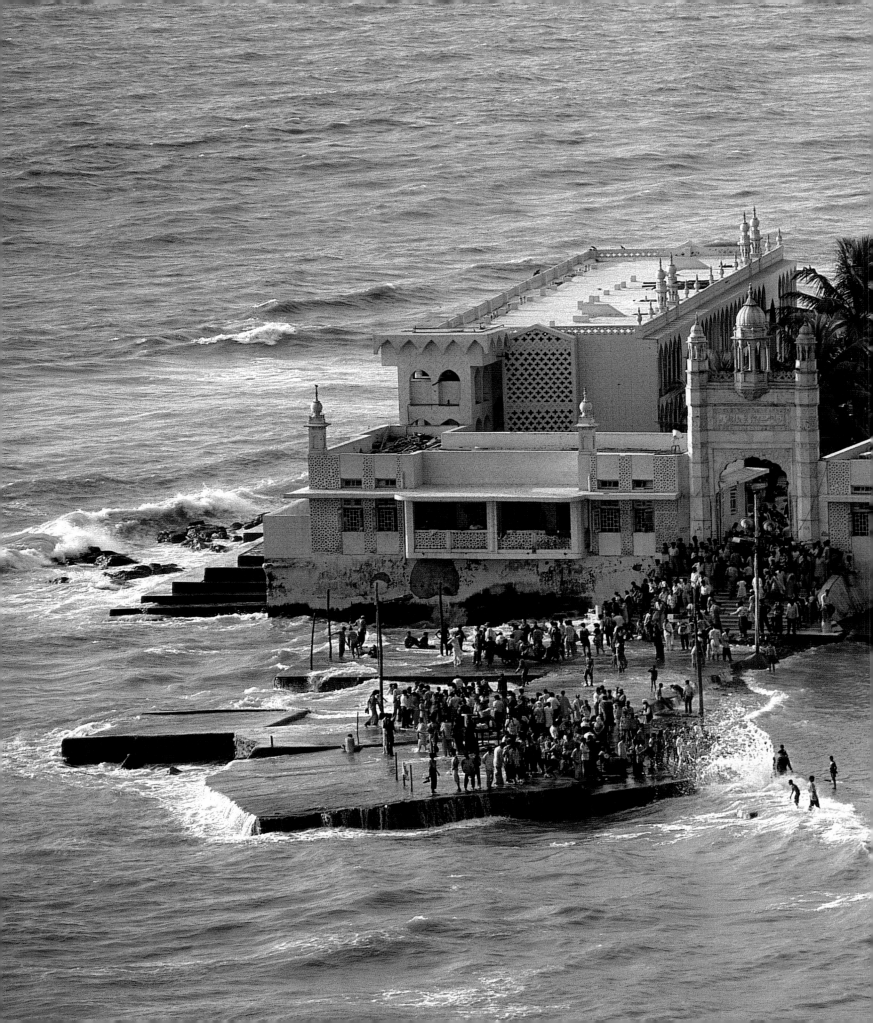

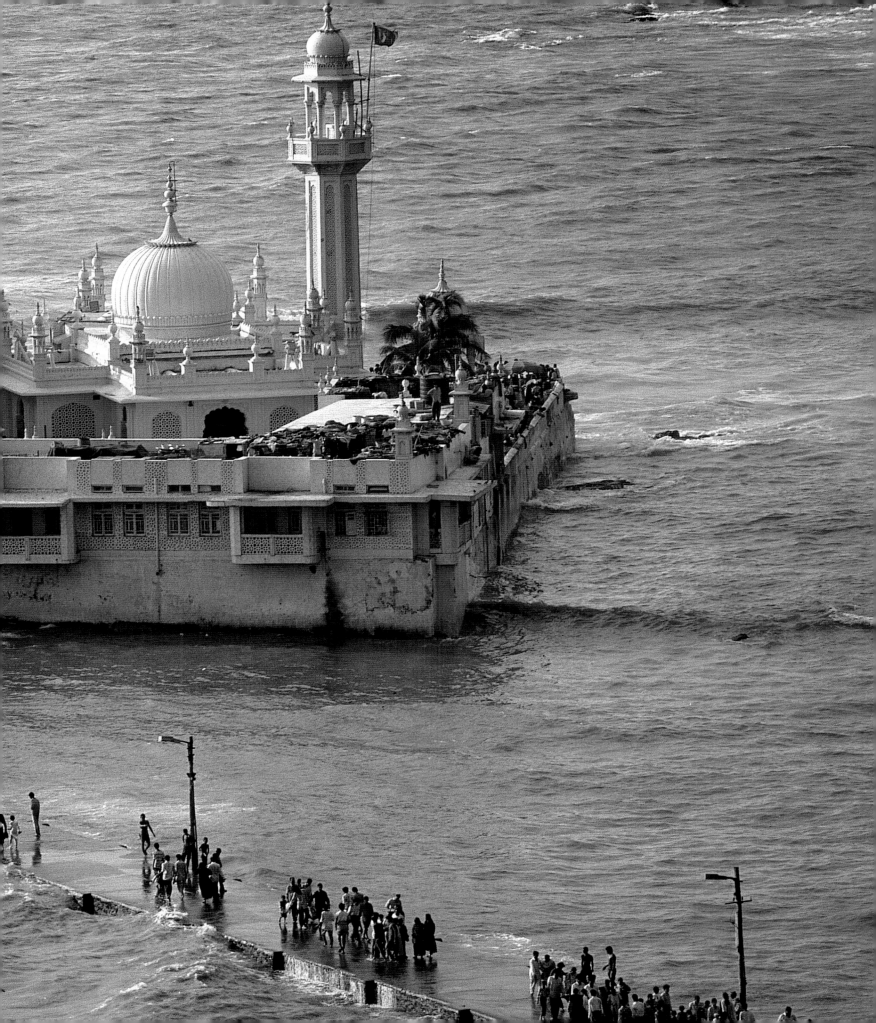

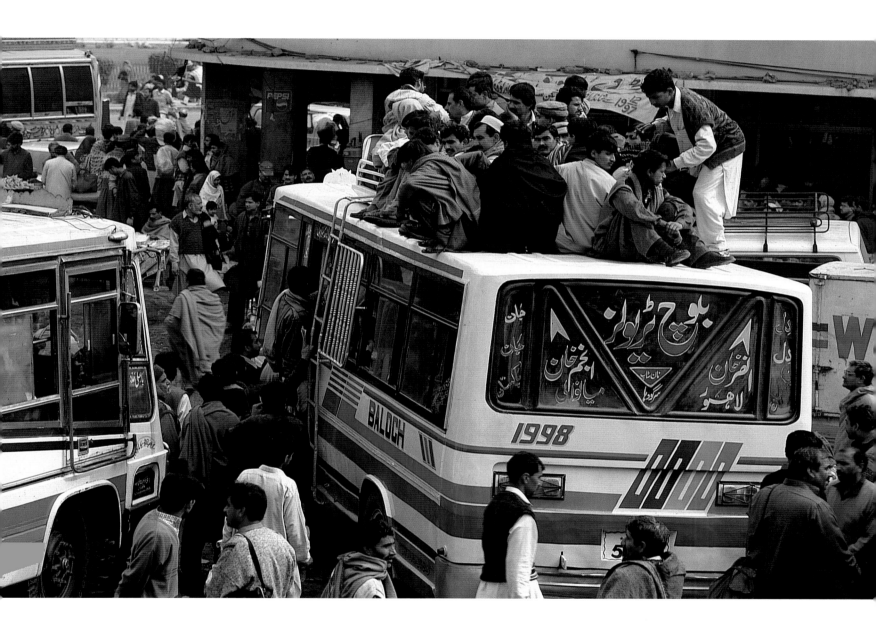

Above: Passengers crowd on to the
roof of a bus heading south from the
terminus in Lahore. PAKISTAN

Opposite: A shopkeeper in Bhendi,
the Muslim heartland of Mumbai
(Bombay). INDIA

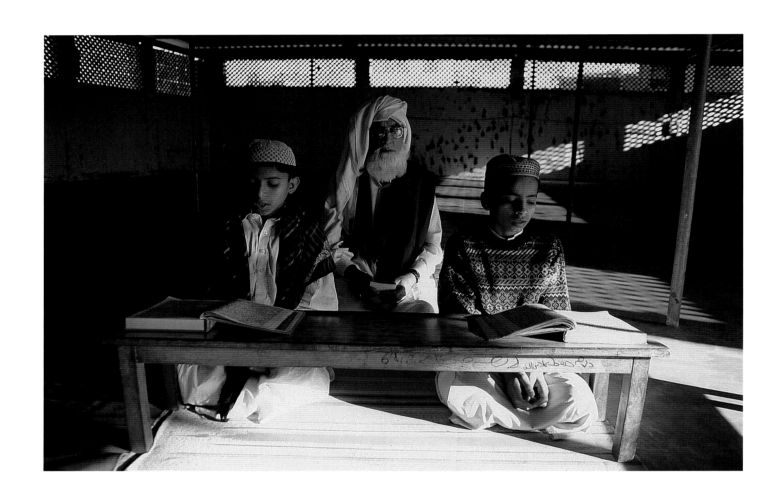

Above and opposite: A madrasa, or
religious school, in Karachi. Pupils
here will learn every one of the Koran's
114 *surahs* (chapters) and must be able
to recite them, in Arabic, by heart.
PAKISTAN

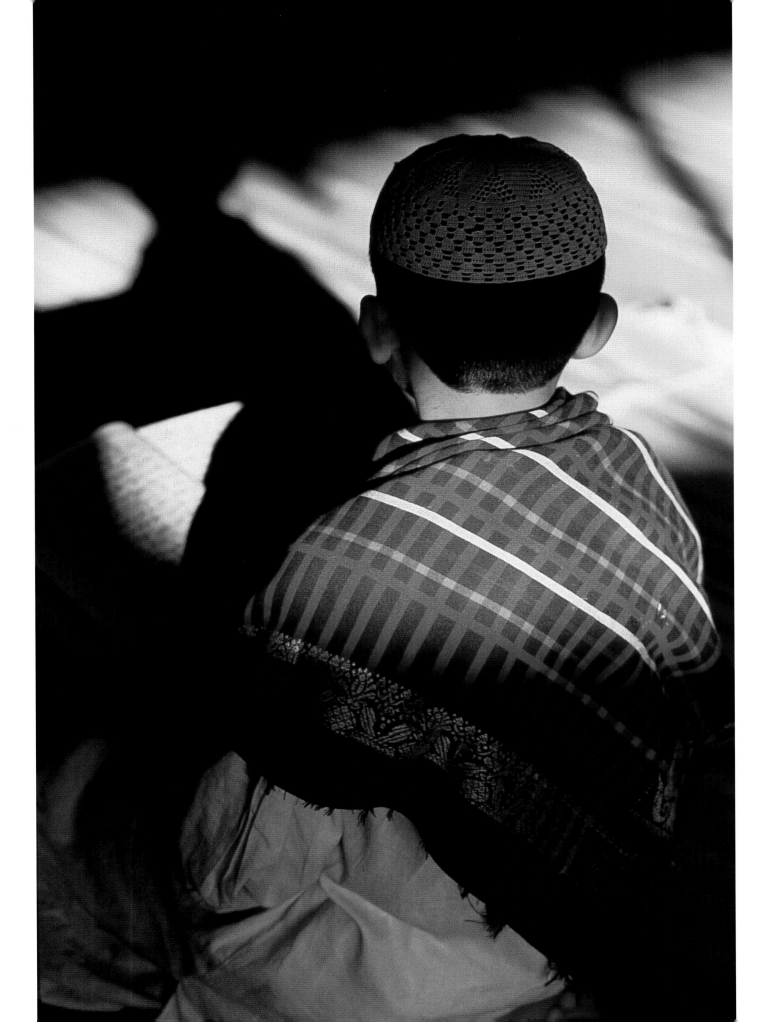

Southeast Asia

In contrast to the violent introduction of Islam to India first by Arab warriors and later by the conquering Mughals, Islam came peacefully to Southeast Asia on the backs of Arab and Indian merchants on their way to the Spice Islands and China beyond.

With a population of just under 200 million, of whom over 80 per cent are Muslims, Indonesia is the world's largest Muslim nation. Across the Strait of Malacca in multi-ethnic Malaysia, the Malays are mostly Muslims and Islam plays an important role in government as well as in society at large.

The inhabitants of Aceh on the northern tip of Sumatra had been converted to Islam by the end of the 13th century AD, and by the middle of the 15th century the Sultan of Malacca, who had come to dominate the trade and the peoples of the region, was presiding over a prosperous Muslim kingdom.

Today, the majority of Indonesian Muslims retain some connection to the country's Hindu–Buddhist past, and there is a considerable degree of tolerance towards non-Muslims. Yet there are tensions. The comparitively very small Chinese immigrant population is responsible for a very large proportion of the country's economic wealth, and it is racial jealousy rather than religious differences that cause the tension between the two groups. And the separatists of Aceh in northern Sumatra are more concerned with getting a better deal from the government in far-off Jakarta than they are about setting up a Muslim state.

And while it was Muslim reformists who provided the impetus in the 1920s for Malay nationalism, Malaysia's constitution today guarantees the very large immigrant Chinese and Indian populations the right to practise their own religions and customs, leading to a rich blend of cultural diversity. However, Islamic resurgence has resulted in Islam being given greater prominence in political life, and the northeastern province of Kelantan, which is controlled by the Islamic Party of Malaysia, has introduced a degree of *shari'a* (Islamic law) in parallel with the existing secular legal system.

Irrigated rice terraces make the most of undulating country in Bali. *INDONESIA*

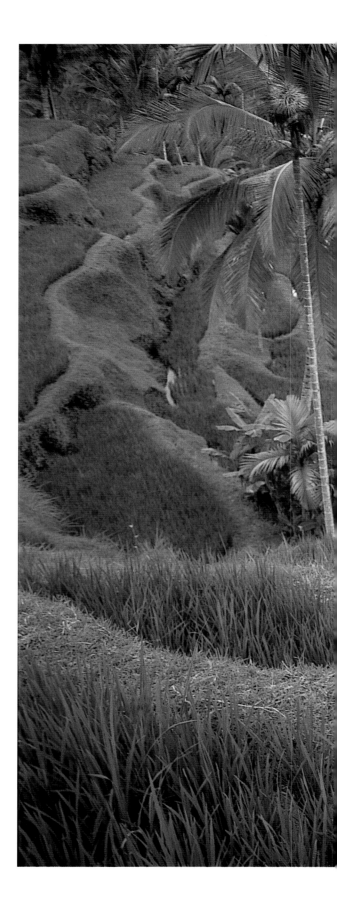

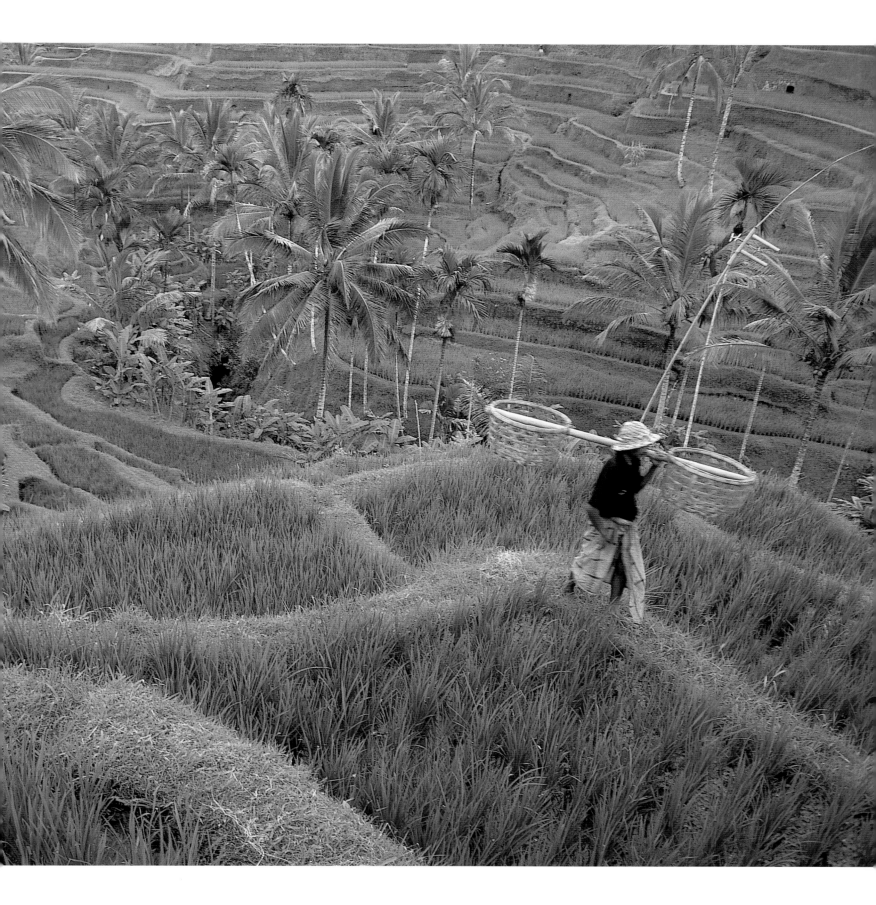

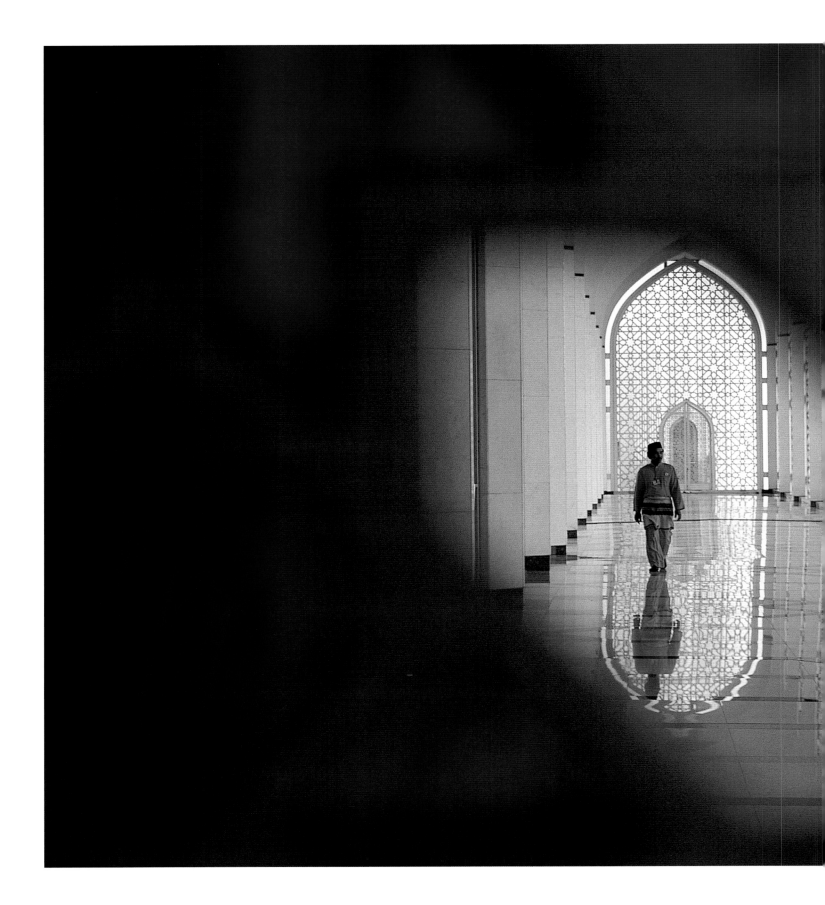

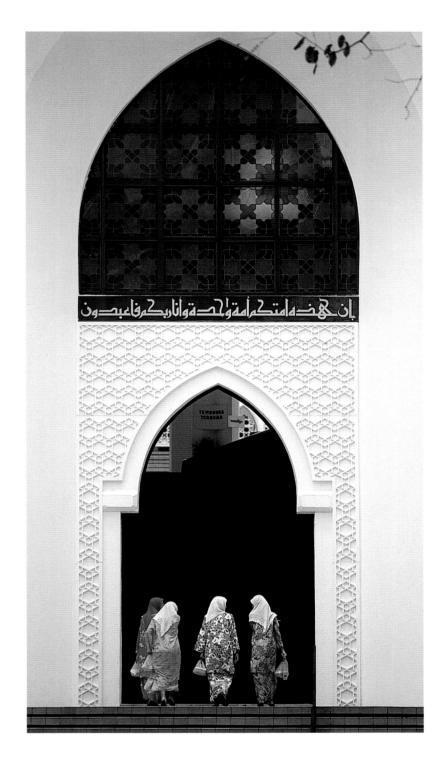

Above: The Ministry of Islamic Affairs in Kuala Lumpur. MALAYSIA

Left: The Masjid Negeri, the State mosque of Selangor, combines traditional Islamic architecture with local styles. Its main prayer hall accommodates 20,000 worshippers. The majority of ethnic Malays are Muslims, but freedom of worship is given to the many Buddhists, Hindus and Christians. MALAYSIA

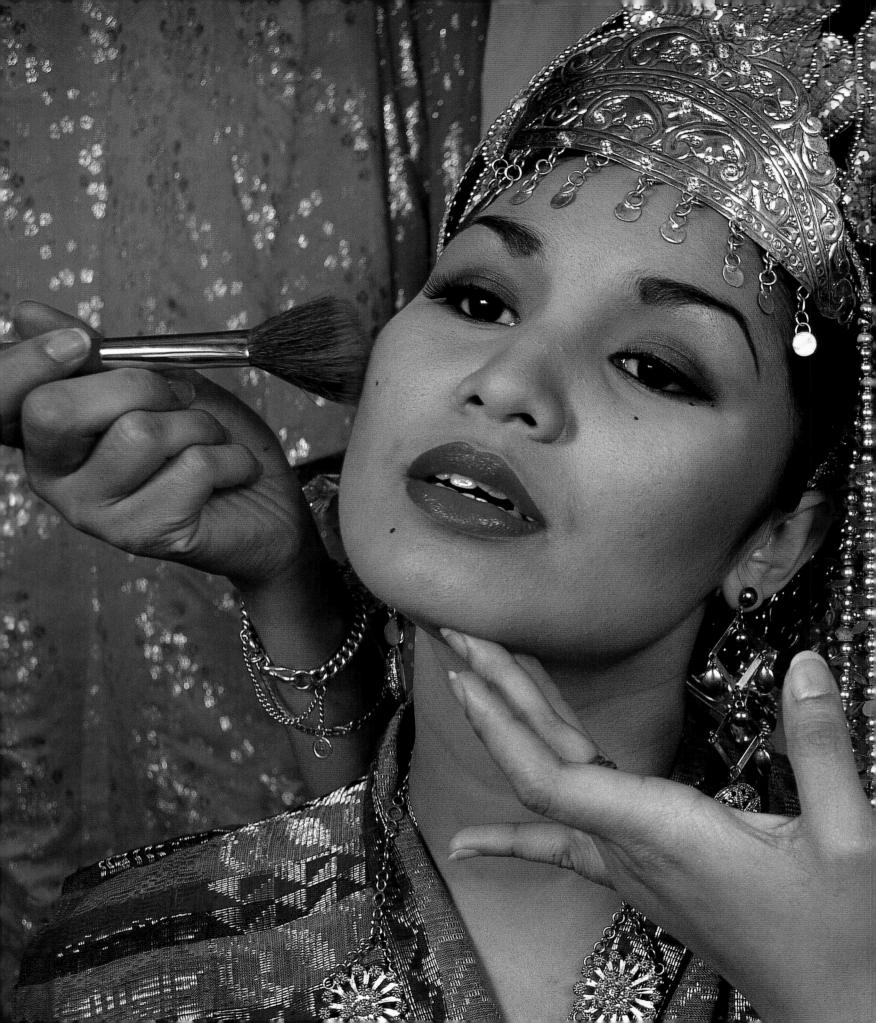

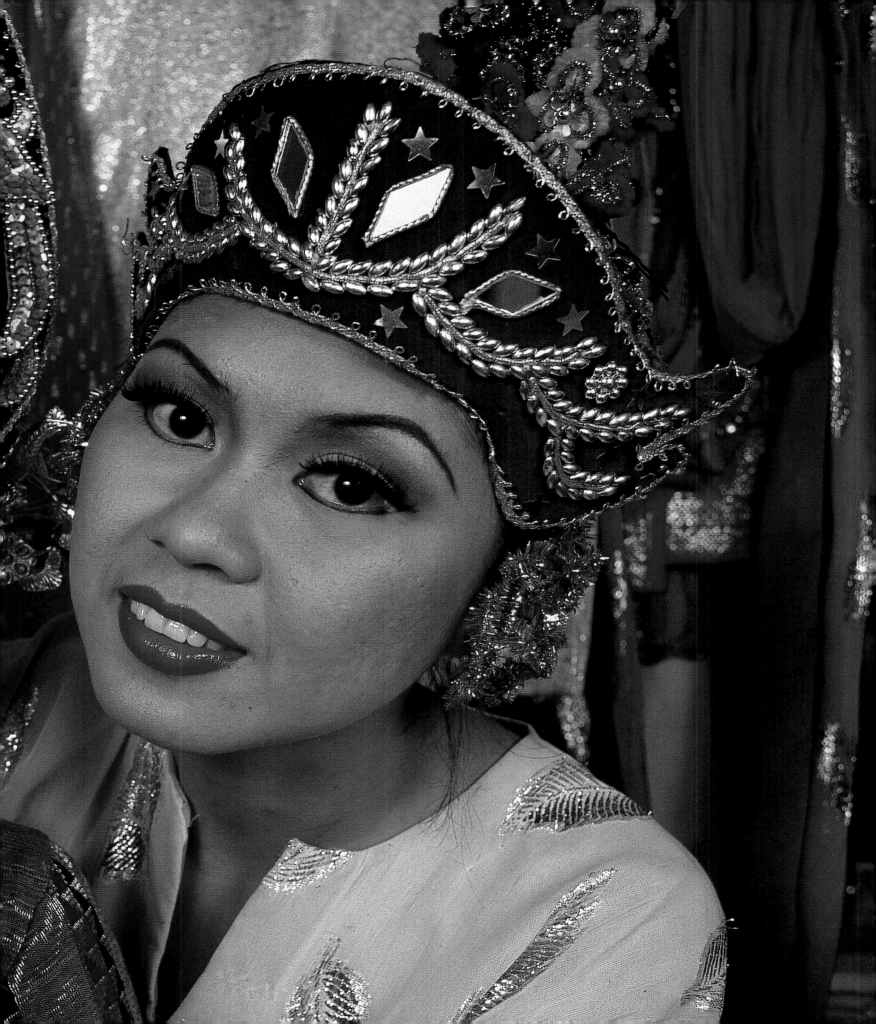

Preceding pages: Dancers prepare for an evening performance at a restaurant in Kuala Lumpur. MALAYSIA

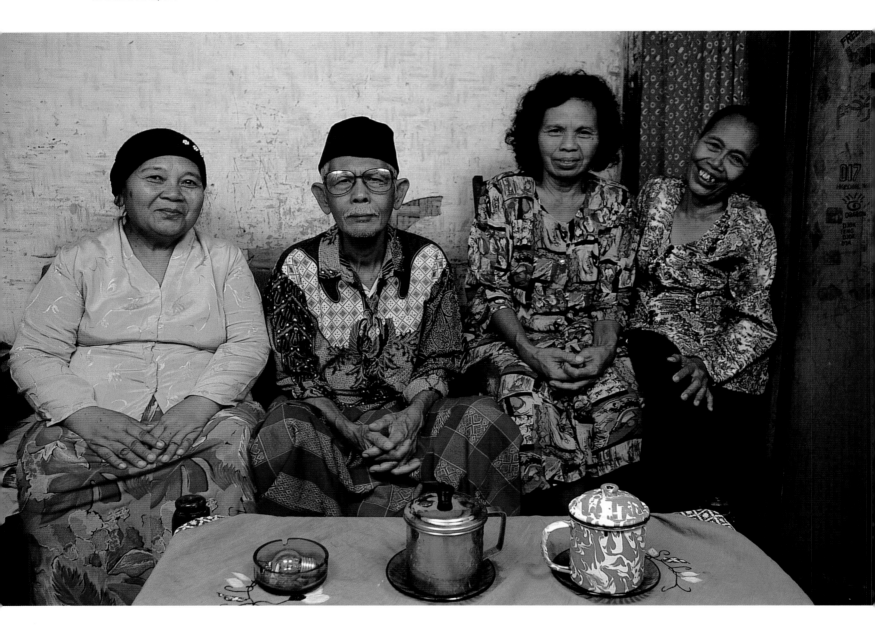

Above: Suradi is 65 and sold second-hand bicycles until he retired. His three wives pictured with him – he married the first when he was 19 and the third when he was 42 – have borne him eleven children. Muslim law allows a man to have up to four wives if the prevailing social circumstances permit. However, each wife must be treated equally, regardless of her age and the length of the marriage. INDONESIA

Opposite: Man with a *nangka* (jackfruit). INDONESIA

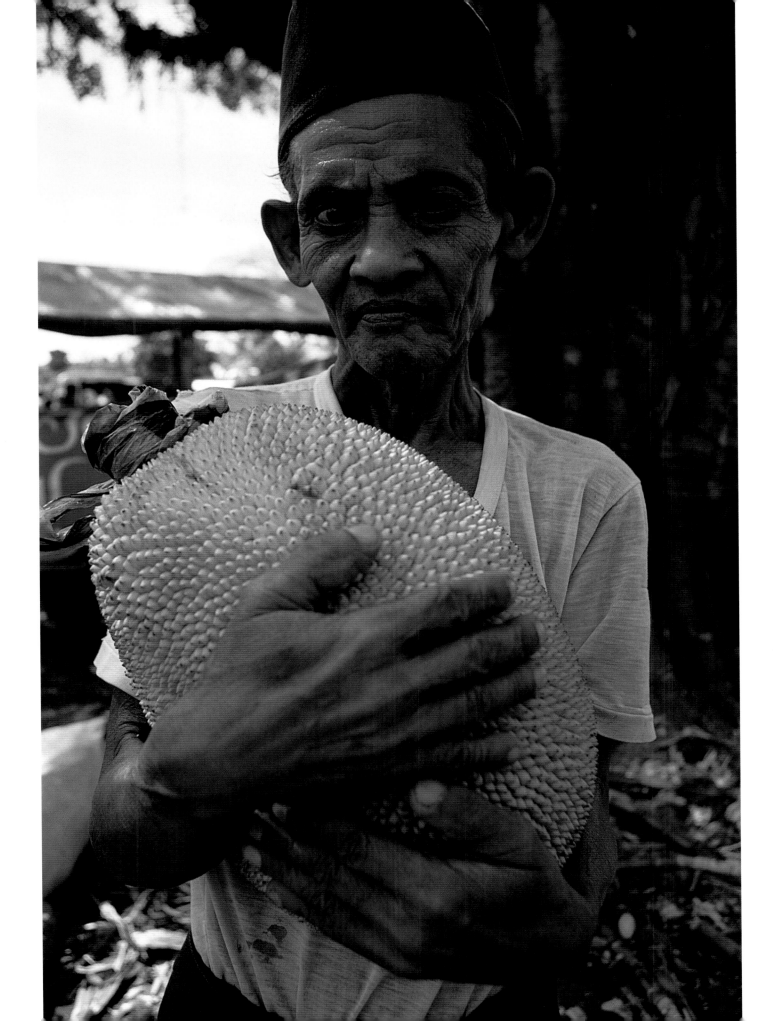

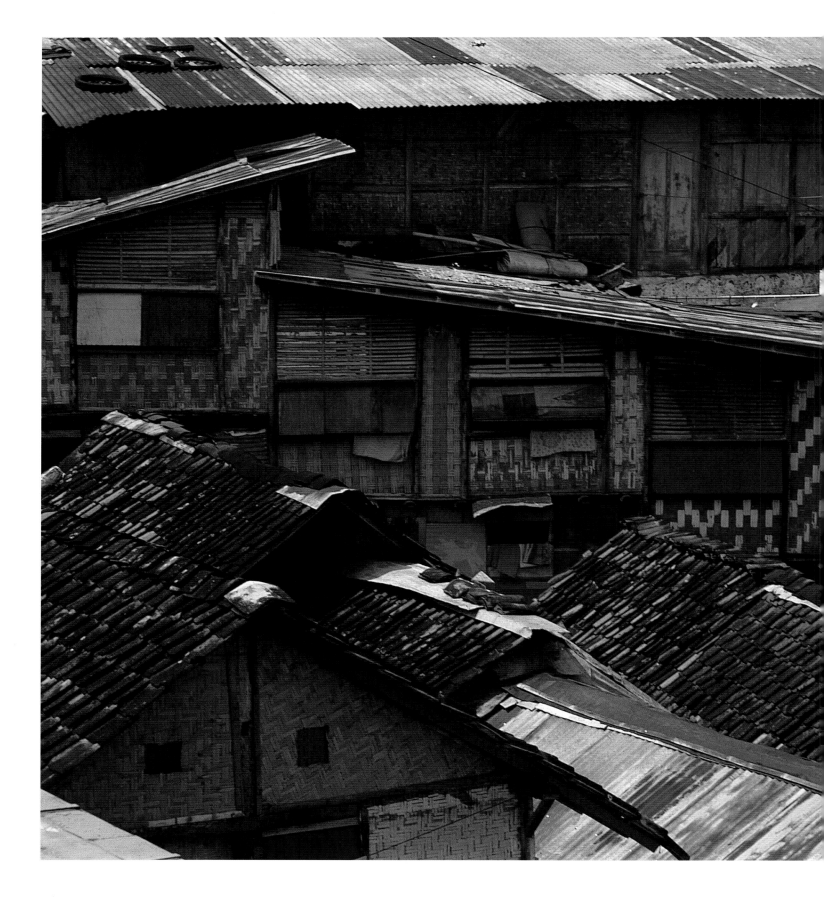

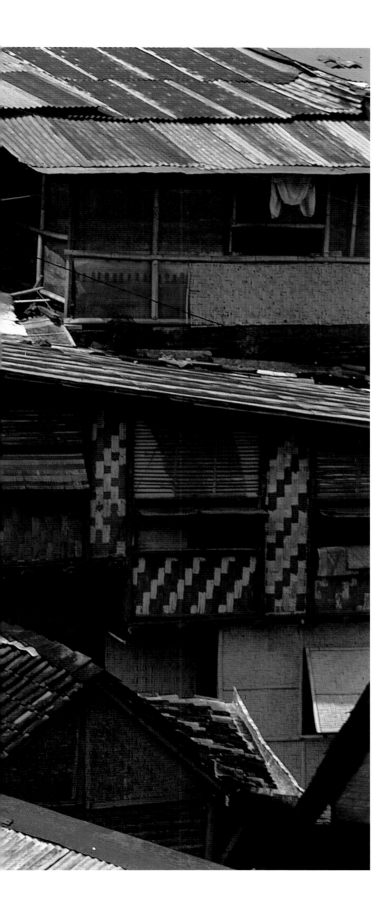

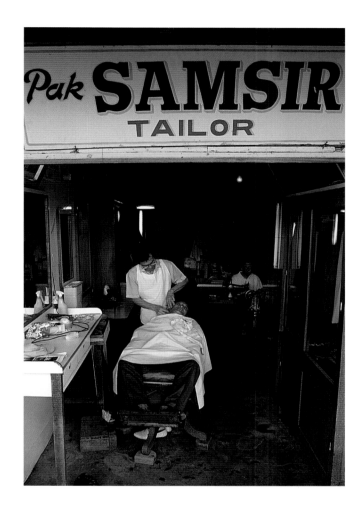

Above: A barber shares a shop with a
tailor in the West Sumatran hill town
of Bukittingi. INDONESIA

Left: Homes cluster on the river bank
in Yogyakarta. INDONESIA

Below: *Becaks*, bicycle rickshaws, while banned from the main streets of the larger cities, remain the basic form of transport. INDONESIA

Right: While post-modern architecture dominates much of Kuala Lumpur, some areas retain more traditional buildings. MALAYSIA

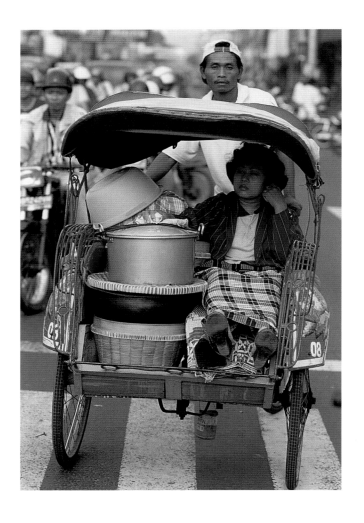

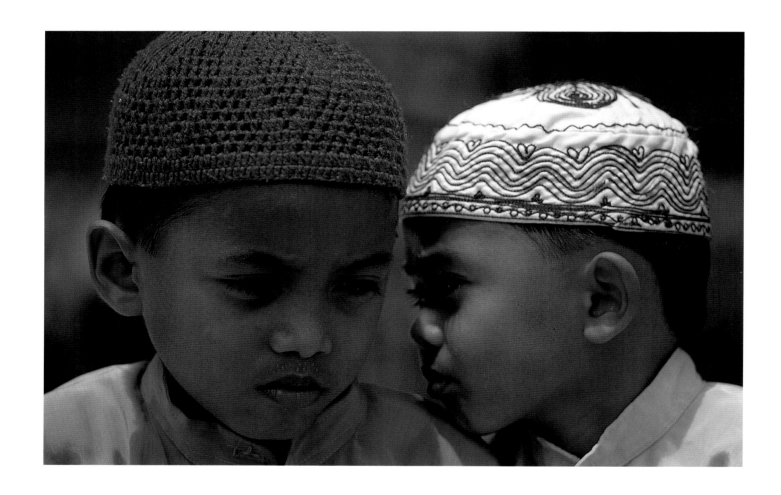

Above and opposite: Children prepare
for mosque in Shah Alam. MALAYSIA

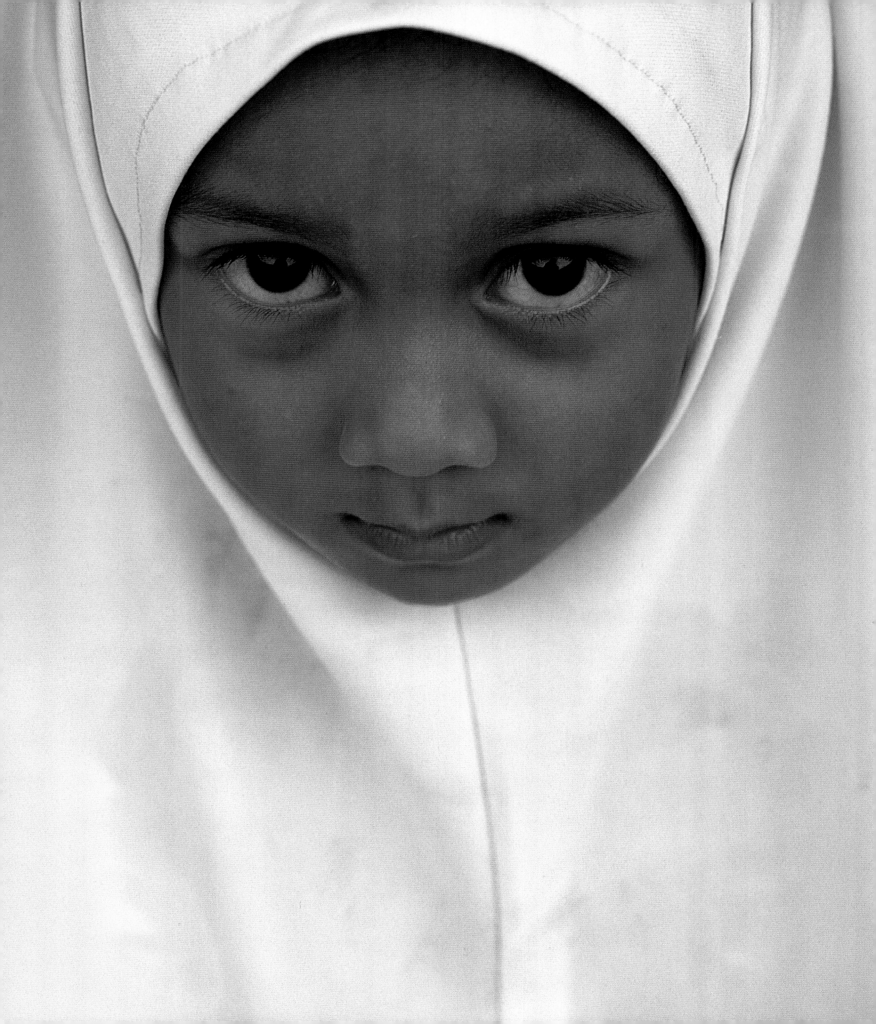

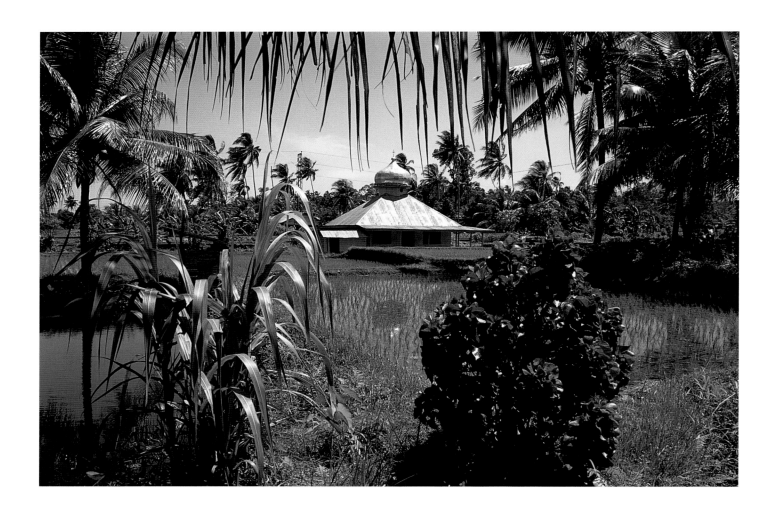

Above: Framed by lush vegetation, a
mosque in the middle of paddy fields
offers a convenient place of worship for
rice farmers in Sumatra. *INDONESIA*

Opposite: West Sumatra is dominated
by the Minangkabau people, who have
traditionally topped their wooden
houses with exaggerated horn-like
gables to reflect their reverence for
the water buffalo. Unusually in the
Muslim world, the Minangkabau are
a matriarchal and matrilineal society:
the eldest female is head of the family,
and ancestral property passes down
the female line. *INDONESIA*

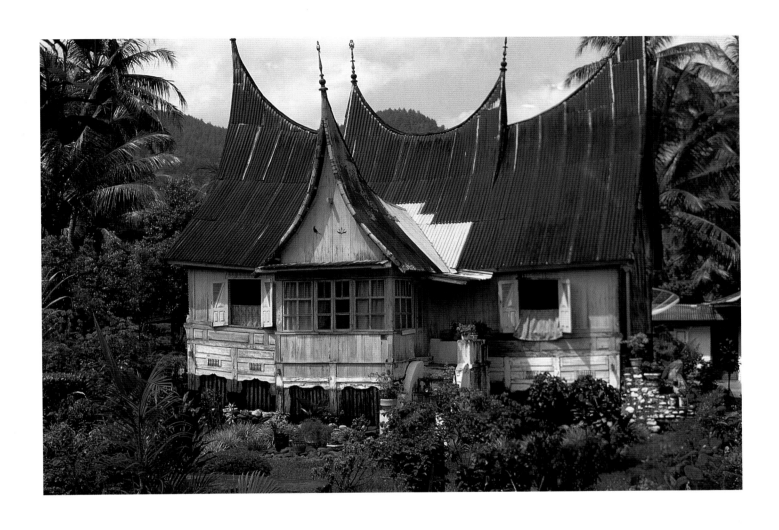

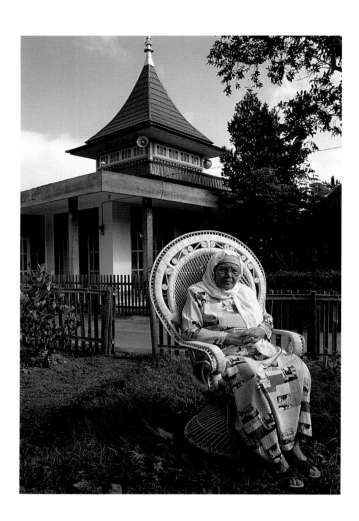

Above: Mushala Hajah Rosma,
who built a successful business on
exporting local crafts, outside her
own private mosque in the village
of Bonjo. INDONESIA

Right: Waiting for a fare – a taxi in
a residential district of Yogyakarta.
INDONESIA

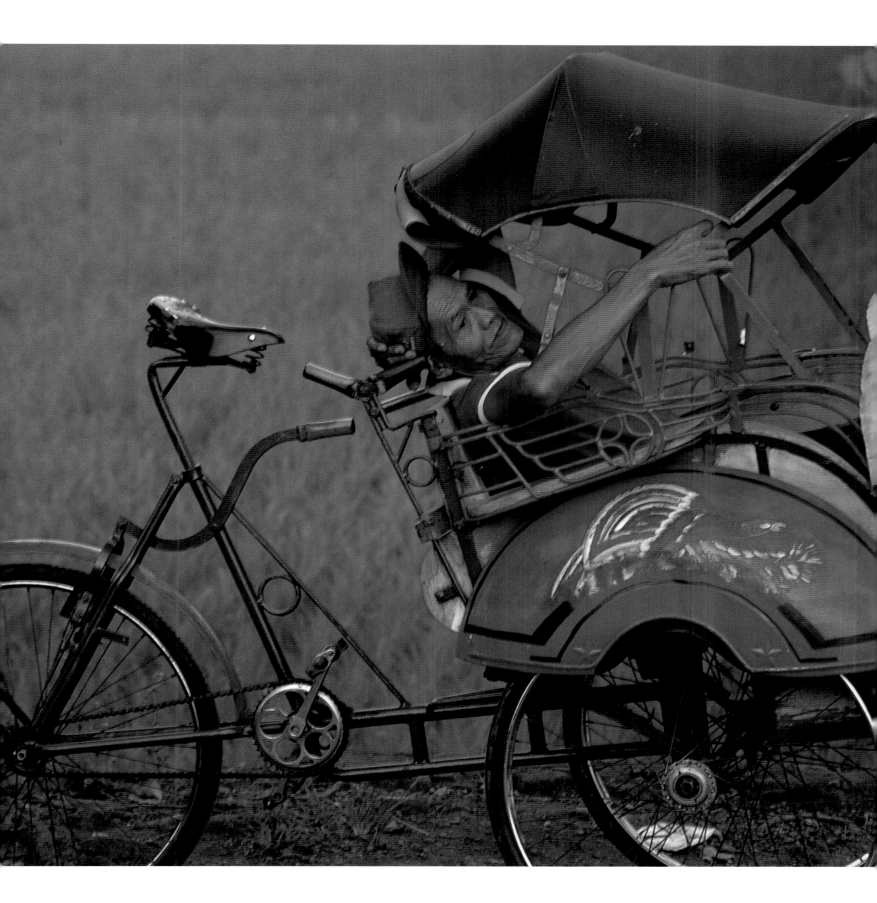

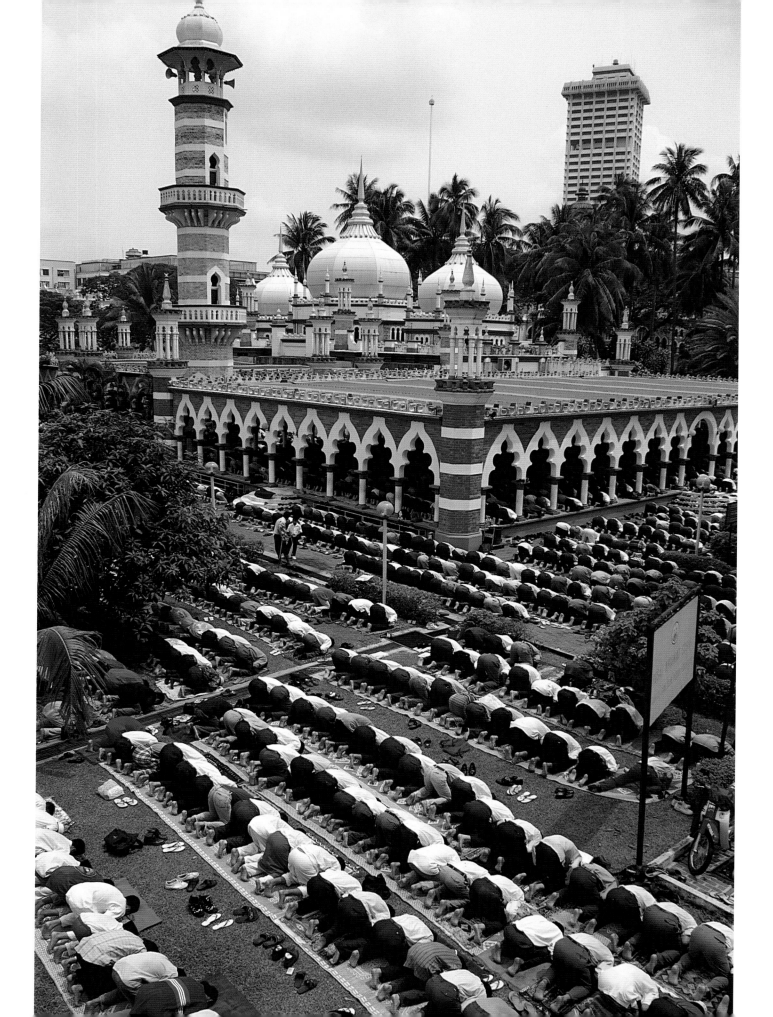

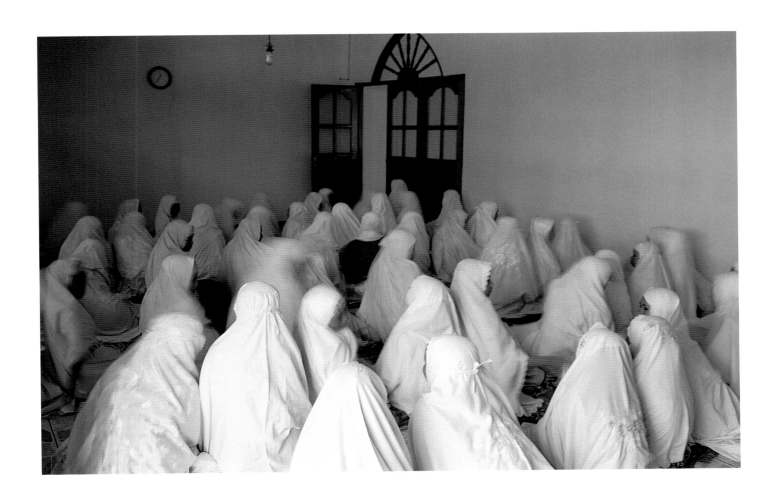

Above: Prayer time at a religious school
for girls at Yogyakarta. INDONESIA

Opposite: In Kuala Lumpur, Friday
prayers fill the Masjid Jamek to
overflowing. Designed by a British
architect and built on the site of a
Malay burial ground, the mosque
opened in 1909. MALAYSIA

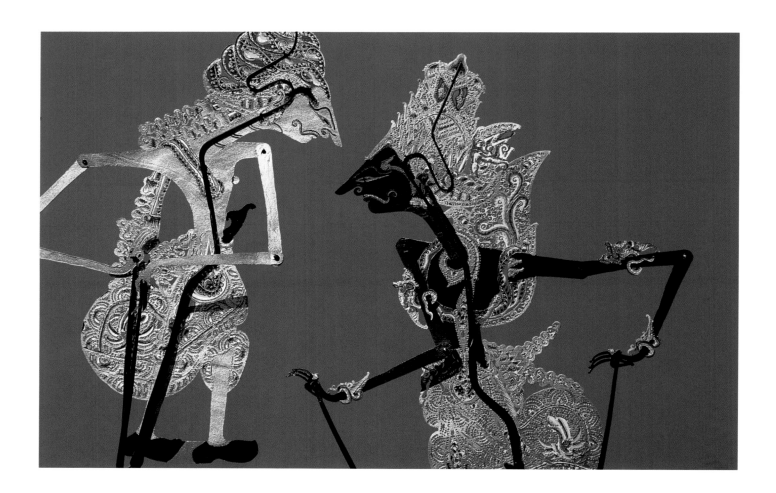

Above: Central to Javanese culture, shadow plays using puppets made of buffalo hide recount epic tales of the past. It is a one-man show with a single puppeteer operating all the puppets while narrating the story at the same time. One popular play relates the story of Amir Hamzah, the uncle of the Prophet Muhammad. Shadow plays have been losing the battle for audiences as television and video take over, but they remain popular for weddings and circumcisions. INDONESIA

Opposite: In the village of Batang Palupuh in western Sumatra, Marfianto, a hotel worker, and his bride Fitriani await their wedding guests. INDONESIA

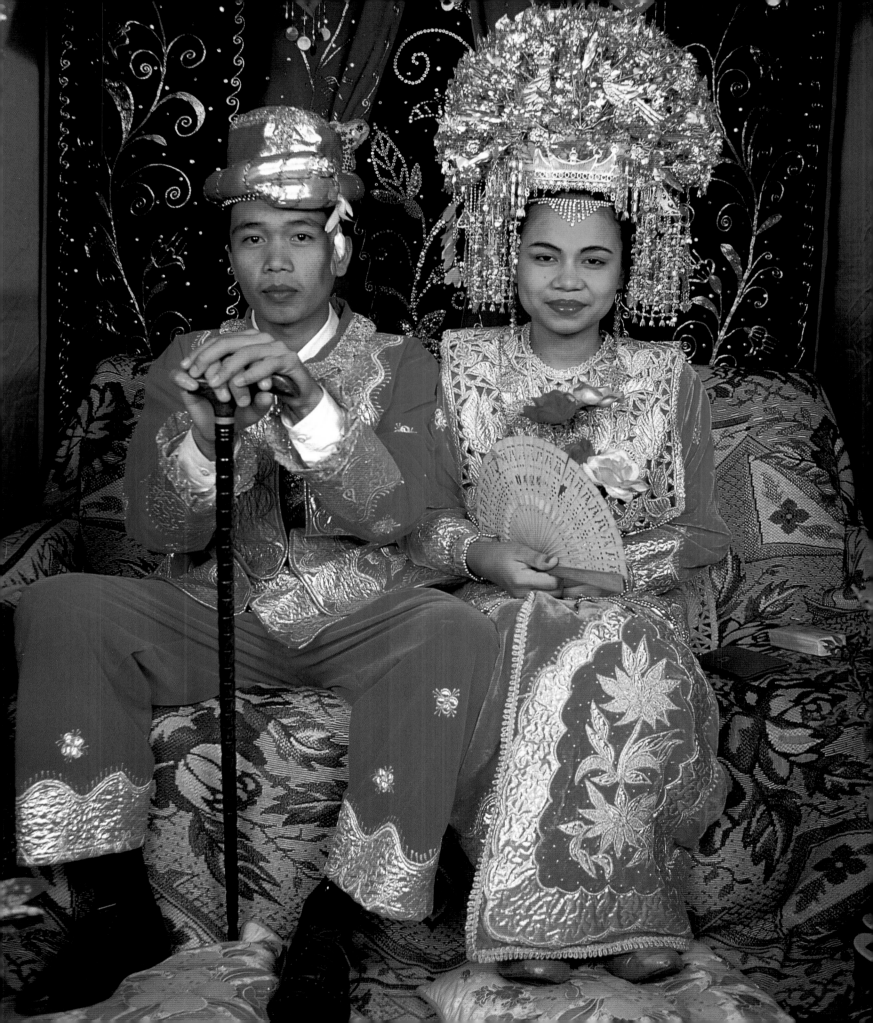

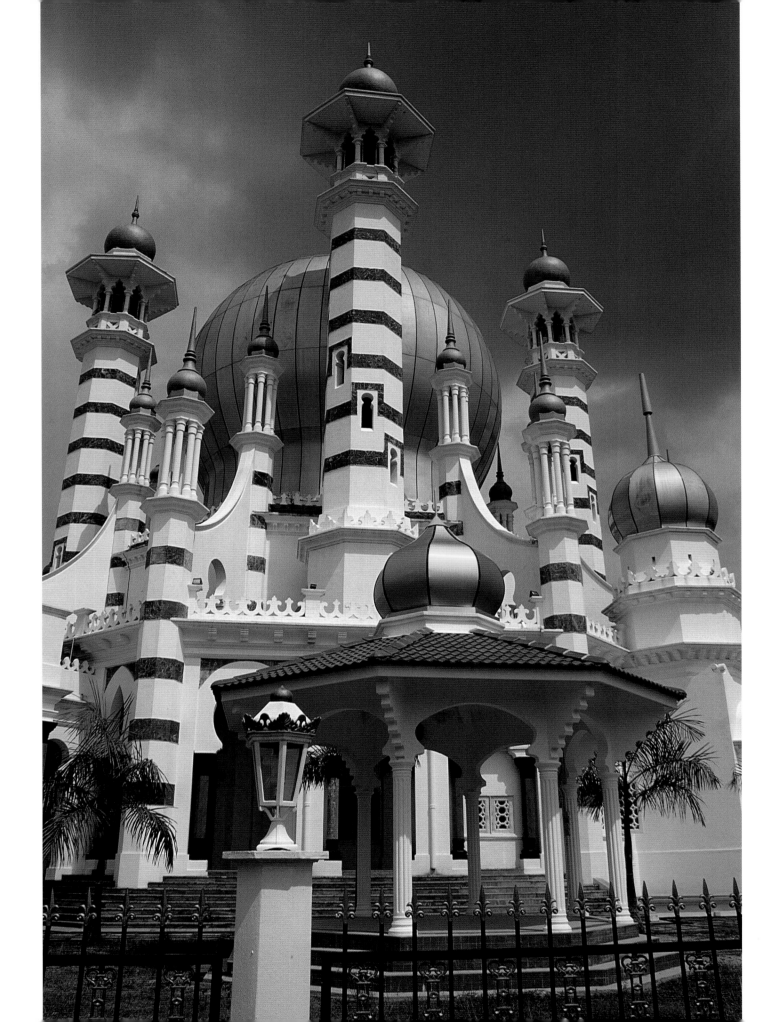

Opposite: The Masjid Ubudiah in Kuala
Kangsar. It was in this northern city
that Malaya's first rubber trees were
planted with seeds from Brazil that
came via the botanical gardens at Kew
in London. MALAYSIA

Above: The vestibule of a restaurant
in Melaka (Malacca). The west-coast
port city became the first Muslim
stronghold in the region towards
the middle of the 15th century AD.
MALAYSIA

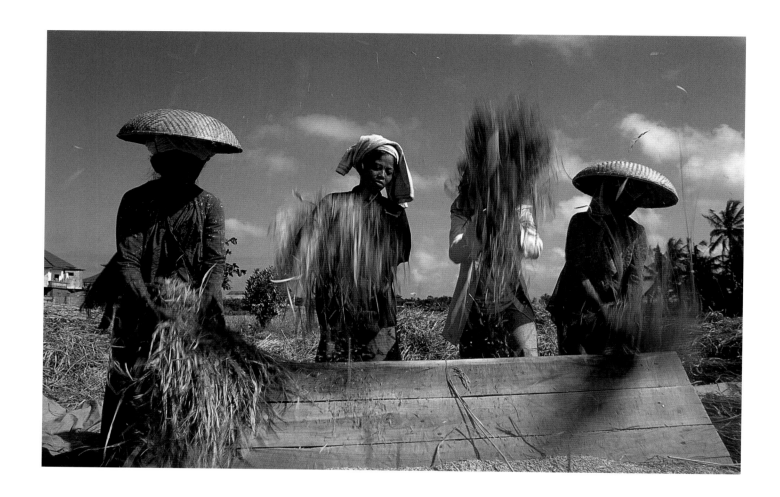

Above and opposite: Rice workers
in Java. So-called wet rice, or *sawah*,
flourishes in the rich laval soil,
producing two or three crops a year.
INDONESIA

Overleaf: Rambutans in a market at
Melaka (Malacca). *MALAYSIA*

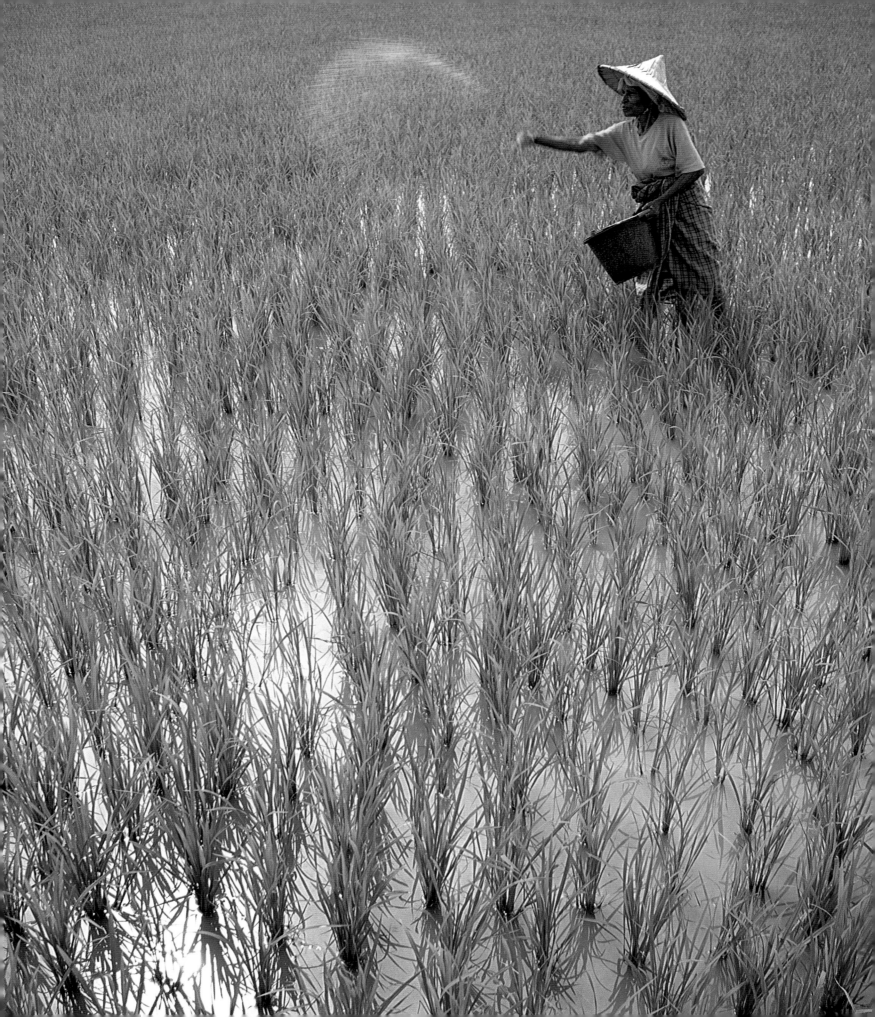